P9-ASF-039

FILMMAKERS SERIES
edited by
ANTHONY SLIDE

1. *James Whale*, by James Curtis. 1982
2. *Cinema Stylists*, by John Belton. 1983
3. *Harry Langdon*, by William Schelly. 1982
4. *William A. Wellman*, by Frank Thompson. 1983
5. *Stanley Donen*, by Joseph Casper. 1983
6. *Brian De Palma*, by Michael Bliss. 1983
7. *J. Stuart Blackton*, by Marian Blackton Trimble. 1985
8. *Martin Scorsese and Michael Cimino*, by Michael Bliss. 1985
9. *Franklin J. Schaffner*, by Erwin Kim. 1985
10. *D. W. Griffith and the Biograph Company*, by Cooper C. Graham et al. 1985
11. *Some Day We'll Laugh: An Autobiography*, by Esther Ralston. 1985
12. *The Memoirs of Alice Guy Blaché*, 2nd ed., translated by Roberta and Simone Blaché. 1996
13. *Leni Riefenstahl and Olympia*, by Cooper C. Graham. 1986
14. *Robert Florey*, by Brian Taves. 1987
15. *Henry King's America*, by Walter Coppedge. 1986
16. *Aldous Huxley and Film*, by Virginia M. Clark. 1987
17. *Five American Cinematographers*, by Scott Eyman. 1987
18. *Cinematographers on the Art and Craft of Cinematography*, by Anna Kate Sterling. 1987
19. *Stars of the Silents*, by Edward Wagenknecht. 1987
20. *Twentieth Century-Fox*, by Aubrey Solomon. 1988
21. *Highlights and Shadows: The Memoirs of a Hollywood Cameraman*, by Charles G. Clarke. 1989
22. *I Went That-a-Way: The Memoirs of a Western Film Director*, by Harry L. Fraser; edited by Wheeler Winston Dixon and Audrey Brown Fraser. 1990
23. *Order in the Universe: The Films of John Carpenter*, by Robert C. Cumbow. 1990 *(out of print; see No. 70)*
24. *The Films of Freddie Francis*, by Wheeler Winston Dixon. 1991
25. *Hollywood Be Thy Name*, by William Bakewell. 1991
26. *The Charm of Evil: The Life and Films of Terence Fisher*, by Wheeler Winston Dixon. 1991
27. *Lionheart in Hollywood: The Autobiography of Henry Wilcoxon*, with Katherine Orrison. 1991
28. *William Desmond Taylor: A Dossier*, by Bruce Long. 1991
29. *The Films of Leni Riefenstahl*, 2nd ed., by David B. Hinton. 1991
30. *Hollywood Holyland: The Filming and Scoring of "The Greatest Story Ever Told,"* by Ken Darby. 1992
31. *The Films of Reginald LeBorg: Interviews, Essays, and Filmography*, by Wheeler Winston Dixon. 1992

32. *Memoirs of a Professional Cad,* by George Sanders, with Tony Thomas. 1992
33. *The Holocaust in French Film,* by André Pierre Colombat. 1993
34. *Robert Goldstein and "The Spirit of '76,"* edited and compiled by Anthony Slide. 1993
35. *Those Were the Days, My Friend: My Life in Hollywood with David O. Selznick and Others,* by Paul Macnamara. 1993
36. *The Creative Producer,* by David Lewis; edited by James Curtis. 1993
37. *Reinventing Reality: The Art and Life of Rouben Mamoulian,* by Mark Spergel. 1993
38. *Malcolm St. Clair: His Films, 1915-1948,* by Ruth Anne Dwyer. 1997
39. *Beyond Hollywood's Grasp: American Filmmakers Abroad, 1914-1945,* by Harry Waldman. 1994
40. *A Steady Digression to a Fixed Point,* by Rose Hobart. 1994
41. *Radical Juxtaposition: The Films of Yvonne Rainer,* by Shelley Green. 1994
42. *Company of Heroes: My Life as an Actor in the John Ford Stock Company,* by Harry Carey, Jr. 1994
43. *Strangers in Hollywood: A History of Scandinavian Actors in American Films from 1910 to World War II,* by Hans J. Wollstein. 1994
44. *Charlie Chaplin: Intimate Close-Ups,* by Georgia Hale, edited with an introduction and notes by Heather Kiernan. 1995
45. *The Word Made Flesh: Catholicism and Conflict in the Films of Martin Scorsese,* by Michael Bliss. 1995
46. *W. S. Van Dyke's Journal: White Shadows in the South Seas (1927-1928) and other Van Dyke on Van Dyke,* edited and annotated by Rudy Behlmer. 1996
47. *Music from the House of Hammer: Music in the Hammer Horror Films, 1950-1980,* by Randall D. Larson. 1996
48. *Directing: Learn from the Masters,* by Tay Garnett. 1996
49. *Featured Player: An Oral Autobiography of Mae Clarke,* edited with an introduction by James Curtis. 1996
50. *A Great Lady: A Life of the Screenwriter Sonya Levien,* by Larry Ceplair. 1996
51. *A History of Horrors: The Rise and Fall of the House of Hammer,* by Denis Meikle. 1996
52. *The Films of Michael Powell and the Archers,* by Scott Salwolke. 1997
53. *From Oz to E. T.: Wally Worsley's Half-Century in Hollywood—A Memoir in Collaboration with Sue Dwiggins Worsley,* edited by Charles Ziarko. 1997
54. *Thorold Dickinson and the British Cinema,* by Jeffrey Richards. 1997
55. *The Films of Oliver Stone,* edited by Don Kunz. 1997
56. *Before, In and After Hollywood: The Autobiography of Joseph E. Henabery,* edited by Anthony Slide. 1997

57. Ravished Armenia *and the Story of Aurora Mardiganian*, compiled by Anthony Slide. 1997
58. *Smile When the Raindrops Fall*, by Brian Anthony and Andy Edmonds. 1998
59. *Joseph H. Lewis: Overview, Interview, and Filmography*, by Francis M. Nevins. 1998
60. *September Song: An Intimate Biography of Walter Huston*, by John Weld. 1998
61. *Wife of the Life of the Party*, by Lita Grey Chaplin and Jeffrey Vance. 1998
62. *Down But Not Quite Out in Hollow-weird: A Documentary in Letters of Eric Knight*, by Geoff Gehman. 1998
63. *On Actors and Acting: Essays by Alexander Knox*, edited by Anthony Slide. 1998
64. *Back Lot: Growing Up with the Movies*, by Maurice Rapf. 1999
65. *Mr. Bernds Goes to Hollywood: My Early Life and Career in Sound Recording at Columbia with Frank Capra and Others*, by Edward Bernds. 1999
66. *Hugo Friedhofer: The Best Years of His Life: A Hollywood Master of Music for the Movies*, edited by Linda Danly. 1999
67. *Actors on Red Alert: Career Interviews with Five Actors and Actresses Affected by the Blacklist*, by Anthony Slide. 1999
68. *My Only Great Passion: The Life and Films of Carl Th. Dreyer*, by Jean and Dale Drum. 1999
69. *Ready When You Are, Mr. Coppola, Mr. Spielberg, Mr. Crowe*, by Jerry Ziesmer. 1999
70. *Order in the Universe: The Films of John Carpenter*, 2nd ed., by Robert C. Cumbow. 2000
71. *Making Music with Charlie Chaplin*, by Eric James. 2000
72. *An Open Window: The Cinema of Víctor Erice*, edited by Linda C. Ehrlich. 2000
73. *Satyajit Ray: In Search of the Modern*, by Suranjan Ganguly. 2000
74. *Voices from the Set: The* Film Heritage *Interviews*, edited by Tony Macklin and Nick Pici. 2000
75. *Paul Landres: A Director's Stories*, by Francis M. Nevins. 2000
76. *No Film in My Camera*, by Bill Gibson. 2000
77. *Saved from Oblivion: An Autobiography*, by Bernard Vorhaus. 2000
78. *Wolf Man's Maker: Memoir of a Hollywood Writer*, by Curt Siodmak. 2000
79. *An Actor and A Rare One: Peter Cushing as Sherlock Holmes*, by Tony Earnshaw. 2000
80. *Picture Perfect*, by Herbert L. Strock. 2000
81. *Peter Greenaway's Postmodern/Poststructuralist Cinema*, edited by Paula Willoquet-Maricondi and Mary Alemany Galway, 2000.

No Film in My Camera

Bill Gibson

Scarecrow Filmmakers Series, No. 76

The Scarecrow Press, Inc.
Lanham, Maryland, and London
2000

SCARECROW PRESS, INC.
Published in the United States of America
by Scarecrow Press, Inc.
4720 Boston Way, Lanham, Maryland 20706
http://www.scarecrowpress.com

4 Pleydell Gardens, Folkestone
Kent CT20 2DN, England

British Library Cataloguing in Publication Information Available

Library of Congress Cataloging-in-Publication Data
Gibson, Bill, 1922–
 No film in my camera / Bill Gibson.
 p. cm.—(Scarecrow Filmmakers series ; no. 76)
 Includes bibliographical references and index.
 ISBN 0-8108-3845-1 (alk. paper)
 1. Gibson, Bill, 1922– 2. Cinematographers—United States—
 Biography. 3. War photographers—United States—Biography.
 I. Title. II. Filmmakers series ; no. 76.

TR849.G53 A3 2000
778.5'3'092—dc21
[B]
 00-030784

Dedication

A world of thanks to my mother, who let me roam the swamps of Florida as a young boy; to my father, who wanted me to be a Merchant Marine officer like him; and to my wife, Harriet, who took a camera to a war-torn country in Africa and has been my soul partner and camera competitor ever since.

Contents

Foreword
by Jack R. Lousma
xi

Preface
xiii

Introduction
xv

Chapter One
The Hornet
1

Chapter Two
Antarctica
33

Chapter Three
The Chase
39

Chapter Four
Sutures and Smelling Salts
51

Chapter Five
Adventures with Ben
59

Chapter Six
Travels with Doolittle
67

Chapter Seven
On the Shoulders of Giants
79

Chapter Eight
Napalm, Elephants, and Grey Flannel Suits
97

Chapter Nine
No Place to Hide
115

Chapter Ten
Making the News
125

Chapter Eleven
The World Is My Oyster
131

Chapter Twelve
Movers and Shakers
157

Index
177

About the Author
184

Foreword

Jack R. Lousma

Our adventures began in other places and at different times, but it was inevitable they would lead to the intersection of our careers and the formation of an enduring and rewarding friendship. When I was a schoolboy, watching black-and-white World War II newsreel action films, Bill Gibson, at the age of 18, was already making them in the middle of the action, where he has remained. While struggling to survive in the churning sea after the USS *Hornet* had been mortally wounded in a Japanese kamikaze and torpedo attack, Bill did not foresee hunting and fishing expeditions with General Jimmy Doolittle, whose Tokyo Raiders he had memorialized on film weeks before, as they roared off the carrier for a rendezvous with the enemy and with history. Nor did I know that with Venezuelan friends we would push and swim after a makeshift log raft carrying hunting dogs and equipment across the crocodile- and piranha-infested Orinoco River. Good judgment and adventure are often strangers.

Bill Gibson was no stranger to history-making events or to the people who made them. His career as a combat cameraman propelled him through World War II with the Navy, the Korean Conflict with the Air Force, and to Vietnam as a civilian on an assignment with the U.S. Marines. With his working climate cycling among bullets, broadcasting, and business for more than half a century, Bill covered U.S. presidents, other world leaders, aviation and space pioneers, and international news events. He directed and produced feature and scientific films, newscasts and documentaries, commercials and music videos, and satellite teleconferences. His clients encompassed the motion picture and video industry, worldwide news networks, airline and aerospace companies, and civilian and military

government agencies. Bill also designed the first automatic system for tracking America's rocket launches and was a consultant to NASA on the photographic coverage during *Apollo 11*, the first manned landing on the Moon.

An avid outdoorsman, Bill Gibson joined General Doolittle on his expeditions in Venezuela, where we met for the first time. We later collaborated on several productions that Bill created and directed: a space documentary for a now-friendly Japanese audience, a nationally teleconferenced hunting debate from the University of Montana, and a series of sportsman's hunting and fishing videos.

Military veteran, aerospace enthusiast, outdoorsman, patriotic American, and friend, Bill Gibson is a master storyteller and relates his experiences with characteristic humor and colorful prose. I am confident that you will find these fascinating recollections of a combat cameraman enriching, enlightening, and entertaining!

Jack R. Lousma
March 2000

Preface

In the early summer of 1941, the city of St. Petersburg, Florida, known in those days as the city of the newlyweds or nearly deads, was occupied by a few thousand locals commonly called as "web feet," "crackers," "conks," "swamp rats"— whatever the winter visitors felt like calling us.

At 18, I was a typical Florida teenager, spending the majority of my time spear fishing, gator hunting, girl chasing, and working as an usher at the Plaza Theater.

This movie palace had class. It held 700 fannies in luxurious, padded seats. The acoustical system was remarkably crisp and clear. A chandelier that looked as though it would be thoroughly comfortable in a Paris opera house sparkled like the heavens before pollution. The smell was fresh. Mildew and wood rot, so prevalent in our part of the country, were absent from this cathedral of persistence of vision.

That's what I remember about the magnificent Plaza. Exactly at 1 P.M., the house lights dimmed and the 70-foot, cardinal-red curtain slowly parted. In synchronization with the massive, moving curtain, music faded in softly. A white gauze curtain, the length of the stage, gradually moved upward. In the projection room high above the balcony, the operator pushed the switch and then waited for what seemed like an eternity for the projector to reach speed. His hand shot forward and moved a lever that unleashed a brilliant carbon arc light through the nitrate base of the film onto the giant screen the old timers called Edison's pallet.

The images flashed by. The hair stood up on the back of my neck. The adrenaline flowed like a tropical rain shower. For the next ten minutes I stood in a darkened corner watching a composite of world news delivered twice a week to theaters everywhere by Warner-Pathé newsreel. Lightning struck and I knew, without a doubt, what I wanted to be.

I imagined photographing Benito Mussolini, his lips curled, chin jutted forward, thrusting up his arms in a gesture of powerful communication with throngs of Italian countrymen in rapt attention, which quickly went out of frame to reveal Mr. Hitler himself punctuating the air with measured, thumping arm and hand movements calculated to stir the believing masses. Then I am capturing, on film, hundreds of screaming Japanese soldiers raising their weapons, celebrating another victory over the Chinese. My next scene is taken in a Ford Trimotor flying over Mt. Euribus in the Antarctica. The pilot turns his head looking directly at the camera and smiles. It's Admiral Byrd.

In my audio-visual fantasizing, I felt that I already knew the leaders, explorers, the movers and shakers of today's world. My dreams were a latent image that only needed a laboratory to develop them.

The odds of becoming a newsreel cameraman were astronomical. There were only 45 full-time news cameramen in the entire country, and only six newsreel companies in the business. The laboratory for granting my dream was right around the corner. It was the summer of '41 and the winds of change sent an advanced message to the four corners of the Earth that something big was up. Something big indeed. A war so gigantic, so vast, so mammoth, that everything before seemed like a skirmish—like kids with garbage can lids and slingshots. The winds of war were blowing hard and, by God, Bill Gibson would play a role in it.

I determined I would record, on nitrate-coated celluloid, the heroes, villains, battles—victories and defeats. The path to fulfill my desire and where it led is what this book is all about. It's an adventure that took me to all the continents of the world and put me in harm's way more times than I care to remember. So, read with me as I tell you about the world as I saw it— through the viewfinder of whatever camera I was using, and yes, sometimes purposely or stupidly, with no film in it.

Introduction

"Stand by to repel attack" uttered the voice over the loud-speakers. This was the same voice from the bridge of our aircraft carrier that usually gave such commands as "chow," "church services," "flight quarters," "anchor and sea detail," and "clean sweep down fore and aft." We may not have known who was giving the orders, but we automatically obeyed them. This time the voice cracked. His authority seemed to have dissipated as if what the mouth was saying the brain didn't believe.

I could certainly understand the impaired dialogue for on all four horizons were black specks, their size increasing by the second. Japanese torpedoes and dive-bombers, ignoring the other ships in our task force, were heading directly for us. Our cruisers and destroyers were circling our ship like Indians around covered wagons. Every gun was concentrated on the attackers. The aircraft had all left the flight deck and, I hoped, were attacking the enemy.

I stepped away from the island to be able to photograph the action in all directions. The scene was spectacular: tracer bullets were heading in every direction with puffs of smoke from the larger guns bursting in front of oncoming torpedo planes. Miraculously, some of the planes kept coming through the barrier of steel, their sites set on the prize itself: the USS *Hornet*, the aircraft carrier that had brought the Doolittle Raiders within striking distance of the Japanese homeland. The incredible success of the Doolittle bombing raid had raised the morale of the American people and had stunned the Japanese warlords. The inescapable was upon us. This was payback day. If the sons of the Rising Sun should die this day in their quest to sink the *Hornet*, all honor and glory would be bestowed upon them by their countrymen.

I rewound my camera and concentrated on an oncoming Val Torpedo plane. Slung under its belly was a torpedo, released not a hundred yards from the ship. At this critical moment, the inevitable occurred: I ran out of film.

My gas mask bag held five more 100-foot cans of film (I had gotten rid of my gas mask so I could carry the extra unexposed film and a four-foot by four-foot black cloth used to unload exposed film without fogging it).

I dropped to my knees, covered my head with the black cloth, and hoped against hope the enemy would not use poison gas. The Bell and Howell handheld movie camera I was using held only 100-feet of 35-millimeter film. The speed of the camera was the standard 24-frames-per-second, which meant that 90 feet of film exposed equaled one minute's worth of whatever scene had been shot. The result was a lot of loading and unloading time with very little shooting time.

An explosion nearby lifted me off the deck, then a series of explosions followed. Here I was, under my hood, as a battle was going on all around me. I have thought many times about one of the Japanese pilots looking down on the flight deck and seeing this sailor with a blanket over his head. I'll bet the Officers' Ward Room aboard his carrier that night rocked with laughter about the cowardly American in the middle of the flight deck covered with a black blanket.

While engrossed in unloading and loading the film in my camera, I had missed at least four torpedoes hitting the ship, one kamikaze who crashed his plane into the island, and two bombs exploding on the flight deck. The U.S. Navy had sent a boy to do a man's job.

Chapter One

The Hornet

The air attack was over almost as quickly as it started. The ship had taken at least four torpedoes and four bombs on the flight deck. Several armor-piercing bombs went through the wooden flight deck, then down through the hangar deck, and exploded within the bowels of the newest aircraft carrier in the U.S. fleet. The Imperial Japanese Navy left a grim reminder that still haunts me and, I am sure, a few hundred other personnel assigned to CV-8/USS *Hornet* on that October morning in 1942.

A dive-bomber pilot or radioman gunner lay face up on the flight deck. His body looked like a small gingerbread boy, blacker than the pits of Hell, with strips of charred skin trying desperately to escape from what was left of him. I knelt as though ready to give him the last rites, then brought the 35 mm motion picture camera up to my face. My right eye pressed against the viewfinder as my left thumb automatically found the start lever. I could feel the supply reel vibrate through the camera on the side of my head sending 90 feet of film a minute to the take-up reel. Between the two reels was the focal plane, where each frame lingered for a 24th of a second capturing, in real time, the funeral service of an enemy.

I stood up and looked down at him wondering how old he was—19, like me, or younger or older. There was no way to tell. Looking aft I could see a large hole you could have dropped a refrigerator through. The flight deck crew was frantically putting out a fire amidships when I spotted a dead sailor still strapped to his 20 mm gun. I raced to the edge of the deck

and in my viewfinder was another sailor trying to unfasten the belt that held his dead shipmate to the 20 mm cannon. The scene had everything in it that I was taught to look for—a sequence of stills that told a story.

I was completely detached from the drama being played out in my viewfinder. I had seen and talked to both of these men in the past year but, at this moment, I was oblivious to everything except that for which I had been trained—that is, until he looked up at me as he gently lay his shipmate down on the gray deck of the gun mount. "What the hell are you doing?" I stopped the camera but automatically rewound it out of habit as he approached. He was screaming: "You dirty bastard . . . you dirty bastard." I think he was crying. I backed away hoping he'd reconsider. He did. I was just trying to do my job.

Later that afternoon, with the ship listing precariously to starboard (which made walking on the hangar deck akin to a stroll up an A-frame roof), I noticed activity going on at the fantail. The ship's chaplain, Harp, was holding services for some of the dead. About ten feet from the action I went into a kneeling position. The high-pitched sound of the Bell & Howell camera, almost like a coffee grinder, shattered the silence and mood of this memorial service taking place on the gray, steel, man-made hillside. The chaplain looked up and saw the camera focused on the body of a dungaree-clad enlisted man ready to be placed in a mattress cover. "Forgive them, Lord, for they know not what they have done," he intoned. He looked at the camera and with a stern nod and then a quick turn of his head implied that I should get my heathen ass away from there. In less than ten minutes' time I was told that my camera and I didn't belong. Should I put the camera down? Go fight the fire on the flight deck? Go below and strip mattress covers to cover dead shipmates?

It was at this moment I realized that cameramen were not part of the so-called team. No one had briefed me on battle ethics. No one told me not to get a close-up of a dead crew member.

I was in a stupor, wandering aimlessly on the hangar deck. The cruiser *Northampton* had a line to the bow of the *Hornet* and was attempting to tow her. The admiral's flag personnel were being told to leave the ship and board destroyers that were alongside but ready to take off in the event of another attack. For some unknown reason I was not covering the activities. I was standing there like a locker on a construction job when our photo officer, Lt. Norton, spotted me, hurried over, and put his hands on my shoulders. "Gibson, I've got to leave the ship. I want you to go below to the sensitized film room and bring up the negative of the Doolittle takeoff—and any footage of the Midway Battle." I thought the man was out of his mind. The ship had no power. It would be pitch-black down there. Fires had been reported, and at least four torpedoes had opened holes. No telling how many compartments were flooded. No one knew how many dead were still there. Only a half-wit would attempt the assignment.

Lt. Norton had a fatherly smile as he handed me a battle light and large canvas mailbag. He patted my shoulder, said, "You're a good man," looked at his watch, and told me to make it as quick as possible. Nick Cassano, who was in the photo lab on the hangar deck, watched in dismay as I moved toward the hatch.

When a ship is in battle conditions, it is placed under watertight integrity, which means that every compartment is sealed off from the adjoining one ensuring that one flooded compartment can be isolated from the rest.

I made my entry into the Black Hole of Calcutta at the hangar deck. On the starboard side, amidships, Lt. Norton closed the hatch behind me. All sound ceased. My ears popped trying to equalize pressure between the compartment and the inside of my head. I began reciting the 23rd Psalm: "Yea though I walk through the valley of the shadow of death." I didn't like the connotation. I was borderline terrified. I knew exactly where the sensitized film room was; I had been there hundreds of times in the past year. It was our temperature-controlled film storage locker and it was my responsibility to bring the film from the photo lab, after it was processed, to this com-

partment. I had to go three decks down and straight across to
the port side of the ship. The secret would be to stay on the
first deck until reaching the ship's portside bulkhead, then
undog (move six locks that make the hatch watertight) and
redog the hatch on the other side. It was like sealing your
casket from the inside.

The battle light cast a narrow beam that I tried to focus on
the deck and straight ahead down each passageway. I prayed I
wouldn't find a body and that if I did I'd leave it. I wouldn't
bring it to the hangar deck. There was film to bring back. I told
myself I was a coward. A shipmate, dead or alive, had priority.
Thank God I didn't have to make a choice.

There were three decks and seven hatches with six dogs per
hatch behind me when I reached the film storage. It had
seemed like an eternity. This room held all of the films that the
ship's cameramen had shot during the past year: the Hornet's
commissioning; trial takeoffs of two Army B-25s off Hampton
Roads, Virginia; traveling through the Panama Canal; loading
Doolittle's plane at Alameda; the Tokyo Raiders' takeoff; the
Battle of Midway, and the sinking of the carrier Wasp.

I momentarily forgot about the situation I was in as I read
the labels on the film cans. Suddenly I felt important for I was
selecting the visual history of the carrier Hornet for future gen-
erations to view. Then it happened. The entire ship shook.
Topside every gun was blasting away. A bomb hit somewhere
knocking me to the deck. Getting up, I made my selections,
stuffed the film cans in the bag, and made for the relative
sanctuary of the hangar deck. I can't recall how I made it back.

The second attack was over before I got there. Lt. Norton
was not waiting for me. The destroyer Morris was alongside
taking aboard squadron personnel and, there, on the bridge
waving at me, was Lt. Norton. He was telling someone about
the film in the bag I was holding over my head. The Morris
came close alongside and I handed the sack over to a couple of
sailors. Lt. Norton smiled and waved again.

Late that afternoon word was passed to abandon ship. The
water was calm, warm and thick with oil. I wondered about the

other photo personnel on board: Hal Kempe, the blonde Swede whose battle station was radar plot up on the island, and Rivatuso, the Italian from St. Louis who manned a camera up on the island also. A bomb had hit there and I hoped they were all right. I heard our photo chief had cracked during the first attack and had been transferred over to a destroyer that had pulled alongside to take off the wounded. That's what I thought about as I floated in the oil in some of the deepest waters of the Pacific.

After swimming about a hundred yards from the *Hornet*, I stopped to rest, and that's when I noticed the other ships that had been circling the *Hornet* were heading away from the main body of survivors. I couldn't believe they were leaving us here. It was pretty obvious the Japanese attack force was on its way and would be surrounding us within a few hours. The mental image of an enemy ship turning on searchlights and eliminating a thousand or so helpless, bobbing ducks dressed in kapok was horrifying. That's when I looked up and saw a number of Japanese twin-engine bombers. I could actually see one of their bomb bay doors open. Floating on my back I watched in horror as the tiny specks grew larger and larger. I stopped floating and started treading water, put my hand over my ears, closed my eyes, and waited and waited for what seemed forever.

The first bomb hit between the crippled *Hornet* and me. In slow motion, my body shot straight up. It felt as though I had received an enema from a high-pressure hose. A second bomb hit the water close by, and I took another trip straight up with another invasion of my body. Everything became a blur after this until I heard a voice shouting, "Give me your hand," as two sailors from the destroyer *Hughes* pulled me up onto their deck.

We put the final holes in the *Hornet* ourselves so the Japanese could not get her and tow her back to Tokyo Bay to show the Japanese people the carrier that brought General Jimmy Doolittle and his Raiders to bomb their homeland.

We survivors were crowded aboard our rescuer's decks. Words about "dirty Jap bastards" and what we would do to

them flowed from stem to stern. My mind was on other things. Never, never again will I be put in a position like this—a historic event—without a movie camera to cover it.

The ramifications of the attack, on a purely personal level, were stunning. The USS *Hornet* had been my home, and now it had been completely wiped off the face of the Earth. I was wearing one dungaree shirt, one pair of pants, one pair of socks, and underwear when I went overboard and was now completely saturated with fuel oil and doing my best not to swallow any of the foul-smelling stuff. All of my personnel records, pay records—everything that had identified me in this bureaucratic world was lost forever deep, deep below the blue water—deep below, where there is only everlasting blackness. The labyrinth of compartments and passageways was now guarded by dead shipmates who would never know when the watch would be changed for their relief was on permanent liberty. At naval headquarters in Washington, D.C., all of the files on the USS *Hornet* would be moved from active to in-active. She was commissioned on October 20, 1941, and sunk on October 26, 1942.

She was huge and took up almost all of Pier 6 at Norfolk naval base. Pennants were flapping. The Navy band, 50 strong, took its place on her flight deck. Hundreds of men in dress blues, mixed with a few chief petty officers, awaited the "call to quarters." I thought I had better get aboard and participate in the ceremonies.

My orders said to report aboard the next day, but there was no way I was going to let the Navy commission my ship without its cameraman. Fresh from boot camp, with my sea bag slung over my shoulder, I headed for the nearest gangway. The Marine guard looked startled as I took my first step up. At that very moment the band began playing "Anchors Aweigh"; other ships in the harbor were blasting their horns.

Halfway up the gangway I looked back as a half-dozen black

limousines dropped off their passengers. No sooner had I reached the hangar deck level when a hand grabbed me and pulled me to the side. Other hands grabbed my sea bag as two other bodies unceremoniously manhandled me into a corner. "You're on report, sailor—they're gonna hang your ass." It didn't take a genius to figure out that I had come up the officer's gangway instead of the enlisted men's, which was several blocks further down the dock. A boatswain's mate was piping aboard Secretary of State Frank Knox, who was followed by Chief of Naval Operations Admiral Ernest King, their wives, senators, congressmen, and other VIPs.

My transgression was rewarded with 30 days' restriction on the ship. During my restricted period, the winds of war were blowing over Japan.

The USS *Hornet*, with all hands aboard, sailed toward the Caribbean on her shakedown cruise—a marriage between ship and crew.

More than 2,000 men had been assigned to the ship—80 percent of them had never been to sea before, and 90 percent of the pilots had just graduated from flight school. It was a Gilbert & Sullivan comic opera, with one series of disasters after another.

Over the loudspeaker, a calm, authoritative voice blared out: "general quarters, general quarters—all hands, man your battle stations on the double." The resulting confusion could only be compared to a turkey farm with a helicopter hovering overhead. Hundreds of men unable to find their combat stations; sailors running aimlessly looking for their battle helmets. These same men were responsible for firing five-inch cannons, 1.1 quad pom poms, and holding a trigger down on a 20-millimeter cannon until the barrel almost melts.

One day a weather balloon was released as a practice target, and our destroyer escort took off for parts unknown. We didn't even wonder why.

An officer suggested tying all the men together so at least we would know where they were. The sons of the Rising Sun should have no fear from this stingless *Hornet*. And yet, with time and practice, the men, at last, became fairly competent.

Japanese Adm. Yamamoto called it "the Divine Wind." President Franklin Roosevelt called it "a dastardly act." I called it my springboard to the future, the opportunity to photograph war. And war it was with the attack on Pearl Harbor, December 7, 1941, suddenly propelling the United States into what now had become a global conflict.

"Anchor and await a visitor" was the message Capt. Mark Mitscher received as the *Hornet* entered Hampton Roads. All liberty for the crew was canceled. There would be no gangways to Pier 6 tonight. The city of Norfolk would have a thousand fewer inhabitants and a very unhappy crew that peered across the waters of the Chesapeake Bay and cursed the sadist who gave the order—an order that would change the course of the war.

The next day, a Capt. Duncan came aboard and was immediately ushered to Capt. Mitscher's quarters. The meeting lasted about two hours. From the bilge to the signal bridge, the rumors were flying. "We were going to Europe to attack Germany." "It's submarine patrol in the North Atlantic." "We're getting a new skipper!"

The next morning the ship pulled into Pier 6 Norfolk. On the pier, waiting to be loaded, were two Army B-25 bombers. The ship got underway as soon as the two aircraft were loaded. An Army major gave the photographic crew a briefing: We were to cover, in motion pictures and stills, the takeoff of the two planes. Until now, the largest Navy plane to take off from a carrier had a wingspan of 40 feet. The B-25s had a wingspan

of 67 feet. The chance that the wings would collide with the island structure was a real possibility.

I was positioned with my camera all the way forward on the port side of the ship. One Army aircraft was positioned about halfway down the flight deck, the other all the way aft. The only crew personnel forward of the superstructure allowed to have their heads above the flight deck were the cameramen.

As the ship turned into the wind, I framed the monster in my viewfinder. The weather wasn't made for good pictures. It had been snowing a little earlier, and now a cold, misty rain swept across the flight deck. I cleaned my lens and held the camera to my chest waiting for the signal officer to point his flag in my direction.

The twin engine bomber moved slowly at first. Its nose was heading directly at me when, in an instant, the aircraft left the deck and proceeded, like an elevator, into the low clouds overhead. I lost the plane in my viewfinder for just a second, which meant I didn't get the entire takeoff. I blew it.

Just before the second takeoff the Klaxon rumbled over the loudspeakers: "General quarters . . . general quarters . . . all men go to your battle stations on the double." A submarine periscope had been spotted, but as I scanned the horizon I saw nothing. One of the destroyer escorts was running at full speed and began dropping depth charges. The scene in my viewfinder was beautiful. I was in a real war. This was my baptism, my dream come true.

An oil slick spread over the water where the destroyer had dropped the charges. The periscope was still there. A message from the destroyer announced that the submarine was actually a sunken ship with its mast sticking out above the water. Was it my karma, my kismet that was keeping me away from real action? Did the Greek god of war want to make a baby photographer out of me? This global war had been going on for over a month. There were battles every day on every continent except Antarctica, and I had just photographed the sinking of a sunken ship!

The second bomber had a longer takeoff, and this one I kept

in frame. The Army officer met us in the photo lab, where we turned the exposed footage over to him. Once again, the loudspeakers were turned on.

"This is the captain speaking. The activities you have seen today are top secret. A leak of these activities could have a drastic effect on the security of our nation. I know that no member of this ship will relate any information to anyone, including family and friends. Thank you for your cooperation."

Except for engine room personnel, all hands were on deck as the *Hornet* sailed under the Golden Gate Bridge. If you were lucky enough to be on the signal bridge, as I was, you could take imaginary liberty through the lens of powerful binoculars mounted on a solid pedestal. The views were complete in every tiny detail, and the girls in office buildings, sitting on porches, or whenever, were our targets. You could get so close to them you believed you could smell their perfume.

We would take turns scanning the shoreline. As soon as the viewer would stop and breathe heavily, the others would beg for a description of the scene. The giggling and knee slapping rivaled a girls' pajama party. This was known as "shipboard liberty."

On April 1, 1942, the ship berthed at Alameda Naval Air Station across the bay from San Francisco. News from the Pacific War was devastating. The Japanese were beating the Allied forces at sea, on land, and in the air. They were definitely the superior power, and our morale was at its lowest ebb. If the United States was to turn the tide, it had better do it soon.

Although I didn't realize it at the time, activity on the dock the next morning was the beginning of the turning of the tide. Two thousand men with dropped jaws watched a parade of Army bombers with their flight crews and support personnel walking alongside. A crane began lifting them on board.

Hal Kempe grabbed a still camera and told me to cover the loading from the flight deck with a movie camera. On deck,

Capt. Mitscher was talking with an Army Air Force officer. I got
as close to them as I dared and began shooting. I had seen this
man before. I knew his face and he was famous. He had been
in dozens of newsreels I had seen back at the Plaza Theater. It
was Jimmy Doolittle, Mister Aviation himself. Here was the
barnstormer, the winner of the Bendix Trophy. This was the
man who had broken every speed and distance record known.
The first man to "fly blind." One of my heroes.

That afternoon, fully loaded, the *Hornet* left the pier at the
air station and anchored just off San Francisco. Liberty was
given to one-fourth of the crew. I could have gone ashore, but
I didn't trust the Navy and I was not about to take the chance
that the ship would lift anchor and take off for parts unknown
without me.

Early the next morning, the ship prepared to get underway
as launches brought 500 hangovers back aboard. Dozens of the
ship's personnel did not return from liberty on time, and, in
wartime, that was treason. One who was left ashore was our
chief photographer. The Bay area commuters had quite a sight
as the *Hornet* passed under the Golden Gate Bridge with 16
twin engine bombers on her flight deck. No one was ready for
the announcement over the loudspeakers as Capt. Mitscher
uttered the most exciting news we could imagine: "This ship
will carry the Army bombers to the coast of Japan, where they
will take off and bomb Tokyo."

At first it was 2,000 men taking the kind of breath that starts
deep in the bowels of the human body, then builds into a wind
devil looking for immediate escape. It passes through the
venturi of the throat forcing the lips to part with a thunderous
roar that would put a 20-foot, mate-seeking bull alligator to
shame.

The cheers ricocheted off the steel plates of the hangar deck.
In the engine room, the burst of jubilance made silence of the
roaring engines. The mess hall was a chorus of banging food
trays, and, on the flight deck, a group of sailors ran toward the
lashed-down aircraft and shook hands with their Air Corps
guests. From the signal bridge to the deepest compartment

below decks, the words spoken by their captain turned a non-chalant crew member into a fighting force itching for battle. Many an officer and crew member looked up to the written message on the stack: "Remember Pearl Harbor." It was a difficult sleep that night.

The aircraft carrier USS *Enterprise*, two cruisers, four destroyers, and an oil tanker sailed out of Pearl Harbor to rendezvous with the *Hornet*'s task force. The group, under the command of Adm. Bull Halsey, met up with the *Hornet* early on the morning of April 13. This joint task force was now code-named "Mike." Weather conditions were unbearable to the Army troops with the ship rolling and pitching with every nautical mile logged.

On April 16, a line was shot from the *Enterprise* to the *Hornet*'s hangar deck. A bag was transferred over the line. Two aircraft carriers, only a hundred feet apart and both belonging to the same Navy, but you would never know it from the faces on the thousand plus men lining the hangar and flight decks of the two ships. If these grown men were five or six years old, they would be shouting: "My ship's better than your ship." And, if they didn't have the Japanese to fight, they would love nothing better than to battle each other.

For all the bitching and griping to their own shipmates about the food, work details, stupid officers, mail delivery—and yes even the rotten movies from Hollywood—it was their ship, home and mother to us all. No one has ever heard a sailor call her "the Nation's ship" or "the Captain's ship." The reference by all officers and enlisted men is: "My ship." In fact, I have never met a Navy man, no matter what condition he was in, who did not walk to the top of the gangway, face the stern of the ship where Old Glory flew, salute the flag, turn to face the officer of the deck, and say: "Report my return aboard, Sir." We all stood a little taller when we returned back aboard our own ship.

On the morning of April 16, 1942, the photo officer assigned three cameramen to film a ceremony on the forward end of the flight deck. My job was movies. The bag sent over from the

Enterprise contained Japanese medals that were given to Americans before the war. After the attack on Pearl Harbor, these Japanese medal recipients asked Secretary of the Navy Frank Knox to deliver them back to their country affixed to a bomb.

Capt. Mitscher and Lt. Col. Jimmy Doolittle stood over a 500-pound bomb and smiled as they wired each medal to its nose. Doolittle looked directly into my camera. In one millisecond I had become an official newsreel cameraman. I was recording a significant moment in history. I had arrived. But, little did I realize in all my wildest dreams and thoughts, that this man I was recording, the daredevil of the air, presidential advisor who had hobnobbed with kings and queens and who was now trusted to lead a wild adventure against an enemy that seemed unstoppable, would one day become a close friend. But that future was eons away as Task Force "Mike" plowed through the hostile North Pacific waters.

The next morning we were a thousand miles off the Japanese coast when fueling operations began. If you're the type who loves wild roller coaster rides, or playing chicken to see who turns off first before colliding, then transferring fuel from one ship to another in gale force weather is definitely your cup of tea.

As soon as the tanker pulled alongside the *Hornet*, all hell broke loose when King Neptune and his kelp-bearded henchmen went into convulsions as the tanker crews shot lines to the carrier's deck. The gap between the two ships turned into a raging river. Like lightening bolts, water shot up from the keels smashing onto the tanker's deck. Crews disappeared under the cascading waterfall. It seemed like a lifetime before we began to count bodies. No one was swept overboard. The lines were connected, and another water bolt smashed onto the tanker's deck. Umbilical cords were attached and the life-supplying black liquid rushed through pipes heading deep to below decks where men were in a different world from the deck crew sailors above. When fueling was completed and all of the lines and pipes were back aboard the tanker, the two

ships parted company. But there was a look between the crews of the two vessels. The look could have a lot of names, but I think you would have to experience refueling in a gale to understand that special eye contact between strangers.

The morning of April 18 saw me at my battle station, which this day was as a roving photographer on the flight deck. There were 30-foot waves and a cloud ceiling that looked as though you could reach up and touch it. This was not a day to launch aircraft from a bucking bronco or take motion pictures in a raging windstorm with green water flowing over the flight deck. How these Army bombers would take off from this pitching, rolling platform was beyond my comprehension. Only 11 hours before the scheduled takeoff begins.

But misfortune and an unlucky roll of the dice intervened, which seemed to be in our enemy's best interest. A lookout on the bridge spotted a fishing boat right in the middle of the task force. A few minutes later, in the *Hornet*'s radio room, an operator intercepted a Japanese radio transmission: "Three enemy carriers sighted at 650 nautical miles." It was one of a ring of picket boats that was part of Japan's early warning system.

The cruiser *Nashville* was ordered to sink the picket boat. By this time I spotted the enemy ship; it was only the size of a pimple in my viewfinder. I tracked it as it raced to the crest of a wave then disappeared into the canyons below. I started the camera knowing all too well that the shot I was recording was worthless.

The *Nashville* opened fire with all guns on the starboard side. This was a battle between David and Goliath. Shot after shot hit all around the small wooden ship—but no direct hits. The *Nashville* headed full speed at the target. Then a dive-bomber from the *Enterprise* dove on the tiny boat, spraying it with 50-caliber machine gun fire. He circled back and dropped a bomb. It missed by a couple of hundred feet. By now the *Nashville*'s guns had demolished Number 23, and there were no survivors. The battle, if you could call it that, lasted 29 minutes, had expended 924 rounds of six-inch cannon shells

and one 500-pound bomb. What would happen when we made contact with the full Navy of the Rising Sun? I wondered.

The unexpected had reared its ugly head and forced us into a decision. We could scrap the mission, and push the 16 Army bombers overboard so the *Hornet's* squadrons would be operational. Or, make a 180-degree turn and save the task force from complete annihilation. Or, send Doolittle and his men on a certain suicide mission, turn tail, and go full speed to safer waters. Admiral Halsey made the decision.

From the bridge of the *Enterprise*, a signalman sent by blinker light the following message: Launch planes to Col. Doolittle and gallant command. Good luck and God bless you. We were 150 miles away from the planned launch point. There was no way the planes could make it to the Chinese runways after bombing Japan. Over the loudspeaker we heard the command: "Army pilots, man your planes." With camera in hand, I made the best time I could on the pitching flight deck.

The call to man your planes that morning of April 18, 1942, was the culmination of four months of secret meetings and coded messages among the highest level of military leaders from Washington to China. Ironically, the President of the United States was not briefed on the mission. Gen. Hap Arnold knew that loose lips in the Executive Mansion would be divulging the details of this top-secret endeavor at the first tête-à-tête in the Madison Hotel dining room.

I set the lens at 12 feet with a wide-open aperture. The faces of the pilots and crews as they double-timed it to their aircraft had more of a look of confusion than had appeared on the dry runs we made in the last couple of weeks. Each one knew taking off 150 miles farther away from the planned launch point was a one-way trip to a Japanese execution party. But, at the same time, their arms were loaded with cartons of cigarettes and boxes of candy, enough to do each of them for a month if necessary.

When I saw Doolittle in my viewfinder, I ran to his plane to be ready for his entry into the bomber. He was as cool as a riverboat gambler nodding that he had a pat hand. He looked

aft at the 15 other B-25s and their crews disappearing into the
bomber's bellies. He turned and looked up at the bridge. Capt.
Mitscher saluted; Jimmy Doolittle acknowledged him with a
brief nod.

There is nothing like being a cameraman. Many people can
witness a major event, but the cameraman is invited into it. If
he's good at his job, he'll record the fear, joy, heartbreak,
pain—all of the emotions human beings are capable of ex-
pending. I must admit at this stage of my cinematic career that
I was a pointer and a panner. I wasn't using my camera as a
vehicle to tell a story. I was an amateur trying to do a profes-
sional's job.

If Hollywood were making a film on the scene being played
out on the deck of the *Hornet*, it would read like this:

Cut to
BOW OF SHIP with green water breaking over
the flight deck.
Cut to
CLOSE UP OF DOOLITTLE'S FACE. His blue eyes
are intense as he scans the instrument panel.
Cut to
CLOSE UP OF DOOLITTLE'S FEET ON THE BRAKES
Cut to DOOLITTLE'S HAND as he pushes the two
throttles forward.
QUICK CUT TO LT. OSBORNE with flag held over
his head waving it in quick circles.
SERIES OF QUICK CUTS:
 AIRCRAFT VIBRATING
 SAILOR with fire extinguisher being blown
into a propeller of one of the bombers. His
arm is detached from his body.
 SHIPMATES carry him to the catwalk
 HIGH ANGLE SHOT of FLIGHT DECK as the BOW
of the carrier heads into a giant trough, then
starts rising on the next wave.

Cut to

MEDIUM SHOT: LT. OSBORNE'S HAND with FLAG points to bow of ship

Cut to

UNDER WING, KNEELING SAILORS pull chocks from the wheels and the aircraft slowly moves forward.

Cut to

INTERIOR OF COCKPIT looking over DOOLITTLE and CO-PILOT, LT. DICK COLE. The plane is moving.

SFX; ROAR OF ENGINES, GALE FORCE WINDS

(The ship is making 20 knots; the wind over the deck is 30 knots.)

Cut to

PLANE MOVES TOWARD THE LAST FEW FEET OF DECK as DOOLITTLE PULLS THE YOKE HARD BACK TO HIS STOMACH. THE PLANE LEAPS INTO THE AIR.

Cut to

CHEERING SAILORS IN FOUL WEATHER GEAR

MUSIC UP as DOOLITTLE'S PLANE disappears into the low hanging clouds.

No director, not even David Lean, could duplicate the sounds, smells, tension—the stark drama of this moment.

This incredible mission of the Doolittle Raiders from the carrier *Hornet* would be told over and over. But if you weren't a part of that moment, you couldn't have experienced the special rising of goose pimples all over your body—and, yes, a few hundred of us had a tear or two mixed in with the cold salt waters of the North Pacific. Damn! I was one lucky sailor. Our ship had only been in the Pacific for a few weeks and already we thought it was us, and us alone, who had began the long haul to turn apparent defeat into certain victory.

The American people, the men aboard the *Hornet*, and the rest of the task force were not told the true results of the raid.

They were not told that all 16 planes were lost. That it was Jimmy Doolittle who led the raid—or released the fact that a U.S. carrier had taken the Army bombers within range of Japan. President Roosevelt smilingly told the press that the planes took off from Shangri La—a fictitious city in *Lost Horizons* by author James Hilton.

None of the Doolittle Raiders made it to the designated, secret airstrips in China. Some, including Doolittle, could have made it, but the radio beacon and runway lights never went on. Apparently someone back in Washington forgot to put one vital piece of information into the plan—the landings would be on the other side of the International Dateline. The beacon and lights were to be turned on the next night. The crews that made it to the China coast parachuted from their planes when they ran out of fuel.

Doolittle and the other survivors were led to safety by Chinese loyalists who themselves became the target of the Japanese invaders. Two days after the raid, Emperor Hirohito ordered his military leaders to teach the people of Chekiang Province a lesson they would never forget.

One of the Chinese, an 80-year-old schoolteacher, was so proud he had led some of the Raiders to safety. For his efforts, he related, "they killed my wife, set fire to my school, burned my books, and drowned my grandchildren in the town well." The man who gave shelter to Raider Watson was wrapped in a blanket soaked with kerosene. The Japanese forced his wife to set it on fire.

What the raid accomplished more than anything was a much needed morale boost. On May 18, Jimmy Doolittle was in Washington, D.C., in a car with Gen. Arnold and Gen. Marshall. Marshall told Jimmy: "We're going to the White House. The President is going to give you the Medal of Honor."

"I don't believe I've earned the medal," replied Doolittle. "I can't accept it." He mentioned that Charles Lindbergh, who was awarded the medal for his flight across the Atlantic, had said he didn't deserve it either.

The Washington Press Corps was waiting in the Oval Office

when the trio arrived. The President told the reporters that Doolittle had returned that day from the secret base: Shangri-la.

"Brigadier General James H. Doolittle, United States Army, for conspicuous leadership above and beyond the call of duty, involving personal valor and intrepidy at an extreme hazard to life with the apparent certainty of being forced to land in enemy territory or to perish at sea, General Doolittle personally led a squadron of Army bombers manned by volunteer crews in a highly destructive raid on the Japanese mainland."* And so, the Congressional Medal of Honor, the highest honor our country can bestow, was given to Doolittle. He commented that someday he hoped to earn it.

I pushed open the last dog on the hatch. The red light in the passageway went out. Every exit from the ship that led to the hangar or the flight deck automatically turned off all the lights in that compartment. This procedure was a necessity so the enemy would never see any of the ships in the task force. A moonlit night was the deadliest time to plow the waters of the Pacific. Darkness was a ship's security blanket.

I stepped out onto a pitch-black flight deck. With one hand on the side of the superstructure, I slowly made my way aft. When my hand no longer felt the steel bulkhead, I took a deep breath, stood very still for a moment and very cautiously moved forward. This was like getting up at home in the middle of the night to go to the bathroom. You knew the way, but in blackness, your little navigator who resides in your mind was still asleep and you were left in a black void. At home, when you proceeded, the worst that could happen to you was to bump your toe into a chair or door or walk into a half-open door, causing only minor injuries. But on the flight deck of an aircraft carrier, one misstep and you're going to fall into a five-inch gun mount or, heaven help you, step overboard. I didn't

*New York Times, May 20, 1942, p. 4.

dare to do either because I had a movie camera in my right hand. The camera had priority over my life.

I made it to the ladder that led to the catwalk. The little navigator in my brain had to have been related to Captain Cooke or Henry the Navigator himself for I made my destination at my camera station to the inch.

This morning was different from any other I had experienced aboard the *Hornet*. The wind blowing across the flight deck brought a new smell to my nostrils—not the smell of human bodies, aircraft fuel, or processing chemicals in the photo lab. No, this smell was feminine. It cleansed the orifice gland of the aroma of Navy and replaced it with the scent of tropical flowers. My God, we were sailing the waters of the Hawaiian Islands. There was no need for a sextant or compass. The smell of ginger was in the air and I was going to see real human beings again. Damn! It was good to be alive in the month of May 1942.

The shrill sound of a boatswain's pipe brought me back to reality from my dreams of a Polynesian island and a giggling Tahitian princess sharing an overripe guava with me.

"Flight quarters, flight quarters. All hands to your flight quarters." A blazing red ball seemed to rise from the horizon in unison to the call. Fighters, dive-bombers and torpedo planes' engines revved up as the same activity was taking place aboard the carrier *Enterprise*. The ships of Task Force 16 and 17 were returning from the field of battle. It has been the same down through the ages—prancing horses with flying manes, chariots as far as the eye could see. Roman warriors marching under the victory arch, medals with colorful ribbons pinned to the victors. At this moment, we don't think of the charred bodies left in the fields or the sailors in their sunken ships, their tomb disturbed daily by continuing tides.

Just before a carrier enters port, the squadrons aboard fly to a land base where they stay until the ship returns to sea. It's quite a sight to see over 100 combat planes in formation flying low over an armada of dreadnoughts. As a ship enters a port, all hands not on duty line up for inspection. This was one of

the times it paid to be a cameraman. I would walk with the executive officer up and down the decks as he scrutinized, from hat brim to polished shoes, the officers and men standing stiffly at attention. I would get within a few feet of this gold-braided mannequin, put the camera to my eye, and start shooting. In the viewfinder was a close-up of my superior officer, but at this moment, he was putty in my hands. He thought he was being recorded on film that would be sent on to Washington, D.C., to be made available to all of the newsreels. Of course, how could he know that the third-class photographer's mate who was taking the pictures had no film in his camera. In addition, my shoes were never polished so one could see a face reflected in them, my neckerchief was never tied properly, and I never had my hat on like the book said. But then again I didn't have to stand inspection like 2,000 other men. Boy, did I love my camera.

The thought of liberty in an exotic port like Honolulu was more than the mind could stand. It had been two months since I had set foot on land, and, at this moment, I could relate to a prisoner on Devil's Island who wanted to escape from the confines of his penal colony. The war was thousands of miles away and I couldn't have cared less if Adm. Yamamoto was in a geisha house or planning another attack.

Reality hit like a lightning bolt as the *Hornet* passed by battleship row. The conning tower of the *Arizona* was all that was visible. Beyond her, the *Oklahoma*, *West Virginia*, and *California* had been destroyed while still tied to their berths. On the *Arizona* alone, there were over a thousand dead shipmates entombed deep in the guts of twisted steel. This stately battleship became the symbol to remember in World War II. In another 40 years, as a civilian cameraman/director, I would be diving into that rusting, steel graveyard with scuba gear and a 35-millimeter underwater camera. The same cold chill ran up my spine as we passed by the conning tower of the *Arizona* in 1942 as it did some 40 years later.

I couldn't help but think of the strange twist of events for the crew of the *Arizona*. On the night of December 6, the "Battle

of the Bands" was held on the island, a competition of all Navy bands stationed at Pearl. The Arizona Band, 35 strong, won second place, and its prize was to sleep in late, Sunday morning, December 7, 1941.

Jacques Cousteau titled one of his films, *The Silent World* and I wondered, as I swam from gun turret to a first deck compartment, if the thousand plus men buried beneath me could hear the music of Glen Miller, Tommy Dorsey, and Sammy Kaye echoing through the compartments and passageways of this proud ship. But that was 40 years and millions of feet of film later.

The Navy hadn't told us of this devastation that we were now gliding by. If our captain, Mark Mischer, now standing on the bridge, had grabbed the microphone and said, "All hands prepare to go to sea, we have a job to complete—to sink the rising sun," every man in Task Force 16 and 17 would have said: "To hell with shore leave. We want a battle." But the reality at that moment was a call over the loudspeakers: "Now hear this, now hear this. There will be no liberty tonight. All hands will remain on board."

Some of the men had already started putting on their liberty uniforms. Groans rocked the steel plates from stem to stern, from the tip of the island to the base of our bilges. For the first time I heard our skipper called every dirty name that sailors have handed down through the ages. Surely Cleopatra's oarsmen, the tars on Nelson's ship *Victory*, and the swabs of John Paul Jones' *Bonhomme Richard* had had some choice words for their skippers too.

Early the next morning, 2,000 men (without hangovers) grudgingly got the carrier underway. Their mood changed as we passed by the battleship *Arizona*. A gut-wrenching sensation was felt by every man above deck who watched the flag fly from the conning tower of this makeshift graveyard that held a cast of warriors who never knew who the enemy was that morning of December 7, 1941. No one had to say a word; it was painted on the smokestack of our ship: **REMEMBER PEARL HARBOR**.

Did the men know their first battle cry was just around the corner? Probably not, for unbeknownst to all we were about to engage in the largest sea battle in the history of the world. The slogan, "Remember Pearl Harbor," was to become a reality.

Something big was about to occur. It was in the sound of the wind blowing across the flight decks of the carriers *Hornet*, *Enterprise*, and *Yorktown*. Two hours out of Pearl Harbor, the aircraft of the three carriers left their land base to return to their ships. Everywhere you looked there were aircraft. The planes of Air Group 8 singled out the *Hornet* from the other carriers and started into the landing pattern. F4F fighters were the first to touch down. They were the most dramatic because they landed at a much higher speed than the torpedo planes and dive-bombers.

The Mitchell camera I was using was the same model Hollywood films were shot with. Photographic equipment in the Navy was first class.

I pulled the rope releasing the pin that swung the $10,000 camera to safety. This feature was installed to ensure that the camera would end up in one piece when an aircraft suddenly turned toward the catwalk. We made this test prior to every flight operation. I lifted the camera back onto the flight deck into shooting position.

My orders were to start my camera when I saw there might be an aborted or troubled landing. Since we photographed at 122 frames per second—which in those days was really slow motion—film couldn't be wasted on perfect landings. Lt. Osborne, the landing signal officer, would bring the aircraft in with a paddle in each hand, conveying to the incoming pilot to lift a wing, lower a wing, gain speed, reduce speed, nose-up, nose-down. He took dozens of things into consideration, including the rolling and pitching deck and possible wind changes. But best of all, he knew the idiosyncrasies of the pilots in all three squadrons. Many of Osborne's wave-offs

saved not only a pilot's life but also the flight deck crews working the arresting gear and unhooking tail hooks, the crew chiefs waiting to service the plane, and, of course, the cameraman on duty.

The first F4F fighter plane turned on final, lining up with the flight deck. He slipped to the right, then overcorrected to the left. Lt. Osborne raised his left arm, then quickly lowered the right arm. The plane was now too low. Trouble. My fingers found the rheostat on the camera motor. In an instant the film was stopping at the focal plane exposing 120 frames per second. The film would be shown to the pilot that evening to help him correct his bad landing habits.

The landing signal officer waved him away. He was now full frame in my finder, and the plane was dropping like a baby grand piano. He hit the deck and skidded full speed into the barrier cables. The flight deck crew was at the plane in seconds, helping the pilot escape before fire broke out. The word came down from the air officer: Plane over the side. The pilot watched as his aircraft was pushed into the sea.

The Pacific Ocean was the largest battlefield in history, yet a tiny atoll, a thousand miles west of Pearl Harbor, became the hub of the largest naval battle of all time.

If the men in our task force had known the size of the enemy's fleet, they would have asked for a postponement of planned activities. The Japanese force of 165 ships sailed from Japan and the Marianas. Destination: Midway Island. The force's brilliant strategist, Admiral Isoruku Yamamoto, planned to draw the U.S. fleet out of Pearl Harbor for a decisive sea battle that the Japanese combined fleet had all the resources to win. But there was a fly in the sushi. We had broken the Japanese code, and Adm. Chester Nimitz put all of his eggs in one basket and decided to throw a surprise party for the oncoming armada.

On the American side were two task forces—Task Force 16, comprised of the carrier *Yorktown*, two cruisers, and six de-

stroyers, and Task Force 17, which included the carriers *Enterprise* and *Hornet*, six cruisers, and nine destroyers. These ships were to rendezvous north of Midway and await the Japanese attack.

The battle lasted three days. I was disappointed in the results—not the results of the battle—we won that hands down. But outside of photographing planes taking off and landing, we witnessed no real action. The closest I was to combat was ten miles away as the carrier *Yorktown* was being attacked. The *Hornet*'s Torpedo Squadron 8 was completely annihilated, with the exception of Ens. Gay who watched the carnage from the vantage point of ocean water while clinging to part of his downed plane. The remaining squadron crew aboard ship scanned the horizon looking for some of their shipmates to return. The *Hornet* was a very unhappy ship that evening of June 4, 1942.

The chief petty officer at the Honolulu Police Department read my orders at 700 hours on Sunday morning. I was assigned shore patrol and found the duty to which I was designated rather confusing: GIBSON, WILLIAM J. 268-87-19 WILL PROCEED TO THE COTTAGE ROOMS ON RIVER STREET AND WILL SEE THAT NO SERVICEMAN FROM ANY SERVICE WILL ENTER THE ESTABLISHMENT TILL AFTER DIVINE SERVICES. Deciphered, this meant that I would keep the jarheads, dogfaces, and swab jockeys from getting a piece of ass (tail) until after church was over. Unbelievable! My government was a pimp in sheep's clothing.

My attire consisted of a regular white uniform, a pair of leggings, web belt, an armband that had SP on it (for Shore Patrol), and a billy club. I used the last to knock on the front door.

She was in her 50s with flaming red hair about the same color as the poinsettia tucked behind her left ear. A muumuu covered her from neck to ankles. She introduced herself as Millie, and with a smile as big as aloha itself, said the coffee was on and come on in.

The building was three stories tall with two balconies jutting out over Canal Street. If you could slow dissolve to 60 years ago, you would have seen a plantation owner quietly sipping a rum punch while watching his bronze-skinned Hawaiians return from the pineapple fields.

Upon entering the foyer I saw a single desk and chair arranged so only one body at a time could get by it. At the base of the stairway was a gate that could be lifted. Millie held the gate up and motioned for me to proceed up the stairs.

The second floor was devoid of furniture. An eight-foot-high enclosure had been divided into four eight-by-ten rooms and no ceiling. Each room had two doors, one that went from room to room and the other, an entrance from the main room.

As I followed Millie up the stairs to the third floor, I could look down and see that each room had a small table, a sink, bidet, and a small cot. The third floor included a living room with overstuffed furniture, kitchen, large dining room table, and five girls, two of them dancing to Dinah Shore singing "Long Ago and Far Away." Millie introduced us, but I could only remember one of the names: Peggy. She was in her early 20s with long, wavy auburn hair. Her eyes were the shape of almonds. Her breasts barely showed in the oversize muumuu.

One of the girls came over, kissed me on the cheek, and laughed: "Boy, are they taking them from the cradle today! Bill, have you ever shaved?" I do remember blushing.

Peggy put the needle on the arm of the Victrola back to the beginning of the record, ran across the room, and grabbed me. "Let's dance, Sailor," she said.

A Fred Astaire I'm not, nor am I capable of a slow waltz, but with Peggy I found my feet gliding along with hers. I didn't even have to think of which way I was being guided. My arms pulled her closer and I thought to myself, if the Navy expected this shore patrol duty to be tough, it was totally nuts.

The song ended and the rest of the morning was taken up with a breakfast of sweetrolls, fresh guava juice, sliced pineapple, and coffee that didn't talk back to you like our Navy mud.

"Okay, girls," Millie ordered, "let's go to work. Bill, you'd better take a look at the line of guys out front. They get a little restless just before opening."

The line stretched for a block and a half. The Navy outnumbered the Army and Marines by three to one. I heard some dirty remarks from a few of men, but had no trouble. The bars opened in another hour, and that's when the fun would begin. I was told to keep all men from entering who looked like they had had too much to drink.

The door of the cottage rooms swung open. In unison, the line of men swayed like a cobra leaving its basket. If a research team were in place at this very moment to measure stress, tension, pain deep in the abdomen, this line of overzealous Romeos would have been the perfect laboratory.

A heavyset woman sat at the entrance taking money. As each customer approached, she would whisper to him, briefly, then yell out the appropriate order. "Old-fashioned" she would gesture toward the left, "French" to the right, and "straight" up the stairs. In one moment, the cottage rooms turned from an eighteenth-century, colonial mansion to an automated relief factory.

The second floor was bustling with activity. This was the place Millie called the bullring. When a man entered one of the connecting rooms, he was told to take off only his shoes, pants, and underwear.

Peggy went into the first door. In less than five minutes, she had been in all four rooms, serviced the guests, and was starting to work on four more.

I climbed up the stairs, looking down on the activities being played out in the bullpen below. As Peggy went into each room, she followed an exact routine: motioning the male over to the sink, she immediately took his penis with one hand and a warm, wet, hand towel in the other and made them connect. He reached his climax immediately. In a flash, she was in the next room. A local woman entered the room and helped the man get his pants and shoes on to make room for the next one waiting at the top of the stairs.

I watched the action in disbelief. I couldn't understand how a girl like Peggy could get herself mixed up in something like this.

About an hour before closing, I was sitting at the dining table on the third floor having a cup of coffee when Peggy came rushing in. "What a day," she exclaimed, "I'm beat." She pulled the muumuu over her head revealing a beautiful, supple body beaded with sweat from neck to thighs. "It's shower time, Bill. I'll be right back."

As Peggy disappeared into the bathroom, my mind held a freeze-frame of her smile and that body that rivaled any pinup I'd ever seen. I paced the floor like a stud colt. "Bill, come here!" I froze. *"Bill, come here!"* I tentatively approached the door and pushed it open. The shower had no curtain. "Take off your clothes," she ordered. Now my involuntary reflexes took over. In a flash I stripped out of my clothes, stepped into the shower, grabbed her, and pulled her to my body. "Hold on a minute, Sailor, don't you know anything about cooking?" I loosened my grasp. It seemed like a stupid question to ask me at this particular moment. "Let me tell you, you never, I repeat never, put meat into a cold frying pan. Warm the pan up first." I carried out her instructions to the letter.

After turning my leggings, armband, and club into the Shore Patrol office, I took a stroll through town. In a pawnshop window I spied a deep-sea fishing pole and reel. The price was $25 dollars and it was a bargain to end all bargains. This was the same kind of gear Zane Grey used to catch thousand-pound sharks. I had to have it. How to get it back aboard ship I would figure out later.

As soon the *Hornet* passed the submarine nets guarding the harbor, the quartermaster on the bridge signaled the engine

room three-quarter speed ahead. This was also my signal to drop a large, feather, red and yellow lure from the fantail. My thumb let out on the drag as the lure hit the foaming wake and followed the flow. When it was about 150 feet from the ship I set the drag. The line was hundred-pound test and I set my feet for the action.

In the depths of the waters off the Hawaiian Islands are the monsters of the seven seas—the magnificent blue marlin. Author and sportsman Zane Grey said that a man hasn't lived until this streamlined warrior from Neptune's kingdom rendezvoused with the fisherman's weapon.

My line hadn't been in place for more than a minute when a fish the color of a tropical parrot took the lure. It was a bull dolphin, also called a dorado in Mexico, lapu lapu in the Philippines, and a mahi mahi here in the Islands. The tip of the pole vibrated like a lightning rod, then bent to the pull of the fish's power. In many men there is a fisherman gene; some women are also lucky enough to have one, too. This gene acts like a narcotic. It will get you up early in the morning with a smile on your face. It will send you into twitching convulsions when you claim your catch from the water and hold it up for the world to see. I would equate the fishing gene with the gene that gives one the same twitching convulsions during a sexual release.

The marlin shook himself free when I tried to bring him up to the deck. I freed the drag to put the lure in position again. An audience was building behind me. "Give you five bucks," said one sailor pulling on my shirt. Another offered ten for a turn.

"What the hell are you doing, Sailor," thundered a voice near my back. I turned, quickly, to see Cmdr. Henderson, the ship's executive officer. The man who never smiled. The man who could make your time on board a veritable nightmare. His face was beet red and he was pointing directly at me. "Don't you know there's a war going on? Confiscate that fishing gear," he told a chief boatswain's mate.

I received 30 days' restriction to the ship. The punishment

wasn't that severe as the *Hornet* never returned to port again.
We would be at sea for over a hundred more days. In a battle
of battles the *Hornet* was fated to be sunk.

It has never ceased to amaze me how two opposing forces
could find one another in the vast expanse of 64,186,000
square miles of Pacific Ocean. Part of winning the war had to
do with one side's superior intelligence in such areas such as
code breaking, tracking ships, coast watching, spying, etc. Ex-
perience of the officers and crews is the real catalyst that ulti-
mately decides the victor.

The goof-ups by both the Japanese and us were a laugh a
minute, except that it's not funny when your life is at stake. A
friend of mine, who was a cameraman in the Army Air Corps
in the Pacific theater, put it in terms that every GI or sailor
would agree with: "I didn't know shit from shinola"—and
here's why: When an island was to be invaded or a sea battle
fought, no one briefed the troops about the size and experience
of the enemy, the weapons they would be up against, and
never the purpose of the action in the "big man's" picture,
except, of course, to win.

Another area of discontent was the act of censorship of an
enlisted man's mail. Before letters left the ship or forward land
base, officers would be assigned to read the enlisted men's mail
and black out anything that might give away location, oper-
ations, strength of a unit—or anything that could be taken as a
means to transmit secrets to the recipient. A wife, girlfriend, or
family member might leak the information to an enemy agent
lurking in an illegal still in Chetam County, West Virginia.

The men hated this intrusion into their personal lives. The
system trusted them to operate sophisticated, expensive
equipment, live under conditions that a condemned murderer
in today's society would not tolerate, and, left in their su-
perior's hands the decisions of the ultimate sacrifice—their
lives.

Many an evening the men would hold a get-together and discuss the fairness of the situation. They would bring up little things, such as, who was minding the store that morning of December 7, or why our torpedoes seldom worked and the enemy's did.

Griping is the nature of the beast and it is said that a good army or navy lives to bitch about everything from the coffee to the inoculations. If this is true, then the armed services of the United States were invincible.

Chapter Two

Antarctica

The C-130 transport, fitted with skis, reluctantly lifted from the ice runway at McMurdo Sound Station, Antarctica. The two propellers on the ungainly beast fought for every inch of altitude and slowly, ever so slowly, banked to the left heading in a southerly direction. Within the shell were 20 passengers all dressed alike in Navy-furnished arctic clothing, along with thousands of pounds of supplies to be delivered to the U.S. South Pole Station.

The passengers, excluding me, were some of the preeminent scientists in the world, each with his own experiment to be tested in the most hostile environment on the planet. It was the "year of the quiet sun" and the year set aside for explorers and global researchers to find new and exciting things our universe had been hiding for eons. I was included in this once-in-a-lifetime event to film a documentary for the U.S. Navy and the National Science Foundation.

The noise inside the aluminum canister of the airframe was deafening. Adding to the roar of the overworked engines was the high-pitched whine of the hydraulic flaps being raised, shaking every bone in our bodies. All of the passengers were staring straight ahead, not looking at one another or even out the ports. You could literally feel the tension as though a catastrophe were about to occur. To the occupants the present situation was a far cry from their everyday activities in temperature-controlled surroundings at universities and laboratories. It seemed forever until we reached the altitude when the

pilot could ease back on the throttles, lower the nose of the vibrating giant, and proceed into cruise mode. A Navy crew member appeared out of nowhere and offered coffee to the hooded group. At once our palpable fear was extinguished as the C-130 barreled through the indigo blue Antarctic skies.

I wondered how many of my fellow travelers were aware of the men who had gone before them. Looking out the port I marveled at the white nothingness below. If death could be captured on film, the polar plateau would be the perfect subject. It was a land of no smells, no tastes, and when the color black appeared, it was in the form of gangrene. Why, I wondered, would anyone in his right mind explore this hell in white. Were the Antarctic explorers of the past masochists with inflated egos—or true men of science? As I looked at my flying companions, there were no conversations and, almost in unison, they each removed one glove and wrote something in a small ledger. If these were the explorers of today, heaven save me from being a team member on any of their expeditions in the future. The names of Antarctic explorers of the past floated into my mind—Scott, Byrd, Amundsen, and Shackleton. And here we were, flying five miles above the historic path of the famous race to the South Pole between the Norwegian Amundsen and the British Scott. Their race to the Pole captured the imagination of Europe. Amundsen used dogsleds while Scott's sleds were motorized. Amundsen's plan was not to carry unnecessary supplies and to use the sled dogs as food on his return from the Pole. With 11 men in his party, Scott was plagued with broken equipment, dwindling food rations, and fatigue. Scott left seven of his men in the base camp while he proceeded with a party of four, arriving at the South Pole on January 18, 1912. There he found a small tent flying a Norwegian flag and a sympathetic note left by Amundsen. On Scott's return journey, two of his men were lost. Scott and the other two members' frozen bodies were found ten months later only 11 miles from the base camp. The note from the race winner was found on Scott's frozen body. Scott's biggest mistake was in not taking a cameraman along.

I was brought out of my historic daydream by a rough landing and the scream of thrust reversers. As the clamshell doors opened, a blast of frigid air filled the plane's interior, and a dozen men swiftly entered the aircraft. Like a SWAT team bursting into a commercial jet to apprehend a group of terrorists, the parka-clad invaders wore wool face masks, hiding their identity from the visiting scientists and the biting cold. Their mission was to unload the cargo before freezing temperatures penetrated the containers of perishables and electronic parts. They pushed and shoved us out of their way, moving quickly to their assigned locations for the unloading process. The scene was more a riot in progress than a family greeting at the terminal. The priority was obvious, and social graces could wait until the aircraft had taken off and we'd had our first cup of coffee.

A forklift entered the aircraft like an Indianapolis racecar pulling into the pit. One of the invaders pointed at the human cargo and beckoned us to follow him "on the double," as the Navy would put it. The noise from the C-130's engines was deafening. Snow Cats and forklifts were everywhere adding to what seemed like controlled mass confusion.

All I could see of our escort's masked face was a pair of deep blue eyes framed with ice on his eyebrows. His arm went around my shoulder and he yelled in my ear: "Welcome to the Pole, you son of a bitch." I knew the voice and, as soon as our group entered the massive opening to the underground city of the U.S. South Pole Station, he pushed back his parka hood, reached up, and pulled off his face mask. It was CPO Leo Loftis. Leo was a Coast Guard journalist—and a good one—whether he was covering a funeral at Arlington Cemetery or the crew of a gunboat in 'Nam. Leo loved adventure and his double martinis on the rocks at the end of a long day. He was one fine piece of work.

My first assignment was to go out to the Pole where the Stars and Stripes flew while Leo took a picture of me. Here, at the bottom of the world, I was a celebrity; I was now the third man to stand on both the North and South poles. After the photo session in 80 below weather, we reminisced about old times.

This was when Leo asked me: "How does it feel to be the third man ever to stand on both poles?"

I should have thought before I opened my mouth. "Well, it's like I have a place with Scott and Amundsen and the few others who made this station at the bottom of the earth possible."

"Well, then," Leo said, "who was the second man who flew solo across the Atlantic?"

"Charles Lindbergh was the first," I replied, "but I don't know who was second."

"Then who in the hell would remember the third man who stood on both poles?" Leo snorted. Reality checks. Exploring is not like horseshoes—you don't get points for coming close.

Before leaving the states, I had asked the Navy for permission to photograph a penguin rookery. Checking the bulletin board I found out I would be taken by helicopter to an Adelie Rookery a few miles from McMurdo Sound. The pilot explained to me that they had other missions so would drop me off, then pick me up on their return. He said I'd be there, alone, for about four hours, and the weather should be good.

Flying low over the Ross Ice Shelf I saw one of the natural wonders of the world. Icebergs the size of Rhode Island, killer whales breaking water in formation scouting the sea lanes for dinner, skua gulls watching from above to share in the feast. An elephant walrus looking like a Miami Beach sunbather, lifted his head at the disturbance, then resumed his sleeping position. And there were the Adelie penguins as far as the eye could see.

The landing of the 'copter didn't disturb this mass of formally dressed waddlers. With a simple "Take care," the pilot waited for me to clear from the blades and took off. In seconds it was like losing your hearing. Thumping helicopter sounds sequed into the harsh squeals of penguins that failed to provide any relief to my sensitive ears. I was stepping into a movie, cast with a thousand midget headwaiters and a cameraman in a green parka.

For the next two hours I photographed penguins in every position they are capable of getting into, which is not very many.

They seemed to have fewer moving parts than a doll made in China.

The mess hall had made me a couple of sandwiches so I sat down with my squawking lunch partners and began eating. They were all around me, staring, gurgling, moving their heads up and down like rock-and-roll dancers. I offered some of my ham sandwich to the dozen or so that were practically sitting in my lap. My first scientific discovery in the Antarctic was that penguins prefer seafood to pork.

I had only been with my new friends for a couple of hours and was already talking to them and imitating their harsh call. It worked. I had hit a note that stopped the head bobbing of the ones closest to me. It was at this moment I was initiated into the secret society of the Adelies.

A brazen male or female (I couldn't tell the difference) bent over, picked up a small rock in its beak, waddled toward me, and dropped it by my shoe. I had filmed them doing this ceremony with one another earlier and thought it might be a courting ritual.

I now had the attention of the masses as I bent over and picked up a small rock in my teeth, waddled over to the same bird and dropped it at his or her feet. The squawking was deafening. The roar of the helicopter that came to take me back to human life saved me. Chief Loftus was waiting as the copter landed. He asked how the shooting went. "Fantastic," I said. "I guess so," he snickered, "you have penguin shit all over your ass."

A few days later I was filming at an emperor penguin rookery. They are magnificent birds, but the Adelie will always be my favorite.

The gossip started immediately upon my arrival at the airstrip. The word was that a commercial jet flown by Pan American Airlines was flying around the world on a polar course and would land at McMurdo for refueling. I could not believe what I heard from my bearded friends: "No way I'm going to meet that plane." "It should be a law." "I hope they all freeze their asses off in their miniskirts."

After all these hotly worded statements, it finally dawned on me; women were coming to the Antarctic, and the male population on this ice continent was furious. This was man's land and women could have no part of it. A boycott was on and every man vowed he would never give "these broads" the satisfaction of a greeting!

I certainly wasn't a part of this group, so I looked for a snow cat to take me to the landing strip. On the way there I thought about the pioneer women crossing the United States in flimsy wagons, fighting a hostile environment and Indians, and helping to build an empire right alongside the men. The plane landed. The women stepped onto the ice continent, then reboarded, and continued on their journey. That *was* a first and was followed by dozens of other women, working in every capacity that was formerly "for men only."

I left a few days later, happy to get back to a civilization I understood and appreciated more than I ever had before.

Chapter Three

The Chase

Load your camera, set the aperture and film speed, and brace yourself. We're putting a Roman candle to your ass and, baby, you're going on a chase.

It will be listed on the flight operations board simply as: *Photo chase.* Of all the assignments I have covered, the chase is the ultimate—the boiler room in your adrenaline factory. It had to be a pilot or chase cameraman who wrote the Air Force song, "Wild Blue Yonder" (known as the Air Force hymn), for it is a death-defying, roller-coaster ride that only a select few experience.

My first chase assignment was at North Island Naval Air Station, San Diego. The Navy, having trouble with vibration of the tail section on the Curtis dive-bomber, needed photo coverage to show to the manufacturer.

I was facing backward in the gunner's cockpit of a Douglas SBD with the canopy open. After takeoff, we met up with the Curtis at 12,000 feet over the Coronado Islands. We were wingtip to wingtip when the pilot of each plane shoved his stick forward and started into a dive. The Curtis filled my viewfinder. The noise from the wind circling inside the cockpit was deafening. Tears started to form in my eyes, making the scene in the viewfinder a continual blur. The subject was there all right, but I couldn't see any details. This must be how it feels to be in a plane crash. It took forever and a second to pull out of the dive. I lost color as my world became all gray. This was blackout time. A giant vice was pressing my midsection

against the back of the seat. Why, I wondered at this moment, hadn't I become a chaplain's assistant instead of a shutterbug?

The good news? The dive was over. The bad news came over the intercom: "Gibson, are you okay? We're going to try it again."

I had a chute on, so I could leave this casket and its pilot madman, but the numbing chill of the Pacific below nullified any further thought of escape. We repeated the drill and a few hours later were looking at the film. It did show a vibration. The squadron commander looked me right in the eye and said, "Good job, Gibson." The mercury in my ego thermometer hit an all-time high.

That evening, a photographer friend confided that he would never want to do anything like that. I told him I loved every minute of it. I lie . . . I lie . . . I lie.

Chase plane photography is hard on the human frame and, the faster the chase plane goes, the more difficult it is to keep the subject in the finder. Case in point: flying with the U.S. Air Force aerial acrobatic team, the Thunderbirds. I felt very special while getting my briefing on how to exit the T-33 jet, which we did while waiting for the pilots who were some of the best jet jockeys in the world.

"Now, if something happens to the pilot, you will have to do the following things yourself, and you must do them in the proper sequence or you're dead. See this pin with the red cloth attached? Pull this to arm the canopy, then push this lever to shoot the canopy away from the aircraft so you can get out. Now reach down for the pin that charges your seat." After this I didn't remember anything this undertaker dressed in Air Force blue said, except: "Don't forget to put your feet in the stirrups or you could cut your legs off when you eject."

The four F-80 jets took off in formation with my photo plane close behind. It's difficult to express the feeling of flying with a precision flying team. It's special—a ballet, an adagio, a waltz. It's all of the rides at Disneyland rolled into one and then some.

The "Gs" we pulled were real belly busters and, like an idiot, I didn't wear a pressure belt (which holds your guts in place). The result of that omission surfaced that evening in the shower. I had a lovely case of hemorrhoids. I got dressed and went over to the Officers' Club. There, at the bar, was Maj. Carr, the lead pilot and commanding officer of the Thunderbirds.

I ordered a drink, took a sip, and informed the major I could not fly with the team tomorrow. "I have hemorrhoids."

"You have hemorrhoids?" he shouted. This got the attention of the patrons. I squirmed. "How far are they hanging out?" he thundered. Now this really got the 30 or so diners interested in our conversation. You could have heard a pin drop. I bent over, hiding my hand so only he could see. I spread my thumb and index finger about an inch and a half. "Like this," I whispered. "Oh, hell, that's nothing," he bellowed, "mine are out like this." His fingers were three inches apart. "You'll fly tomorrow." To this day, whenever I see a military jet jockey, I know he has a minor medical problem.

Photo chase missions are dangerous, and the inevitable occurred when a photo plane collided with the brand-new B-1 bomber, a billion-dollar catastrophe. This was what I was getting into, but calamity happened to others, not to me. My commanding officer was Col. Dan McGovern, an Irishman if ever there was one.

Mac was (and still is) a cameraman's cameraman. Like me, he dreamed of being a newsreel photographer and, as a youth in New York City, would carry the equipment of the Warner-Pathé crew on local assignments.

During World War II, Dan was assigned to cover the Eighth Air Force bombing raids over Germany. The War Department was grumbling that it was getting no photography of the air action. Mac went on a mission to find out why. It would take a hundred cameramen on one mission to cover the job. He needed to record what ten men on a B-17 or B-24 do from

takeoff to landing to show why so many never returned. He sent an urgent message to Washington: "Send me 50 Bell and Howell cameras posthaste."

No one questioned his request. Upon receipt of the cameras, Mac loaded them, then shot a slate with all 50 cameras with the date and his name as cameraman. Next he received permission to train 50 crew members to use the camera. He taped the aperture opening so it couldn't be changed and the cover so it couldn't be opened accidentally.

The navigator, co-pilot, top gunner, tail and waist gunner, and crew chief all had their assignments. The exposed film was sent to Washington, where the brass ooed and aahed over the coverage. Sgt. Dan McGovern was given a battlefield commission.

Mac was my photo officer at Holloman Air Force Base. The base and its neighbor, White Sands Proving Grounds, was to be the home of our fledgling space program. Here the photo planes chased missiles and drones where the sky turns from a deep blue to an ebony black.

The most exciting chase I was ever on was at Holloman on a top-secret project called Grudge. The mission? To get pictures of unidentified flying objects that were sighted on a daily basis in this area of New Mexico.

I was called at home on a Saturday morning to go directly to the flight line where our B-26 photo chase plane was waiting. I turned on the car radio to an El Paso station and heard the announcer excitedly describing a golden glow in the heavens. It was, he said, pulsating and huge. Thousands of El Paso residents were watching this strange phenomenon.

The aircraft had both engines going when I arrived. I crawled into the bomb bay and started forward to the Plexiglas-covered nose. I automatically put on my earphones and started to load the camera. In seconds we were airborne. The pilot had the radio tuned to Biggs Field tower where the position of the mysterious craft had been reported. They said they could not see any object on radar, but it was definitely visible to the naked eye.

Here I was in a World War II bomber that would be lucky to exceed 240 miles per hour, and we were going to rendezvous with a ship from another planet? Good luck! I read somewhere that the hummingbird had a heart rate of 1,400 beats per minute. If this was true, I should have been looking for a petunia instead of looking in my finder for an unknown but visible object. Over the intercom came the stuttering vice of the pilot: "My God it's huge! Do you have it, Gibson? Do you have it, Gibson???"

I could see nothing but blue sky. The pilot's cockpit on a B-26 is above and slightly behind the nose compartment, so he could see things above us before I could. I had the camera tilted to its limit. Then, slowly, in the top of the finder, a pulsating, glowing object appeared. I grabbed the mike and told the pilot to get the nose up so I could see the entire thing. He brought the nose up, revealing more. "Nose up," I yelled into the mike. I turned the camera on just in case the object disappeared like so many other reported sightings had. "Go on oxygen," ordered the pilot.

I looked at the altimeter; it read 13,000 feet. The plane was now vibrating from its nose-up attitude with insufficient power.

The object began to fill the frame against the dark blue sky. I had just recorded a photographic masterpiece of a vehicle from the far reaches of space. Step aside Brady, Steichen, Adams, James Wong Howe, Margaret Bourke White—all of you so-called masters of the camera. Gibson has arrived!

When a balloon pops, it takes only a microsecond for the beauty of the object to disappear leaving only wrinkled remains like the recently shed skin of a reptile. My balloon popped in slow motion so I would never forget this moment. I had been photographing the planet Venus, our morning star. A recent volcano eruption in Indonesia had created ash and dust particles that went into our stratosphere creating a large, pulsating planet Venus.

Before the government bureaucracy became so touchy about using its parks for photo backgrounds, the thrill of a photo chase through the golden ditch was a visual that would be stamped on the focal plane of my mind forever. I've made that trip deep into the Grand Canyon a dozen times, and each one was more spectacular and exciting than the last. One such flight was to photograph the new *Gulfstream II* on one of its test flights. The chase plane was a converted B-25 with a plastic nose for straight-ahead photography with a 190-degree viewing angle. I had the cone, which was the tail gunner's position during the war, removed and installed a plate to mount the camera. The operator's head and body could be outside the aircraft, as there was a pocket just around the tail that acted like a vacuum. When you knelt outside the aircraft, no wind blew in that one area.

In some of those jumbo jet commercials that most everyone has seen, the photography was done from this B-25. This is how it was accomplished. The pilot of the B-25 would have his aircraft about 8,000 feet above the California coast. I would be in the open tail position. From ten miles away, the jumbo jet headed directly for the B-25. As it approached and then appeared full-nose in my viewfinder, I radioed the pilot to stay in that position for a minute. He was so close I could read his badge.

After getting that shot, I shut off the camera, crawled out on the ledge, and stood halfway up. You could imagine what the pilot, co-pilot, and engineer thought of this mad cameraman waving to them from outside the plane.

Not all such photographic excitement ends so easily. In the same aircraft, while shooting the feature film *Catch 22* in Mexico, there was to be a reveal shot of a B-25 coming over a hill. Frank Pine, the photo plane's pilot, sensed an air-to-air collision and pulled straight up to avoid a head-on crash. The cameraman in the tail was not strapped in and flew out the tail opening. He was not wearing a parachute. His body was found the next day among the tumbleweeds of a Mexican desert.

The most comfortable aerial chase I have ever participated in was racing with the moon's shadow over the Arctic Circle at an altitude of 40,000 feet. National Geographic and Douglas Aircraft company outfitted A DC8 jet with optical windows for international scientific groups to record a total eclipse over the Arctic Circle. There are just four total eclipses a year, and the majority are centered at the most remote spots on our planet.

To observe or record this phenomenon, scientists of the past had to brave wars, cannibals, jungle bugs, and Arctic freeze to be at the one spot on Earth where you could view the totality. Those few extra seconds of exposure were precious moments to solar scholars who discussed coronas, Bailey's beads, umbra, penumbra, and airglow as if these words were part of our everyday vocabulary. I would nod my head as if I understood every word they uttered.

When you're on a scientific expedition and you want to be a part of the establishment, you learn to nod your head when the expert talks. Adjust your body a little closer to the expert's moving lips as if he or she was giving you life-saving information. I have listened to some of the World's most renowned scientists for ten minutes and never understood one thing any of them said. I recall one "nodding" incident that did not turn out all that well.

I was a consultant to NASA on the *Apollo 11* program, assisting with the design and coverage of the camera on the LEM (lunar excursion module), which would record Armstrong and Aldrin's first steps on the moon. In this capacity I was invited to the monthly field directors' meeting at NASA headquarters in Washington, D.C. Get the picture? Forty or more space scientists and engineers and one out of place cameraman, sitting at a huge conference table listening to experts in their field imparting important information.

Once such meeting featured a gentleman from the Goddard Space Center. His lecture dealt with controlling global weather

from future space stations. Every now and then I made eye contact with him and immediately gave my "yes, I understand you" nod. I looked around the table and noticed that the others, too, bobbed their heads in the same fashion.

About 15 minutes into the lecture, Wernher von Braun raised his hand. The speaker immediately acknowledged him. "I'm sorry," von Braun said, "I must be an idiot. I do not understand anything you are talking about. Could you please put your information in more general terms?" The others at the table mumbled in agreement. I slunk down in my chair. My nod was marked as phony, but this time I was not alone.

But, back to the chase. Our prey: the shadow of the moon racing across the surface of the earth at 1,710 miles an hour. Our jet flew 525 miles an hour. Our goal was to extend the totality of the eclipse for the 55 scientists a total of 44 additional seconds.

This was a first in the study of solar phenomena, and I had a window all my own wedged between a radiometer to measure solar radiation and astronaut Scott Carpenter, whose job was to study dim sky phenomena near the eclipsed sun.

Over the loudspeaker we heard the excited message: "T minus one minute." The light in the cabin was an eerie grey/black that seemed to move to and fro throughout the cabin. It would have been the perfect moment for Edgar Allan Poe to recite "The Raven." For, if there is such a thing as ghosts in the stratosphere, the dark lights were indeed shining ghostly images on men and instruments. Like Poe's poem: "Each dying ember wrought its ghost upon the floor," I wondered if some of the others felt a cold chill run through them. But no one looked at one another because outside our optical windows was the greatest show on Earth. I really mean the greatest show in the universe.

A shrill whistle filled the cabin. This was the agreed-to signal announcing the sighting of Bailey's beads, which marked the beginning of the totality. It is that precise moment when the sun's last rays shine through the canyons on the rim of the moon. The sun's corona, visible only during an eclipse,

glowed against the black background of space. The planet Venus appeared in all her glory and she was magnificent!

If the masters of the past, the painters and composers had been in the place of our solar observers, I wonder what brilliant new sounds they would have created for us and what their paintings and tapestries would tell us of what they had witnessed.

With precise navigation, the totality was extended 42 out of the possible 44 seconds. The scientific community named this period of time "The Year of the Quiet Sun." I also called the film we made the same. It won awards around the world and, a few years later, I was invited by the Soviet Academy of Science to make a similar film in Siberia, this time a total eclipse occurring over a small town on the eastern slopes of the Ural Mountains.

Another kind of a chase was the "Who's Out There?" type. The Air Force called the project "Blue Book," and its two sub-projects were named "Grudge" and "Twinkle." Those of us who worked on Blue Book had top secret clearances, but were still not told anything other than what we were to film. The only briefing came from our base photo officer, Dan McGovern. "You've all heard the rumors of unknown, high-performance aircraft sighted around White Sands and Holloman. We've received a highly classified request to obtain motion pictures and stills of these unidentified vehicles. Don't ask me any questions; I won't answer them. The assignment is simple: Have your camera loaded and ready at all times. Keep your eyes to the sky."

We had heard of one of these so-called high-performance discs crashing around Roswell, New Mexico, in 1947, and sup-posedly it had little out-of-this-world creatures aboard. Scuttlebutt like this was usually tossed off as rumor, hearsay, or just plain storytelling. Yet there had been plenty of sightings, and our job was to interview the people who had seen them, using

a single-system sound camera. During most of the sessions I thought I had just entered a party where the participants were fitted with straitjackets. But a few of them made you think. One such interview was with a sheepherder who spoke no English so we had a Spanish-speaking translator question him. He described a large, wingless airplane that hovered over his flock of sheep late in the night. The sheep, he said, did not run, nor did his herd dogs. He drew a picture of the craft and it was amazing—like the sketches from sightings of the past.

We didn't process the film at Holloman. It was taken by jet to another facility, and I never found out what had happened to the film or where it had been taken.

Many people tend to put UFOs in the same category as ghosts, mysticism, magic, and other forms of the occult or supernatural. As a result, anything even remotely related to UFOs is a difficult subject to broach without risking an immediate loss of credibility. Members of the mainstream media rarely broach the subject because none of them wishes to be ridiculed.

So, some 40 years later, I was part of an investigation team to sort out and, we hoped, put to rest the UFO hoax of the century: top secret photography of an autopsy of so-called aliens who had been removed from a crashed spacecraft near Roswell in 1947. The videotape (called the Santilli video) I watched was supposedly from film shot by a U.S. Army cameraman, which surprised me since there were no records of any Army cameramen sent to the crash site. Forgetting for a moment the Army cameraman's claim that he had shot "several hundred reels," the videotape copy was full of historical inaccuracies and poorly photographed.

Over the years since Project Grudge, I have been asked many times to be a keynote speaker at UFO expos and seminars around the country. I said no to all but one, and that was a big mistake! It was held in the Santa Monica Convention Center, not far from where I lived. For weeks after, all sorts of UFO believers called my house, came to the front door, or simply camped out across the street in the park. Never again!

Don't misunderstand me; like many people, including pre-eminent scientists, astrophysicists, and other well-educated citizens, I think it would be the height of egocentricity to suppose Earth and its people are totally alone in the vastness of the universe as we understand it today. Are other intelligent life forms somewhere out there? If not, I find the alternative terrifying.

Chapter Four

Sutures and Smelling Salts

If you have been a documentary cameraman for any length of time, you and your camera will end up in a hospital operating room. Of all the assignments I have covered over the years, this is the location I hate the most. It's not that I don't appreciate the talent, hard work, and compassion of these mask-wearing body engineers. But I don't have a chip in my brain that allows me to watch the gory goings-on in this green poker parlor.

I was the director/cameraman on an Air Force film entitled, *Operating Room Procedures*, another titled, *Birth of Triplets*, and still another as a civilian cameraman/director in the jungles of Africa where none other than the grand Dr. Albert Schweitzer operated on a strangulated hernia. The very worst, however, were field operations.

During World War II many surgeons performing amputations in the field were making mistakes that resulted in the patient ending up with gangrene and needing yet another amputation. At Bethesda Naval Hospital, they were preparing an emergency training film on the proper procedure for amputating in the field.

The motion picture cameraman assigned had a ruptured appendix, so I was sent to the hospital as his replacement. An attractive nurse helped me into a green gown and matching mask. The camera and lights were still set up from shooting the day before, so all I had to do was load the film and be ready for action. I was not ready for what followed.

A sailor, no more than 19 years old, was wheeled into the

operating room. His eyes had that look of battle—a look that no anesthesia can cover up. In seconds the lead surgeon said, "Get a close-up of this." He took a stub of the sailor's arm and pointed it at my lens. "Hurry up," he barked as I tried to push the tripod into position. I focused on the stub, which was red with patches of black. A knife came into frame and slashed just above the stub. The doctor was saying something like it should have been cut here. I grabbed the tripod's legs to brace myself. I remember sliding ever so slowly to the floor. As I regained consciousness, a nurse had my head in her lap as she administered smelling salts. Jack the Ripper was yelling, "Did you get the shot?" And "Where do they find these lousy cameramen?" Another photographer was requested immediately. The cute nurse must have felt sorry for me and took me to the cafeteria for lunch. As soon as I spotted one of the entrees I felt dizzy again. The dish of the day was spare ribs. I was not hungry.

In Vietnam during the Tet offensive, I was in a helicopter that set down at a South Korean base. A marine, who had stepped on a land mine was rushed aboard and placed on the floor of the ship. Fresh blood from under his bandages oozed down his leg. His privates had been completely blown away. As the 'copter took to the air, I set my camera on the floor a couple of feet from his body. I lay down next to him and focused the lens on a face that belonged on the cover of *Saturday Evening Post*. This was Rockwell in all of his glory for this young man's face was the face of all young men who gave their lives or limbs to a homeland they loved and believed in. His brain was deep into a never, never land brought about by a strong painkiller. Yet, he looked me straight in the eye. His eyes moved from my camera to make eye contact with me. I set the camera aside and took his hand in mine. "You're going to be all right," I shouted over the noise of the chopper with its throttles wide open. He closed his eyes.

I often think of this young marine who would never reach manhood as we think we know what manhood is. He would never feel the thrill of his children rushing from the house to

welcome him home. He would never burst with pride as his son struck out the last batter in a Little League game. I had film in the camera, but I didn't shoot the scene. A young marine and I know the reason why.

All types of propaganda films were used by the armed services during the war. The films that had an everlasting imprint on my memory cells were the series on venereal diseases, another of my least favorite subjects. There is not a man or woman who took the oath who will ever forget the visuals presented by the various services' motion picture groups.

I was assigned to photograph a group of people who got more than they bargained for. They were not in a position to say, "You can't photograph my privates." We didn't have our disgruntled actors sign a photo release. And, being in the service, they had no voice in the matter.

The pharmacist's mate (known in the Navy as a "clap mechanic") pointed to a tape mark on the floor. "Step on the mark straight on to the camera," he ordered as each patient, one at a time, stepped in front of my camera. "Did you get that, Gibson?" he yelled. I would nod my head and keep shooting. "Okay, now let's get the side angle." Thank God the scene in the viewfinder was in black and white. Just like in combat, I kept my left eye closed.

One of the patients balked: "You're not photographing my dick," he mumbled gruffly. "You don't have permission to show me in a film." If he had been a member of the Screen Actors Guild, he would have been right as rain. However, he was a member of the U.S. Navy, and his (and everyone else's) soul—and, in this case, privates—belonged to the defenders of the nation. After a threat by the pharmacist's mate to give him a shot in a very sensitive place, he stepped quickly forward.

In the brief 30 minutes it took to film the sickly-looking (read: disgusting) organs, my dignity as a cinematographer, combat cameraman, and visual reporter was shot to hell. I

hoped against hope that this so-called job would not be part of my resume when I left the service.

On my second tour of combat duty I was assigned to Photographic Squadron 1. The Navy abbreviated this as VD-1, which, when translated into Navy jargon, meant V = aviation, D = photo squadron, and 1 = which squadron we were in. All of us were issued leather flight jackets with a patch that had our name, rank, and squadron number. They were handsome jackets, and we wore them with pride.

After a few missions mapping enemy islands we were given R and R leave in Sydney, Australia, which is like giving a chocoholic a five-pound box of See's candy or an alcoholic a gallon of cheap wine. The girls were gorgeous and super-friendly—to everyone but me. I found out why when one girl asked how long I had been sick and pointed to the VD-1 patch on my flight jacket. Then I remembered that no one from our squadron had worn his jacket. That was the last time I wore mine for the remainder of my stay in Sydney.

Of all the hospitals I have taken my camera into, the one that is imprinted on my mind the most lies 50 miles from the equator in Equatorial Africa. During morning rounds it was not strange to see a goat follow behind the hospital staff, or a baby chimpanzee in the arms of a nurse as she tried to juggle a clipboard while taking instructions from the doctor.

The crowing of a rooster cut through the thick, humid air as one of the doctors waited for a native translator to interpret the patient's ills from the Fang language to French. It was Sunday morning, and church services in Fong, German, and French began after the hundred or so patients were taken care of. This is the hospital of Dr. Albert Schweitzer, located on the banks of the Ogowe River in the country of Gabon in West Africa. My first visit to the hospital was in 1963, followed by trips there in '64, '67, and '69.

Albert Schweitzer, one of the most inspiring men of the

twentieth century, was a doctor of medicine, of music, of philosophy and theology. He was known around the world as a man who believed in his fellow man. His writings were simple and direct. One such was, "When I hear a baby's cry of pain change to a cry of hunger, it is the most beautiful music in the world. And, there are those who say I know something about music."

Ben Marble and I arrived at the hospital with no advance notice. Our entrance shook up the staff and the grand doctor himself. We had traveled up the Ogowe River in a pirogue (a canoe-like boat). Ben grabbed a paddle from one of the natives, bent over like an Olympic scull rower, and started chanting like a sound track from a Tarzan movie. Our six crew members roared with laughter and joined in the festivities. Along the bank, women washing clothes yelled some kind of instruction, and the laughter and mimicry echoed through the forest and across the waters of the Ogawe. By the time we pulled up to the banks of the hospital, Ben had created a scene reminiscent of a rock concert.

From the various buildings, staff and patients peeked out to see what the commotion was all about. After an extended negotiation about fees, our six temporary employees placed the camera cases and luggage on their heads and started up the path to the main building. Again, Ben and his willing chorus began the chant. It was the perfect moment to say, "Dr. Livingston, I presume." And there he was, staring out of a screened window while calling for Dr. Friedman, his assistant.

If ever there were two obnoxious paparazzis, Ben Marble and Bill Gibson should have received the cameramen's "Personal Intrusion Award" of the year. Schweitzer simply stared in disbelief as Ben and I began setting up lights and tripod without permission.

The doctor's office had a handmade desk set by a screened window in the corner of a large open room. A tabby cat was sitting on the desk on top of some papers that I was sure were Schweitzer's writings about atomic bombs or Bach's music.

Friedman, a perfect replica of Schweitzer as a young man,

entered the room. "Can I help you, gentlemen?" he asked politely. Ben quickly replied, "We're making a film for Air Afrique Airlines on the 12 West African countries they service and would like to include the hospital in it."

Friedman translated what Ben had said into French and Schweitzer replied in French, turned his head, and petted his cat. He picked up a feathered pen, the kind you only see in old movies and museums, gently moved the cat off of his papers, and started to write.

Friedman told us it would be all right to photograph the hospital and, after we finished shooting, he would give us a tour of the facilities. A few days later a nurse told me why they let us stay after our rather rude and boisterous entrance. Now that they knew we were filming for the Gabonese government, Schweitzer wanted us to show the hospital and its staff in a good light for the bureaucrats in Libreville. Factions in the country's capital were trying to close the hospital and send the all-volunteer staff to their respective homelands. A modern hospital, with all of the latest equipment, sat empty in Libreville for lack of patients. Various native tribes boycotted the new, air-conditioned facility because the staff there didn't understand their tribal customs.

At the Schweitzer Hospital, the sick could bring their families and possessions, even their dogs, pigs, and chickens with them. Schweitzer understood the basic needs of the West African people and had made his hospital an extension of their villages. It was not uncommon to see a healthy relative of the patient in the bed while the sick one sat on the floor. This was the patient's very first experience in a real bed, and sharing new pleasures was an attribute that the Gabonese natives seemed to have an abundance of.

The all-volunteer staff came from the Four Corners of the globe, from every walk of life. These seekers were looking for a place that would make their personal world a better one to live in. Perhaps, too, some of the greatness of La Grande Doctor would rub off on them.

At dinner, Ben and I were placed just to Schweitzer's right.

He bowed his head, and everyone held hands as he gave the blessing. This chain of hands was a study in diversity—an American Peace Corps volunteer who did carpentry work on the deteriorating hospital buildings, a Japanese doctor and his wife who ran the leper hospital, to a Swiss student who became a nurse's aide to Friedman, a German Jew who had on his wrist a tattoo identifying him as a prisoner in a Nazi extermination camp. So here were men and women from all walks of life giving to others with no tangible reward anticipated. I was impressed.

The first day of filming was depressing. Friedman took us up a path from the main hospital to the leper hospital on the hill. A patient was carving a figure on a block of wood. "John," the doctor said, "I would like you to meet two gentlemen who would like to take your picture." One of John's hands was missing and only a stub was visible. He reached out to me for a handshake. I took a deep breath and slowly moved my hand toward his. "Don't touch him, you idiot," my mind was telling me. "Keep your distance." My hand met with his stump, which was covered with large growths that took on the form of small brains. I closed my eyes for the moment when contact was made. John was smiling from ear to ear revealing a mouth that had no tooth left.

Friedman saw my concern. "Don't worry, Bill, Hansen's disease is not contagious. While leprosy has always been a dreaded disease, it has never been highly infectious, and we now have medication that arrests it. In this section of the hospital, we can house more than 300 patients. Most of the facilities here at the complex were paid for by Dr. Schweitzer's Nobel Peace Prize money." I thought about the givers and takers of the world that morning. Without a doubt, I was in a covey of givers.

The next stop on the tour was at a 12 × 12-foot building separate from the rest with a board across the door to keep anyone from getting out. A small hand found its way out through a crack in the wall. It began to curl into a fist, then opened wide, then curled into another tight fist. A moan,

almost like a growl, accompanied the opening and closing of the hand. Friedman reached out, placed his hand on the fist, and gently stroked it. "We found this girl running amok in the jungle," he stated. "She had been taken to the local witch doctor for a cure for her rather serious mental disorder. The witch doctor's remedy was to pour hot wax into her ears. We keep her locked up because she has suicidal tendencies. I've been working with her on a daily basis and she's beginning to improve."

It's quite a sight to go to the riverbank early in the morning and watch the newly released patients ready to go back to their villages. There was smiling and talking a mile a minute about their stay in the hospital and showing their operation scars to any one who would look. Come to think of it, they were no different from the Madison Avenue crowd bragging about its recovery from Cedars of Sinai.

With all of the sacrifices and human kindness Schweitzer had given to the world over the years, he still had his critics. A couple of writers who had spent a day or two at the hospital wrote books tearing the good doctor apart. They accused him of accepting large sums of money and hiding it in Swiss banks. They charged him with improperly caring for his patients by allowing animals to run all over the hospital grounds and into the recovery buildings and by not feeding the children. They also insisted that the lack of air conditioning imperiled patient's lives.

These so-called authors were at a different hospital from this one, for what I saw was what the grand doctor's "Reverence for Life" philosophy was all about. This beautiful, all-encompassing axiom was born on the banks of the Ogowe River and spread its message to the four corners of the Earth. As Schweitzer said, "I am not here in Africa as a social worker. I am a physician, and my job is to eliminate pain. If I can accomplish that then I can face my maker with a smile."

Chapter Five

Adventures with Ben

These must have been the same emotions General George Armstrong Custer and his soldiers felt when the warriors of Sitting Bull, Gall, and Crazy Horse attacked them at Little Big Horn.

They were mad as hell students looking for the enemy and ready to kill. More than 200 strong, they approached our vehicle screaming Indonesian obscenities that ricocheted through the streets of Jakarta louder and more frighteningly than air raid sirens. Ben Marble was in the back seat when our driver, who was Chinese, grabbed my hand and, in pretty good English, stated with finality, "We're going to die now." I had never seen such fear on someone's face, even during the war. He looked as though a high-powered air hose was blowing on his cheeks causing them to ripple. He bit the top of his lip and blood began to flow from his chin to his shirt. When the mob was about 50 yards from our car, our driver panicked, stopped the car, opened the door, and took off running. My Arriflex was on the floor of the backseat. "Give me my camera," I yelled at Ben. He threw the case on the driver's side, grabbed a Nikon still camera, and started shooting. By the time I got the movie camera out of the case, plugged in the battery, set my speed and aperture, the mob had beaten up on our driver and was bringing him back to the car. He looked dead to me. Every inch of window space was filled with screaming faces pressed against the glass. I made a slow pan. For a brief moment I felt secure looking through the viewfinder with my left eye closed. But the real world was in my left eye and it opened when a

hundred hands began to rock the car and Ben and I ended up on the ceiling. And then it seemed as if a thousand hands were pulling me out on the street. I don't know what I said, but like magic the crowd backed up. Marble was lying alongside of me when a young man lifted me up. "Are you Americans?" he asked. What was the right answer, I wondered. Marble took the gamble and said: "Yes, we are Americans!"

"We are sorry," the former terrorist said, "We thought you were Czech communists." When he said this the students' voices raised once again. The only word we could understand was, "kill, kill!" That we weren't the objects of this hate anymore was comforting. The car was righted on its four wheels and the bloodied driver tossed into the rear seat. "What hotel are you in?" asked the leader. "The International," Ben and I answered in unison. "Follow us," he said. The students turned away from the car and began to run toward the hotel. We gladly followed what looked like the Boston marathon in Indonesian costumes.

The hotel clerk put our driver in a room and called the house doctor while another Chinese employee began cleaning him up, all the while murmuring how stupid it was to go out into the streets of Jakarta.

Marble and I went to the bar and ordered mai tais with all the trimmings. There was no one else in the bar or the lobby. This was a brand new, sparkling clean hotel with only a few rooms occupied.

Ben gave me his "know it all" grin and said he wanted to make a toast. We clinked glasses. "A toast to you, Gibson," he said softly. His voice then raised about ten octaves: "Why the hell are we making a tourist destination film in a country on the brink of civil war? We could have been killed tonight!" Lowering his voice to a civil level he continued, "Do you know something? Traveling with you is a blast a minute. What's your next surprise?"

The wait for the next unusual occurrence took several weeks, while we were making another destination film, this time in West Africa. Our guide, a Frenchman working for the

airline, told us of a remote, native village some ten miles from downtown Cotonou, in the country of Benin (formerly Dahomey). He said the village people had created a pornographic shrine in memory of a French colonial governor who frequented the village and commanded the villagers to participate in open sex orgies. "This is a subject that I don't think fits the criteria for a tourist destination film, Ben," I mentioned. He replied with the greatest authority, "It sounds to me to be a good education on local social diversities." I knew better than to argue the point; when Ben made up his mind it was a done deal.

Turning off the highway onto a palm-lined dirt road, our guide warned us of the potential danger with the natives of the village: if they were not disposed to receive us as friendly visitors, they could cause trouble. He further advised, "There have been a number of murders here, and the government does nothing about them."

At the end of the road was a clearing about the size of a football field, as level and clean as a new pool table. Around the perimeter were palm huts, each built about three feet off the ground with open porches on three sides. Poinsettia and hibiscus bushes were placed in perfect harmony with the surroundings along with magnificent jacaranda trees with their deep, scarlet aura. The mad French governor had tried to duplicate Eden, and the natives had kept it that way in reverence for their sex-crazed colonial bureaucrat.

The memorial was, without understatement, unique, and obviously not found in a typical village in West Africa, new Guinea, or the Solomon Islands. It was more like the Paramount Pictures back lot. The shrine was located at the far end of the field. As we neared the palm-covered display, I asked where the natives were because there wasn't a person in sight. The emptiness of the area made me feel uncomfortable, rather like the quiet moment just before the mallet hits the kettledrum.

I got out of the car and gazed in disbelief at the most astonishing series of sex sculptures I'd ever seen. Some really

talented and experienced craftsmen had painstakingly created each life-size piece with meticulous detail. Seated on a throne was a replica of the former governor, his private parts held in the hands of a naked native woman. His white hand stretched from the sleeve of his uniform to caress the oversized breasts of a smiling black girl. On the floor, directly in front of them, were two dogs fornicating and four natives depicted in various sexual positions with each other.

Ben was shooting stills from every angle. "Don't take pictures!" yelled our guide, "They don't like that!" Marble didn't miss a beat as he climbed over the railing to get a closer angle. That's when I heard the chorus of voices coming from the other end of the compound. The natives had arrived, well over 180 of them. In the middle of this mass of black was one, short man with a 12-foot bullwhip that he lifted over his head and jerked backward, sending the braided line hissing like a king cobra looking for its prey. Just as rapidly, he yanked the whip forward and, at the limit of the throw, splitting crack got the attention of the anvil in my ear. The scene was like something out of a 1940s movie serial.

Our guide spat something in French and jumped into the car. I quickly followed him, ready to leave the scene, which was swiftly turning into a no-win situation. I shouted at Marble to get in the car, but he had turned his camera on the advancing mob. This seemed to make our adversaries angrier than ever. The bullwhip snapped again, followed by loud screams by the masses.

Marble turned, ran for the car, opened the door, tossed in his Nikon, and hurriedly took our instant Polaroid still camera from its case. "Get in the car now, Ben!" I snapped. Ignoring my pleas, he turned toward the oncoming sea of bodies and waved the camera over his head, screaming like a Moro warrior on a suicide mission. At ten paces he took a shot of the small man with the whip. When Ben halted, so did the natives. The minute needed for processing seemed forever. The Frenchman muttered, "Your friend is mad. He will get us killed. Let us leave him." I grabbed his shoulder and ordered him to wait.

Ben took the finished print and handed it to the man with the whip. At first there was dead silence, then a chorus of ooohs and aaaahs. One of the natives grabbed the print and saw himself in the shot. There were more ooohs. As the photo was passed from hand to hand, the ooohs turned to laughter.

Marble moved closer to the whip man and motioned to him to hold the whip in the air. As he did, Ben took another shot and waited patiently for the processing. Upon seeing a close-up of himself, he dropped the whip and danced a barefoot jig while clutching the precious portrait. By this time, I had left the confines of the car and stood alongside Ben. "You're crazier than a March hare, Marble." I was interrupted by a command from the little whip man. Walking toward us from the center of villagers was a stately gentleman wearing a loud, print shirt. "It's the Chief," said our guide, who also left the car to join in the fun.

When he heard who the man was, Ben ran back to the car and loaded another pack of film—this time color, not the black and white he had been using. While our driver was talking to the chief in French, Ben took a photo, and, when it was processed, handed it to him.

It's not often in this life one can witness the surprise and elation of a person's first look at him or herself in a photo. I'd swear the chief grew ten feet tall while his chest puffed out, buttons almost popping off his colorful shirt.

Ben and I took turns sitting in the chief's chair, drinking homemade beer. The village was ours. I set up the camera as the villagers danced for us, and the drums played a body-moving beat heard in this part of Africa for thousands of years. Strangely enough, I felt as though this was all familiar.

Ben Marble was vice president of advertising for the corporate office of Douglas Aircraft Company (now known as Boeing) plus a half dozen other departments, along with the film and television group that I ran.

Ben lived with his wife, Bea, and their three boys in Mandeville Canyon, just north of Santa Monica, California, where he corraled his polo ponies. Coincidentally, the Marble family

lived across the street from Don Douglas, Jr., who was then
president of Douglas Aircraft.

None of us who were there will ever forget the sight of Ben
walking down Mahogany Row, the executives' corporate hall,
with cow shit on his boots singing, "Hooray, hooray, the first
of May, outdoor screwing starts today." Most of the other vice
presidents scattered to their respective offices to count their
stock options, trying to ignore Mr. Marble's uncouth behavior.

As unusual as he was, there was no head of customer re-
lations in corporate America who was any better at his job than
Ben. The day he died he was doing what he loved most,
playing polo. His mallet made contact with the ball and sent it
winging like a homing pigeon through the goalposts. Ben's
body slid slowly to the ground. His horse never left him but
stood silently, like a bronze statue, watching over Ben's body.

Ben Marble was an adventurer and explorer, at home with
waiters and presidents. Thousands of people who knew him
didn't mourn his passing but celebrated a spirit that loved life
more than wealth or prestige. In all our travels and travails, the
following is my favorite story—one that Ben starred in and no
one involved ever forgot.

The rancheros are a group of a hundred horsemen from
around the United States who ride the former trail of the
Spanish ranchers in Santa Barbara, California, each year.
During the old days, these men went from ranch to ranch,
helping neighbors calve, brand, and herd their cattle. Over the
years the rides became more of an elaborate equestrian picnic
than a work detail. The riders broke up into individual camps
with distinct names, and each camp would try to outdo the
others. Over time one group proclaimed itself the descendants
of the original riders and expanded the yearly ritual. European
chefs were brought in to do the cooking. Buckboards carried
Hollywood entertainers to the camps at night. Music from the
Gay Nineties mingled with the smell of pine trees and euca-
lyptus, all drifting cheerfully to the shores of the Pacific. The
most important event, however, was to create and implement a
practical joke to top the previous year's.

A week before the ride, Ben took me to lunch. We could never talk about any of our activities in the Executive Dining Room. Our conversations stood out amid the talk of production lines, field station activities, or lost or won government contracts.

"Okay, Gibson, I need an idea—a trick—a gimmick—no, a happening so spectacular it will give goosebumps to a corpse. You've got five days." That was certainly one of my functions, and I rarely faltered when challenged. But this time I hit idea block.

For the next few days I checked with other members of the rancheros. They made it sound as though everything had been done before. Now whose brain could I tap? Bingo! I called aviators extraordinaire Frank Tallman and Paul Mantz at Tallmantz Aviation, Orange County (now John Wayne) Airport. If it could be done in a plane, one of these two eagles in flight gear could do it.

Marty, the right and left hand of the office, got Paul on the phone and told him his favorite shutterbug was on line one. Although in his 60s, his voice was as powerful as Clarence Darrow's. "Bill Gibson! Let's get Doolittle and Marble, do a little dove hunting and fishing down Baja way," he thundered. I interrupted and asked if we could put a saddle on his L-19 (a World War II observation plane) that Marble could sit on and throw horse manure on the rancheros.

"I love it, I love it," Paul crackled, "I even have an old saddle here in the hangar. When do you want it done?"

"A week from this Friday morning." I said.

"Does Ben want to do this?" Paul asked.

"I haven't told him yet," I blithely replied. Paul was still laughing when I hung up the phone.

I was waiting in Ben's office when he rushed in. He never simply walked; everything was in double time. "This had better be good, different, and with pizzazz or you're on my shit list, Gibson," he barked.

"Well, speaking of shit, Ben, just close your eyes. I'm going to paint you a picture. It's early in the morning. The rancheros

are on the last part of the ride, about a quarter-mile from the mission in Solvang when, one after another, they look to the skies. They see a low-flying, high-wing aircraft heading directly at them. They cannot believe their eyes for, on a saddle strapped to the fuselage, is Ben Marble. They are aghast as he reaches into the rear cockpit, grabs a handful of horse shit and throws it down on them."

Marble jumped out of his chair, vaulted over his desk, and stood in my face. "You're a fucking genius, Gibson!"

Some ideas look great on paper, some will always remain in the creator's mind, and some never see the light of day. That's what I thought of this crazy concept that should have remained in the attic of my mind, collecting cobwebs.

I watched Ben climb a small ladder and place himself in the saddle. The crew chief who flew with Paul Mantz adjusted the stirrups and makeshift seat belt. A plastic garbage bag of fresh horse manure was put in the rear cockpit. As Don Adams, one of the still cameramen, clicked away with a single-lens reflex, I was en route in my own plane from Santa Monica to get some aerial photos. I told Paul I would take off first so we could get shots of the takeoff and closeups of Ben in the saddle.

What a smooth and, thankfully, uneventful operation it turned out to be. No mishaps. We all lived through it nicely. Marble received a standing ovation from a very sophisticated audience. There was only one glitch. None of us took into consideration the consequence of propwash over Ben's body. When the plane taxied onto the ramp, he had a smile a mile wide. Wedged between each tooth were tiny chunks of brown—the same stuff was on his eyebrows and eyelids. His face was covered, like chicken pox, with khaki-colored horse poop.

Chapter Six

Travels with Doolittle

Four 337 Sky Knight Cessnas, flying in formation, skimmed over the bush-covered llanos of central Venezuela. I was in the rear of one of the aircraft where four seats had been removed, leaving me to sit amid food supplies, ammunition, guns, fishing gear, tents, hammocks, a case of French wine, my camera gear, and whatever else our South American hosts could think of to jam into the interior of this six-place, private plane.

In the pilot seat was Enrique Lander. In the right-hand seat was Gen. Jimmy Doolittle. They were speaking to one another in Spanish and I didn't understand one word they said.

The general turned his head toward me and said: "We're almost there, Gibson, brace yourself." His blue eyes sparkled and he gave me the famous Doolittle grin—that grin that had preceded hundreds of adventures of the past. I thought back to that day on the USS *Hornet* as his B-25 bomber slowly gained speed on the wooden flight deck of the carrier, then suddenly jumped in the air like a jack-in-the-box. The last thing I saw of his plane was the tail, where two wooden broomsticks, painted black, looked like guns that would, we hoped, fool the Japanese enemy.

What kind of man would take off from a carrier deck in a bomber that was designed for long, land-based runways, to a destination that could not be reached, and fly over the enemy's homeland when they knew you were coming. If someone had told me on April 18, 1942, that some day in the future I would

become a close friend of this awe-inspiring man, I would have recommended a strong sedative and a Navy shrink.

The landing was rough, and how the landing gear survived the punishment of hitting scrubs, holes, and stopping 20 feet from a wall of trees was miraculous. The general turned to Enrique and said, "Good landing." He may have won every aviation award known but, evidently, I knew a lot more about good landings. We were met by Carlos, the camp chef, who greeted us with a silver serving tray that held crystal glasses filled with bubbling, chilled champagne.

The campsite looked like something from a Hollywood set. The trees formed an umbrella protecting the site from the blazing heat of the sun. There was a heavy smell of mosquito repellent recently applied over the area to keep the flying bloodsuckers from joining the festivities. A tributary of the Orinoco River was just a few feet from the camp, and it was at this moment I saw something that took the fun out of the junket. On the opposite bank of the river were about 20 caiman, a close relative of the crocodile family, basking in the sun. "What the hell are they doing here?" I said. Kiki Roemer, a six-foot-four Venezuelan, who could have doubled for Tarzan, muttered in broken English, "They won't hurt you. Just don't bother them." "Where do they go after the sun goes down, and could you hang my hammock a few feet higher than the rest?" I replied.

I knew about crocs because I've photographed them in West Africa as well as the giant salt-water variety in the South Pacific. In one of my documentaries I had mentioned that more humans were killed every year by crocs than any other critter.

My mind was taken off these prehistoric neighbors by the constant moving of the tree limbs. Upon closer observation I saw birds—hundreds of them in every shape and color. I could have rented this outdoor aviary to the Audubon group and made millions. Some were singing, others were chatting as if at a morning coffee klatch. If one could have separated the sounds, they would have pleased the lovers of classical, big band era, rock, and, yes, even rap. I don't know if they were

welcoming us to camp or telling us to return to our concrete jungle. The scene was a moving rainbow that would have excited such artists as Dali and Picasso, although, on second thought, even they could not have done justice to it. It took only a few minutes to have my lens pointed at the visual feast. I was in cameraman's heaven.

Everyone was taking lawn chairs down to the river's edge. I was told to grab one and join in. I automatically reached for my camera and was instructed: no camera, this is fun time. Just grab a chair and come on. So I did. As shotguns were handed to each of us, Kiki said, "We go for dinner. In a few minutes it will be sundown and the dove will come flying right over us. So load your guns and take turns shooting. We will see how good you gringos are."

Just as he had predicted, four doves came from around the bend in the river straight for us. Kiki was in the first lawn chair. He stayed sitting, swung the gun in an arc, and fired. The first dove tumbled through the air and hit the water. "Great shot," I said as my mouth opened wider in disbelief. The instant the dove hit the water, piranha turned the placid water into a boil and the dove disappeared, feathers and all. The same thing happened to the next shooter.

Doolittle spoke up: "You gentlemen are not planning your shots properly. To get away from the predators in the water, you must wait a moment, then shoot, and your prey will land on the riverbank." It took a minute or two before the next flight of doves flew over. The general waited until they were overhead. Two shots rang out and two doves tumbled on the riverbank. Just waiting for his chance, a small caiman raced from the water, had himself a quick feast of the two birds, and returned to the water. I have heard men laugh before, but this time it brought tears to our eyes. No one laughed harder than Kiki who, I suspected, knew what would happen and set us all up. "Carlos," Kiki thundered, "substitute something else for dinner."

After a gourmet meal that would have rivaled a five-star restaurant, Enrique briefed us on our jaguar hunt. "We call the

jaguar *El Tigre*. Some of them weigh more than 400 pounds. He is the largest member of the cat family, stakes out his territory, and no one had better cross his boundaries. That's how we will get the one tonight. Kiki will call it in with the gourd." He held up a hollowed-out gourd about the size of a medium pumpkin. "He will growl into the gourd like a tiger, and the cat will come to see who's violated his territory. It was last seen after killing cattle about a mile from here. We will walk down the river and save ourselves about a quarter of a mile."

"Walk down the river?" I said, You're out of your gourd, and that's not a pun."

"Quiet, Gibson," said the general, "they know what they are doing."

Enrique continued, "The water will not be over two feet deep. You must wear tennis shoes and scrape your feet along the bottom. The reason for this is that the river is full of skates and a few electric eels. The Latin name, *Electrophorus Electricus*, is fitting because they are capable of creating a charge of 220 volts at one ampere, which could stun or even kill you. So, if something rubs against your leg, stop for a moment and it will go on its way. Above all, don't panic and kick. And, oh yes, there are anaconda on the river and bank. Leave well enough alone. Also, forget what you saw this afternoon with the dove and the caribe—that's what we call the piranha. They were so named after the Caribe Indians who were very good at killing Spanish conquistadors back in the early days. It might interest you to know there are more than a dozen different species of the caribe; however, they are cowards unless gathered together in a pack. Remember again, just respect what is out there and you'll be okay." It was moments like these when I knew I should have been a baby photographer in Podunk, Idaho.

The lecture over, we began our adventure. The general carried my tripod, Enrique my photo light and battery. I held the 16 mm Arriflex close to my body as we entered the water single-file. It was warm, but cold chills ran from my sneaker-covered feet to my Australian bush hat. My khaki shirt, with

epaulets, really made me look like Mr. World Adventurer. (Have you ever noticed that TV anchormen and sometimes women field correspondents wear khaki shirts or trench coats with epaulets when they are covering a war or a disaster scene? Well that's the reason for the epaulets—to change a chicken shit into a hero. Well, on me, the change never took place.) I thought of Jesus, how he walked on water and how wished I could too. And here I was in the worst position at the end of the seven-man line. We had only gone a few feet when I thought how, in movies, predators always attack the last one in line.

I eased my body between the general and Kiki. It was starting to get dark and we were being watched by caiman resting on the riverbank. Who knows what was lurking underwater, and I did my best not to think about that. The walk to get to dry terra firma felt like moving through cobwebs in a basement. It was totally dark when we reached the top of a hill where the tiger calling was to take place.

The group was instructed to get set in a semicircle, with Kiki and his gourd in the middle. I set up my camera about 15 feet in back of the group and triple-checked all its "living" parts, like the film speed, clean lens, dust-free pressure plate, focus, and finder. Then load and a quick check run. At this moment in a cameraman's life, he or she is completely engrossed in these tasks. The camera is not a mechanical object or a tool of the trade. It is a living, breathing partner that we talk to, scold, caress, worry about, and even love.

We were all advised to be quiet when Kiki started his serenade. He bent over the gourd. His mouth moved to the opening as he commenced with a low growl, then progressed to a stronger growl until the sound grew to fill the whole area. If there was another cat within miles, he would have to be king of the llanos to answer this dare. Hours passed, yet Kiki never let up. He must have had the lung capacity of a Himalayan guide.

I don't suppose you have ever been taken, but I will confess that, at this moment, I thought that perhaps this was a snipe

hunt, and when the sun came up in the morning, all would have a great laugh and pass the story on. My thoughts were interrupted by a low, short growl from a distance away.

"Quiet!" Kiki hissed, as he lifted the gourd again and growled. A few seconds passed. This time the answer was an unmistakable challenge. Kiki whispered in Spanish, then English: "We have a tiger."

The hair on the back of my head stood up. I turned my floodlight battery on and the small red light lit up. "Turn that off!" Kiki hissed in Spanish. The general repeated it in English. I turned it off, reached in my ditty bag for a roll of tape, and placed it over the on light. Once again I turned on the battery, and this time no one noticed.

All the hunters had flashlights. Only Kiki and the general had guns. We all waited what seemed like hours but in reality was only minutes. Kiki now made a noise like a low cough of a baby that ended in a really deep growl. The reply was now just yards away. I could literally hear it breathing. Kiki said, "Now." I turned on the camera and the floodlight and there he was—barely ten feet from us. He was poised to spring as both rifles fired. The noise was deafening. The cat dropped in his tracks. The whole thing only took a few seconds. Flashlights played back and forth across the animal's body. Kiki stepped forward and prodded the spotted skin with the muzzle of his rifle. I kept shooting the action and made a slow zoom, filling the frame with the head of this former king of the llanos.

The title of the documentary I was making was *Venezuelan Adventure*, and the client was VIASA Airlines, the official airline of the country. The night hunt would take up a maximum of four minutes' running time of the 26 total minutes of the film. I needed shots of jaguars, long shots, and close-ups moving toward the camera looking for prey. In other words, I needed a build-up or I would have to ask the general, the talent of the show, to do a soft shoe.

The general's body strength was amazing. His stamina and athletic ability were that of a 20-year-old and he was 79.

While in Venezuela we visited the Shrine of Christ on the

summit of Mt. Bolivar at an altitude of 12,400 feet. I was panting like a Siberian husky walking the Sahara. The general saw my plight, jumped in the air, landed on his outstretched hands, and began waking on them up the stone steps to the shrine. What was it this man could not do?

I made three trips to Venezuela with the general. Each one was a cocoon loaded inside with exploration, hair-raising adventures, and a million laughs. Our Venezuelan friends were men of a different breed. They were the ultimate sportsmen—whether it was hunting, fishing, scuba diving, or bush piloting, these risk-takers lived for the moment. And, when the sun took its last peek in your direction, they were sophisticated hosts who could put the protocol manager for the royal family to shame.

When I told them I needed close-ups of *El Tigre* to match shots of the hunt, they went into what I called the "Venezuelan powwow." Crowded into a tight circle, they all began to talk at once until satisfied that they had come up with the right approach to the situation. Then they broke ranks like recruits at mail call and the selected spokesperson delivered the message. "My brother-in-law has a ranch in the llanos. He captured a cub when its tiger mother was killed. We will fly to his ranch tomorrow, and you can get your filming done."

The male *El Tigre* was named Petunia and was caged under a jacaranda tree near the rear of the ranch house. He paced the cage, glaring at the strangers who were taking such an intense interest in him and his steel-fenced cage. "He is a very friendly cat," said Hector, the owner of the ranch.

It was time again for another Venezuelan powwow and, although I still couldn't understand what they said, I certainly could read their body language. One of them pointed at me and then the cat. Another lifted his shoulders and pointed at me, then at the glaring cat. Then another raised his hand as though he were firing a rifle. At last the spokesperson, José Pigna, approached me with the verdict, "Beel, set up your camera over here. We will let the cat out of the cage. I will be right in back of you with a high-powered rifle in case anything goes wrong."

Guns and ammunition were brought out from the ranch house and given to three of my protectors. José continued, "If the cat goes for you, we will shoot. Don't worry, the tiger is really a pussycat. Nothing will go bad."

I set the tripod low about 50 feet from the cage. The background showed none of the ranch buildings, so the scene looked like the wilds. My low angle would make the cat look very large. I was ready and nodded to my hosts. Petunia stood at the open cage door. I set the tripod fluid head so I could pan his movements smoothly.

In an instant he jumped through the door of the cage and stretched. "José," I whispered.

"I'm right here Beel," he whispered back. The bolt action right over my head told me that José had put a 30-60 shell into the business part of the rifle.

"I don't think that's necessary," I said, "at least I hope not."

Petunia spotted us and began moving toward the camera. I quickly zoomed in and focused. The scene was fantastic and exactly as I had hoped. I was photographing a stalking cat in full frame, looking straight into the camera. I was now zoomed all the way back to wide angle. Any closer and he would be out of focus. Then I did the one thing that a cameraman should never do in a situation like this: I opened my left eye. The real world was now open to my brain—not the fairyland world of the viewfinder. Not five feet in front of me was the killer of the llanos. Three-hundred-fifty pounds of mean cat. I whispered, "José?" There was no answer. "José!" I repeated. Still no answer. I was becoming very uncomfortable (read:) panicky. Louder now, I said, "José!"

His voice came from above. He had climbed a tree. "I'm right here, Beel."

"Don't shoot," I said, thinking that maybe I was in his line of fire." And then I heard the beautiful sound just as I ran out of film. It was Petunia purring. Slowly, very slowly, I reached my hand out and scratched the side of his head. The purr sounded like a freight train as a tongue, rough as sandpaper licked my wrist.

A few months later, Petunia had to be put away. She had killed a cameraman who had been shooting a TV series. I only remember the purr.

After the raid on Japan, Jimmy begged Gen. Arnold to send him to the European theater. He was now a brigadier general, and generals didn't fly missions, but, that didn't deter Jimmy from going on bombing raids with his squadron. Eisenhower, Supreme Commander of the Allied forces, gave Doolittle a direct order to cease flying combat missions, but he flew them anyway. Jimmy would never ask another man to do something he wouldn't do.

James Harold Doolittle was born in California in 1896. At age three, little Jimmy traveled to Nome, Alaska, with his mother to join up with his father who, like so many men of that era, was seeking his fortune in gold. When Jimmy started school he had long, blond curls and was the smallest kid in the class. The other boys taunted him, so school became his training ground as a fighter.

In his teens, the family moved back to California where Jimmy won more than 20 official fights as a lightweight, weighing in at 135 pounds soaking wet. He entered Los Angeles Junior College to study mining engineering and found that he also excelled at gymnastics. In 1916 he entered the University of California at Berkeley determined to continue boxing. The university had no category for a 135-pound fighter on its boxing team so he fought as a middleweight. Doolittle became the university's middleweight champion, no mean feat for a pint-sized but very determined young man.

With all his accomplishments—and there were so many—the attribute that impressed me more than any other was his down-to-earth attitude with everyone he met. When we pulled into a hotel with baggage and camera gear, he would be the first out of the vehicle to help the bellboy unload. He always took the time to talk to maids and waiters, never considering

himself to be at a higher or lower station in life than any of his fellow men.

One incident I remember vividly illustrates the commonness of this very uncommon man. It occurred at the tenth-anniversary ceremony of the Air Force Ballistic Missile Division, to which I had been invited. In the parking lot a camera crew was unloading its van. I asked if I could help and picked up a large tripod, video camera, and battery case and started toward the stage set up outside the building. A major general when I knew from Cape Kennedy was standing in the middle of the walkway talking to a senatorial group from Washington. "Good morning, Bob," I said. He looked up in disbelief that I had so demeaned myself as to carry camera equipment. He knew me as a corporate director for Douglas Aircraft. At this moment I heard a yell. It was Jimmy Doolittle making his way through the crowd. "Gibson, let me help you with that stuff," he said as he grabbed the battery pack. "Good to see you old buddy," I replied. Together we made our way through a stunned group of so-called VIPs. Jimmy wouldn't have noticed the disdain or, if he did, it couldn't have mattered less—but I never forgot it.

He was the sort of man who left his mark on everyone he met and most of us would always remember his considerable impact on us. He also had the kind of charisma that few people have—that magnetic quality that made heads turn when he walked into a room, banquet hall, or onto a flight deck.

In the last on-camera interview I had with him, I asked if he had ever known fear. He chuckled, his blue eyes flashing their electric charge as he said, "Fear?" No, not as you might know it. In all of the emergencies I've been in, I was always too busy to feel fear. But, if I were flying at 10,000 feet, both wings fell off my aircraft, I couldn't open the canopy and had no chute, I believe I might feel that emotion.

When he died in 1993, there was a small article on page two of our local paper. It mentioned, briefly, his raid on Tokyo and the barnstorming in his younger years. It captured less space than the baseball scores.

Lowell Thomas wrote a wonderful biography about Doolittle, and the general himself wrote, *I Could Never Be So Lucky Again*. Both books are worth a read and are a reminder that our heroes are hard to come by, never more so than today.

Chapter Seven

On The Shoulders of Giants

My love affair with spacecraft began in the late 1940s when I was attached to the U.S. Air Force. It was one of those New Mexico mornings when the tumbleweeds rested against fence posts. The dust had vanished after an early morning shower swept down from the gypsum hills of the White Sands Monument to disappear in the crevasses of the Organ Mountains, their pipe organ-like pinnacles casting a shadow, like long fingered hands, on the White Sands Missile Test Range 3,000 feet below.

The countdown to a missile (that's what we called them before some bureaucrat demanded they be termed "space vehicles") named *Aerobee* was at the five-minute stage. Inside the nose cone atop the rocket was a canister that housed two mice. Attached to the canister was a World War II modified gun camera trained on the two rodents who would, after launch, experience weightlessness, something the scientists needed to see. The location was Holloman Air Force Base, New Mexico. These were the early days of our space program, and they called for good old American ingenuity. This was a duct tape and wire operation. There was no money to pay the contractors. The warehouses for parts were empty. There wasn't even a billet for a safety officer, which was just fine with the photographers because we could get as close to the missile as we dared.

On another *Aerobee* launch, Capt. Dan McGovern, our photo officer, requested a helicopter to cover it. "Gibson," he ordered,

"I want a shot looking straight down on the launcher. I want to see that bird coming right at the camera." The pilot was newly assigned; in fact, it was his first duty station.

We pulled the side door off the 'copter to give me a full view of the launcher and blockhouse. Once in the air I yelled to the pilot, "Get closer!" I pointed to the tower housing the 30-foot firecracker loaded with fuming nitric acid and aniline for fuel. We were damn near over the top of the tower as I started the camera. "Back some," I shouted, but it was a tad too late; the pilot was not ready. The time was T minus one second. The rocket rose so quickly the pilot was unprepared for the flame and power coming from the business end of the projectile.

The helicopter jerked to an almost upside-down position as the rotor blades screamed for more power and we headed for terra firma. Traveling the last couple of hundred feet seemed like an eternity. I was on the floor of the craft with my feet out on the skid. "Should I jump before we hit? I might have a chance with only a broken, torn up body," I thought furiously. The whole scene appeared to take place in slow motion as I tried without luck to climb back into the 'copter. I'll never know how close we were to the ground when the pilot miraculously righted our wild mosquito hawk and made a rough but safe landing 50 yards from the blockhouse.

Capt. McGovern came running over, ducking his head below the still turning rotor blades. "Did you get it?" he yelled over the sound of the engine. "I got it!" I yelled back. He patted my shoulder grinning like a Cheshire cat. The pilot now had his say: "Fuck you stupid photo people!"

The film turned out to be fantastic and was used on the opening of the Walter Cronkite program, *20th Century*. I'm sure Walter and the millions of viewers would never know the true story of that three seconds of film.

White Sands Proving Grounds was the Army's testing ground and shared the desert range with Holloman's Air Force Base. The Department of Defense, for whom I was now working, sent me to New Mexico to cover the launch of the V-2, the German weapon that had terrorized England during

Attack on the USS *Hornet* at the Battle of Santa Cruz,
October 1942

U.S. task force heading to the Battle of Midway, June 1942

Jimmy Doolittle pinning Japanese medal on bomb; photograph courtesy of Hal Kempe, U.S. Navy

Author photographing Antarctic penguins, November 1957

Author running around the South Pole, November 1957

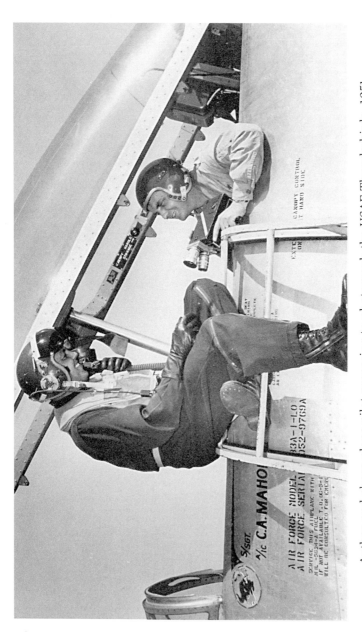

Author and chase plane pilot preparing to photograph the USAF Thunderbirds, 1951

B-25 photo chase plane, 1970

Author and fellow photographer Joe Longo in the tail
photo platform of a B-25

Shrine in Cotonou, West Africa, 1967

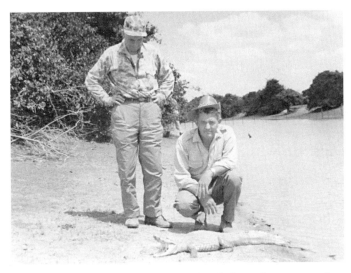

Author and General Doolittle with a baby caiman near the
Orinoco River in Venezuela, 1967

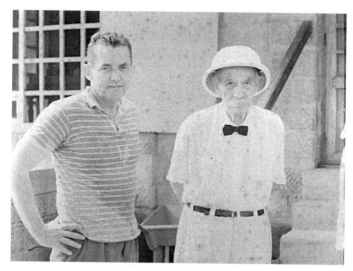

Author with Dr. Albert Schweitzer in Gabon, West Africa, 1963

Ben Marble atop his saddle on L-17, 1966

Author and General Doolittle on a soundstage, 1967

Atomic bomb explosion at Bikini Atoll, 1946

Armchair traveler on Curtis Pusher, 1968

Author photographing Eleanor Roosevelt, 1951

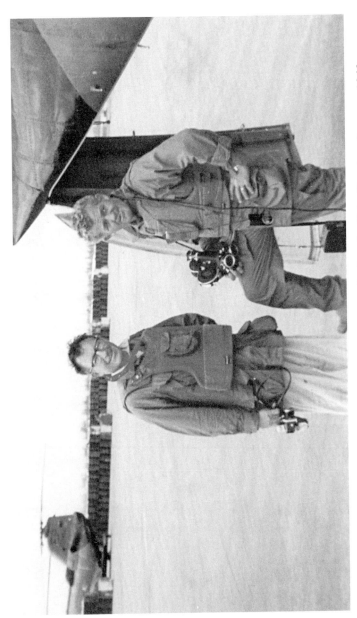

Author and Ben Marble in Da Nang, Vietnam, during the Tet offensive, January 1968

Charles Lindbergh in blockhouse on pad 17 for the launch of *Pioneer I*, August 1978

The grave of Dr. Albert Schweitzer

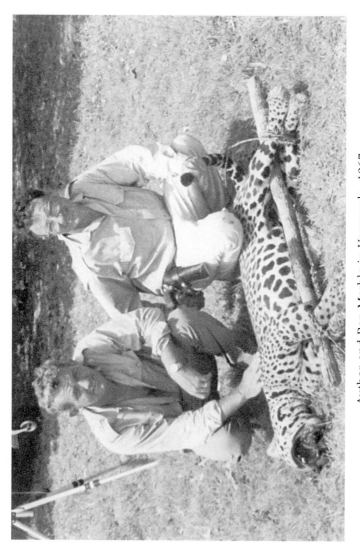

Author and Ben Marble in Venezuela, 1967

Author photographing Fermin Espinoza in Spain

The bull that got me!

World War II. A few of the V-2s had been captured by American forces at the close of the war in Europe and now were being put to use in our fledgling missile program. Also brought over, quietly, through the Mexican/U.S. border was the German "dream team" of engineers headed by Dr. Wernher von Braun, boy wonder and space dreamer.

This day at White Sands was my first meeting with von Braun. I entered the blockhouse and asked a white-smocked worker where I could find the safety officer. He looked at another man and asked in English with a thick, German accent, "Hans, who is da safety officer?"

Hans answered: "Ve haf no safety officer." As he spoke, a tall, handsome man walked over to me.

"May I help you?" he said, with a less pronounced German accent.

"Please," I replied, "I have a photo team from DOD and we're assigned to cover the launch and would like to know where we can set up our cameras." He did look more like a Hollywood leading man than a slide-rule warrior.

"In Germany," he said, "our cameramen would get just beyond the concrete pad." The guy was a charmer. "Anything you or your crew need, please do not hesitate to ask me," and, with a big, genuine smile, put out his hand to shake mine. "Good luck to us all," he said. Then he turned back to the consoles blinking their weird messages from the "bird"—the word used instead of "missile."

"So, where do we set up?" asked Sgt. Bates.

"On the edge of the concrete pad," I replied. "No way some Kraut photographer is going get closer to the bird than an American."

We set up our cameras on the edge of the pad. With every second of the countdown to launch, the V-2, loaded with LOX (liquid oxygen) and ethyl alcohol, seemed to grow taller than its 46-foot height. Sgt. Bates remarked, "What are we trying to prove, Gibson? Why not use longer focal length lenses and get back where we won't get our asses singed?" I didn't reply.

At the command, "Fire!" the giant firecracker just sat there

not moving. Over the loudspeaker came another thick, German accent: "Ve vill resume count in 30 minutes." The blockhouse door opened and a short, heavyset technician in a white smock ran pell-mell toward the liquid oxygen-belching bird carrying a small ladder.

I racked my camera from shooting position to looking straight through the lens. This gave me a close-up of this crazy German who was now taking off a hatch at the base of the V-2. He pulled himself up into the working parts of the wing-less bomb. About two minutes later his feet emerged, searching for a toehold on the ladder. In seconds he had the hatch back on, picked up the ladder, and ran back to the blockhouse.

"Ve vill resume count at T minus five minutes," were the new instructions.

Twenty years later, as a new member of the Directors' Guild, I was directing von Braun on Sound Stage 5 at Twentieth Century Fox Studios in the feature documentary, *Footprints on the Moon.* I asked him about that moment at White Sands. He laughed.

"That was Hans, one of our technicians at Peenemünde. He was replacing the igniter of the V-2, which was a spark plug from the Model T Ford."

The throat of the engine spit a bright, orange flame across the pad toward our cameras. The sound pierced the anvil in my ears as the invisible blacksmith shattered the working parts of my hearing system. Obviously our German counterparts packed their ears with cotton or used some other kind of pro-tector. We lacked foresight and paid dearly for it.

The V-2 lifted slowly, gaining speed with every foot of al-titude. In less than a minute our cameras were pointing straight up, when, in an instant, my viewfinder was filled with a blinding, white light, then a boiling red color with hundreds (perhaps thousands) of pieces of metal dancing in the fire.

The sound of the explosion sent the message to my brain that a guy named Galileo once said, in space, a feather falls at the same speed as a metal ball. We weren't in space and no feathers were falling, but chunks of body-ripping shrapnel were. Our still cameraman took off for the horizon.

Experience had taught me not to run, to keep shooting, and not to open my left eye. Everything in the viewfinder is fairyland. Make yourself *thin*. It worked. Pieces of the bird were scattered over the entire area, but our photo crew was unharmed. The film was classified "Secret" and would rest in a Washington vault.

If someone had told me that this team of rocket scientists would put a man on the moon, even give him a car to explore the lunar surface, well, I had a bridge to sell him.

The announcement sliced through the 95 percent humidified air of the palmetto-covered perimeter of Complex 17: "Searchlight operators, turn on your searchlights." Twelve surplus, World War II antiaircraft searchlights flickered ghostly blue as their beams of light reached full charge from their trailed generators. Almost simultaneously they were focused on the four-story-high, intermediate-range ballistic missile.

Fueling operations were complete as the Pan American contract vehicle pulled away from the giant, white, wingless bird. For hours and hours, liquid oxygen had flowed into Thor's fuel tanks were only inches away from an adjoining tank that held jet fuel called RP-1. The two substances, once mated, result in an explosion rivaling the power of 50 napalm bombs.

It is true that while I've managed to do a lot of stupid things in my photo career, this one took first prize. After two disastrous failures with the Thor missile, I suggested placing two high-speed cameras a few feet away from the engine. The only place to mount them was ten feet below the ring on which the base of the missile rested.

The cameras were placed in two-inch-thick steel housings with the same kind of optical flat glass used in steel furnaces. The photo contractor, RCA, refused to put its cameras in such a dangerous position and they didn't want anyone outside their cameramen's union even touching a camera on the Cape. So I

rented the appropriate cameras from Grant Loucks at Allen Gordon Enterprises in Hollywood, telling no one, of course. Grant was an innovator and camera specialist. He knew cameras, from the coated lens to the power source, and had a lot to do with the improved photo coverage of missile launches.

The blockhouse's loudspeaker came alive: "We are resuming the count at T minus 30 minutes, all personnel clear the area." At that moment I was in the dark under this massive bomb trying to load two cameras. "Gibson, get your ass out of there!" The command came from Captain Brandy Griffith. I placed the housings over the cameras, cleaned the optical glass, and climbed up out of the pit. A car was waiting, engine running, at the blockhouse to take us out of the danger area.

The countdown was in "terminal" count: those last ten seconds when hundreds of men and women take a deep breath, cross their fingers, and pray. This is their child. They've all poured hundreds of hours into this white monster of the cosmos. The engineers, technicians, and contractors are all responsible for a part, a section, a function, and a result. They were reminded day after day that the Soviet Union was ahead of us in the mad race for space. America's teams, according to the critics, were Laurel and Hardy amateurs who weekly lit up the sky with failure after failure. The use of the word "terminal" count was depressing, and I, for one, objected to it.

Test director Ted Gordon pushed the button. All eyes were riveted on the bird. There was no fire. It just sat on the pad and burped liquid oxygen out of its vent valve. Powerful Thor, the Norse God, sat there like a sour barn horse refusing to leave the corral.

I was called over the optics radio network to return to the pad immediately. The cameras would start at minus one second. We were out of film and I was the only person who could go under the bomb and reload. Because of a shower earlier in the day, the ignition wires had gotten wet, which caused the misfire. The Pan American detonator crew was rigging new ignition wires when Capt. Griffith and I arrived at the pad. Ice from the liquid oxygen covered most of the missile.

The ignition crew, Brandy, and I were the only ones allowed on the pad. The rest of the launch crew remained in the concrete blockhouse.

I had a flashlight and two unexposed 200-foot cans of film as I entered the gateway to hell. I had no business being here. "Never," I said to myself, "make yourself the only one who can do a task. Train someone, anyone you can send in your place. Be like a politician during a war."

The sounds from the Thor were frightening. Gurgling, bubbling gas escaping and ice continually dropping from the sides of the missile made the word "stressful" less than adequate. My hands were shaking so much I didn't think I could load the cameras. I thought back to how frightened I was when I went below decks on the sinking *Hornet*. It seemed impossible to ask God's help now, when I had yet to keep any of the promises I had made then. I don't remember loading the cameras or putting on the protective covers. A cameraman's ghost must have helped me. We made the fast getaway as, once again, the countdown was resumed. At T plus one second, explosive bolts released the tie-downs and the white projectile lifted slowly from the pad. Then there was total silence. The propulsion system failed and the Thor fell back to its launch ring, the tail disappeared into the pit, and an explosion that could be seen a hundred miles away gave the senior citizens playing shuffleboard and lovers on the beach at Fort Lauderdale a moment of daylight. My cameras were chopped liver.

Early the next morning I joined the salvage crew. The pad looked like the German city of Dresden at the end of World War II. One of the crew called my name. "Gibson, here's what's left of your camera," he said, as he held up a 200-foot reel of film from one of the ring cameras.

"Don't move!" I shouted, "Don't move!" He had in his hands the take-up reel with exposed film inside. I couldn't believe my luck. I grabbed the reel—covered in jet fuel—from his hand. I found a piece of duct tape and covered the reel, hoping against hope that there was only a small amount of fog on the edges of the last few feet of film.

I made the drive from the Cape to Patrick Air Force Base where the photo-processing lab was housed in record time. My problems now began, not with the film, but with the bureaucracy.

"No, we will not put that film in our machines. It's contaminated and undoubtedly already ruined. We're confiscating the film, as you had no permission to put cameras on the pad. The Air Force and RCA are responsible for all cameras and photo personnel. This will teach you a lesson."

"Go ahead," my mind told me. "Grab his necktie and lift the little bastard up and toss him like a discus across his desk." I have never in my life felt this kind of anger. Hatred replaced tolerance and sense.

A secretary interrupted and said I was wanted on the phone. More troubles. The caller was a Douglas Aircraft lawyer from the corporate office. "What the hell is this about you renting two very expensive cameras that have been destroyed? You had no permission to rent them, and you had no rental order number!" He went on and on like any lawyer in heat (they get that way when they have you in a corner). Before I hung up on him he said something about my paying the cost of the cameras—$12,000.

The bureaucrat was grinning from ear to ear. He was looking at an adversary whom he had battled with for the last few months and who was now in deep trouble. He was sure he had finally gotten rid of me. "If you destroy that film, I'll have your ass!" I yelled as I hurried out of the building.

Capt. Millard Griffith, U.S. Air Force, better known to his friends and enemies as "Brandy," was the Thor project officer. One well-known fact in the aerospace business was that Brandy had been a captain longer than anyone. His move up to major would always be *after* the next review. Brandy was a doer; he would skirt protocol, regulations, and egos to get a job done—not the best way to gain a promotion. The fact that he had a doctorate in engineering didn't seem to help his upward mobility, either. Ultimately he made colonel but it was a long overdue advancement.

I found him assessing the damage from the night before. If anyone could get the film processed it would be he. Just a month before, I was told that the Thor might be launched at night. If this were the plan, there would be no photographic coverage. I told Brandy I needed light, and somewhere in the big world of government supply, there must be searchlights.

"How many do you need?" he asked.

"Eighteen with portable generators," I replied.

He turned his back to me and moved to one of the launch consoles, picked up a phone, and started talking. Then he wrote down a new number and dialed it. This went on for two hours. He finally hung up the phone and looked me straight in the eye, "I've got your frigging lights and generators. Now I have to figure out a way to get them here from an Army base in the Washington state." He swiveled in the chair and got back on the phone. Every now and then he would get angry and he would drop the name of Gen. Schriever who was then the commander of the Air Force Ballistic Missile Division.

Like the Cheshire cat, Brandy hung up the phone, gave me his best devilish smile, and said: "I need a cigar. Mission accomplished, Gibson. Your cargo will be delivered Sunday morning on ten C-118s." If Brandy wanted a cigar, I'd have ripped one from Castro's mouth. Then I mentioned my problem with the photo lab. Once again he sprang into action, grabbed the base phone directory, and called the man holding the film. Invoking Gen. Schriever's name several times in between some very forceful language, he told the lab guy in no uncertain terms that he was to process the film now and that "Gibson was to be there watching." As he hung up the phone, Brandy gave me his famous "I got it done again" smile and then looked grim. "I hope for your sake there's something on that film. If not, don't you dare tell anyone I helped you. Now get out of my hair. I've got a launchpad to rebuild."

Four hours later I was alone in the PostOp Flight Briefing Room at the Cape. I switched off the overhead lights and turned on the projector. Fogged film flickered on the screen. "Please," I said under my breath. "Please." At that moment the

screen was filled with a scene as sharp as a winter's morning. The main engine bell emitted thousands of tiny sparks as the two vernier engines snapped into takeoff position. The bird lifted slowly, giving a great view of one of the vernier engines as it went totally out of whack. I screamed something (can't remember what), turned off the projector, rewound the film, and called Brandy. "Get your Air Force blue-covered ass over here and bring the troops. It's all here buddy, we did it."

After screening the footage for the umpteenth time, Ted Gordon, launch director, called Douglas in Santa Monica and Rockadyne Corporation in Canoga Park to describe precisely the malfunction. Jack Bromberg, vice president at Douglas, gave me a sure sign I was no longer in trouble: "Thanks, Gibson, you just saved us a lot of time and millions of dollars." I received a standing ovation from some of the most uncompromising critics known—missile engineers. Gen. Schriever, himself, called Don Douglas, Senior. I was told by Cape Field Station supervisor Bill Duval not to worry about the cost of the cameras. I felt good!

In the few years between my government service and serving as head of the film department at Douglas Aircraft, I was a director of photography in Hollywood. But now, in my new job at Douglas, I was hooked. No longer did I care about a call to shoot a TV sitcom on a stage in Hollywood or have bagels early in the morning on the set with Lucille Ball, Jack Webb, Lee Liberace, and a host of others in Tinseltown. Not that I didn't like them or my job, I certainly did. But it was time to move on. Forget about designing any more special effects on *CBS Climax* or *Playhouse 90* with John Frankenheimer.

I was with a different group now. These people didn't talk about awards or what a co-worker wore to dinner. This new bunch talked about leaving Earth, visiting other planets, making miracle medicines, manufacturing new metals in zero gravity, and unraveling the secrets of the universe. The people in my

viewfinder at Cape Canaveral were cut from the same cloth as da Vinci, Verne, Edison, Goddard, and the other dreamers of the past who would have spent their life savings to spend launch day in a blockhouse.

Before the missile men and women moved south to Florida, the highest point on Cape Canaveral was a lighthouse that had warned seafarers for years of a reef that jutted out into the Atlantic. The inhabitants then were lizards, pelicans, armadillos, a few birds of prey, and alligators of all sizes lurking in the swamps a few yards from the Cape's north beach.

In late 1947 the action began with the Army building its tower to house the Jupiter missile, a beefed-up version of the V-2, named after the Greek god. The Air Force built two towers to launch its intermediate range ballistic missiles, named Thor, after the Norse god of thunder and lightning. The Navy was also present with its missile, Vanguard.

The stopper was pulled on the flow of money in Washington, D.C., and the contractors and their subcontractors began seven-day-a-week work schedules. Yankee ingenuity would show those Soviets just who would rule the high ground. Also present from all points of the compass were the media, waiting with paper, pencils, and cameras with very long lenses just outside the south gate for the launches of these new top secret weapons.

I was now with Douglas Aircraft and, along with two of my cameramen, Bob Forster and Dewey Smith, filmed every detail of construction, missile transport from California to Florida, assembly, and attempted launch of our Thor missile.

One of the most interesting aspects of this "race for space" was the secrecy factor. Not only were the Soviets, obviously, denied the results of the launches, but so were the American public, the press, and the various armed services. It was not strange to see the Thor team hiding in the palmettos watching, with binoculars, the Army team getting ready for a launch of a Jupiter, as just outside the South Gate, the media waited for the tower to be pulled back. Armed with telephoto lenses, they would focus on the blood red tower that housed a chalk-white

leading actor. In the flat lands of Canaveral, it was easy to spy. And the competition between services and contractors was the order of the day. Of course, what you see is not always what you get.

Cape cameras and the press tracked the bird until the sky filled their viewfinders with a spectacular explosion, which, unfortunately, occurred more often than not. Another race was on after each explosion as the members of the Fourth Estate jumped into their vehicles and sped to the pay phones on Highway A1A, causing a few accidents along the way. One member of the press was arrested for pulling a competitor from a pay phone and knocking him out. Cape personnel anxiously waited for the morning edition of the Orlando paper so they could count the number of mistakes in the previous night's story.

At last, the world press was invited to observe the launch of Vanguard, which held the first U.S. satellite in its nose cone. We would show the world that there was nothing to hide. We were an open society. Come one, come all. Watch America's first satellite soar into space. We would show the Russkies how proficient we were in this launch business.

The Vanguard lifted off the pad about nine inches then settled back down in dramatic fashion. The flames could be seen from Cocoa Beach, over ten miles away. The world was laughing at anything made in America, from cars to hula hoops, especially our efforts to launch missiles successfully.

The finger of blame pointed everywhere. The contractors blamed the bureaucracy of the armed services, the armed services blamed the politicians for not starting or properly funding the programs years before, the politicians blamed the educational system for not teaching enough science courses. Senators and congressmen each blamed the group on the other side of the aisle. The media loved every minute of it. Meanwhile, the Soviets' success rate with Sputnik circling Earth made our space team look like kids playing in a sandbox.

Now it was time to go to the Man with hat in hand. "How long," the power brokers asked, "how long would it take you, Dr. von Braun, to get one of our satellites up there?"

Von Braun's answer startled the assembled brass: "We can put one in orbit in 30 days."

No one believed him. "We'll give you 60," they answered.

True to his word, von Braun and his team modified the Jupiter rocket and placed America's first satellite in orbit around Earth. Looking for a bigger story, one member of the press asked von Braun if we had put anything live, like a monkey or mouse, in the payload. Von Braun laughed and said, "Not unless a Florida cockroach sneaked in while we were not looking." From that day on, America's space team managed an evolving program that would ultimately outdo the competition.

Many critics of von Braun were convinced he was a devout Nazi, but a fair review of his writings and behavior while in Germany during World War II says otherwise. He was a visionary, extraordinary engineer, musician and, I thought when I got to know him, a remarkably humble human being.

Once inside and part of the space program, I met some very fine people—a few who became friends for life. One was Miles Ross, deputy director of Cape Kennedy. Mike, as we called him, and his wife Pat, graciously entertained scores of guests from all over the world at their own expense. I've heard it said more than once that to have a title at the Cape or Johnson Space Center was to become broke. Uncle Sam saw no reason to reimburse his employees for wining and dining important NASA visitors. After the disastrous fire that took the lives of astronauts Gus Grissom, Roger Chaffee, and Ed White, Mike resigned his job at TRW to take the deputy director's job. He took a substantial reduction in salary and was forced to sell his TRW stock so there would be no connection between a government employee and a major aerospace manufacturer.

One of Mike's favorite and most embarrassing stories took place on a hot, humid night in Florida after a very long day preparing for that night's launch. Thinking he had time for a quick snack, Mike bought an Eskimo Pie from a vending machine and unwrapped it. He was about to take a bite when he was interrupted by the arrival of a limousine. He knew it contained a VIP, he quickly put the hand holding the Eskimo Pie

behind his back. The limo door opened, and out stepped Lyndon Johnson. Mike moved forward to welcome the vice president and shake hands when he realized the now melting chocolate ice cream bar was in his right hand, oozing out between his fingers onto a perfectly tailored white jacket and light-colored slacks. For a well-brought-up Ph.D. from MIT, it was an embarrassing situation, made even worse in launch control by fellow engineers who just couldn't overlook the obvious.

In June 1962 Launch Operations Center moved from Marshall Space Flight Center in Huntsville, Alabama, to the Atlantic Missile Range at Cape Canaveral, North Merritt Island, Florida. In November 1963, five days after the death of President Kennedy, by Executive Order of then President Lyndon Johnson, Station No. 1 of the Atlantic Missile Range was to be known hereafter as the John F. Kennedy Space Center or, as we called it, KSC.

Cocoa Beach, the nearest little city to KSC, was called "Sin City" by many of the clergy and a number of wives who were left at home while their husbands were assigned to the Cape. One evening I was at the bar at the Starlite Hotel when two nice-looking women sat down alongside me. "Where are you from?" I asked.

"Virginia," they replied.

"And you're here to watch a bird go up?" I asked, keeping the conversation going.

They giggled; then one leaned over, whispering, "We hope to get laid by one of the astronauts. Do you know any of them?"

That was an easy question to answer but I pretended ignorance. The astronauts were national heroes, and it seemed that everyone wanted a little piece of them. If some of them had a zipper problem, they could solve it without my assistance.

At every launch there were post-flight parties that ranged from invitation-only events given by the prime contractor to hundreds of BYOB celebrations. It was a freewheeling, fast-paced life filled with hard work, tough decisions, long nights, and fun whenever possible.

The Surf Restaurant on Route A1A on Cocoa Beach had an unusual gimmick. If you were in the bar during a launch, your drinks were free. There were very few takers. What you would see is 20 or more paying customers standing outside, cocktails in hand, as they watched the flame of a missile on its way downrange.

Mike Ross and his boss, KSC director, Kurt Debus, gave me a single-source contract to make an all-important safety film on Apollo launch procedures. I had four weeks to complete it. Little mistakes were occurring with more frequency, and a feeling of complacency seemed to taking over the veteran launch team. One of the so-called mistakes involved a bolt that had been inserted backward in the release arm of the launcher. Not discovered, it was signed off on by one inspection team after the other until, quite by accident, an engineer felt the arm move when he applied pressure. It was fixed immediately. Had it not been detected this mistake would have caused the vehicle to blow up, killing three astronauts and causing extensive damage to the launch pad.

We recreated five accidents to show how the domino theory, like a missile, has a reaction for every action. Titled, *Anatomy of an Accident*, the film won the National Safety Film of the Year award but, much more important, I would like to think, it saved lives, money, and time. Every person on the *Apollo* project was made to sign in and view the film. I now had camera access to areas on the Cape that were the envy of cameramen everywhere.

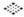

For a brief moment the people of the Earth held their collective breath. The emerging picture was in black and white and began to display a shadow that took on the shape of a spider or beetle. The voice that followed was about as exciting as a librarian checking out a book, but what the voice said was dramatic: "Tranquillity Base here. The Eagle has landed."

In my viewfinder was a line of reporters all speaking dif-

ferent languages. Inside the press center at NASA Center just outside Houston, Texas (the Johnson Space Center), the sound of dozens of typewriters mingled with the mumbling of languages from around the world. My soundman and I, connected by an umbilical cable, moved down the aisle while the 35 mm Arriflex camera captured the pundit's dream assignment: earthlings on our moon. Tears spilled down the cheeks of a reporter from France. Another was waving his arms like a centipede signaling for his mate. I caught glimpses of the television monitors with the lunar excursion module (LEM) resting on the Sea of Tranquillity as every person in the center waited for the hatch to open to witness the first man from Earth emerge.

I felt cheated that I wasn't able to sit in my Lazyboy with a vodka martini savoring this exquisite moment. For the past six months, I had been a consultant to NASA on the design and coverage of the video camera that now had the world in a rash of goosebumps. The camera was working—so far—in an environment with a daily variation of temperatures from plus 266 degrees Fahrenheit to minus 280 degrees. No small feat. Not that I could take full credit, but at this moment I felt that it was my camera alone up there some 230,000 miles away from Earth.

Over the years I have interviewed, with my camera, more than 30 of our astronauts and two Soviet cosmonauts. I have also produced, written, and directed many space documentaries, including *A Ride to Remember* for Tokyo Broadcasting Company, which was about America's first female in space, Sally Ride. These pioneers of the cosmos are a unique breed, and I feel blessed for having the opportunity to associate with them.

Jack Lousma and his wife, Gracia, are two of our very special friends. Jack was the pilot on Skylab 2 and commander of Shuttle III. We invited Jack to join us on a fishing and hunting trip in Venezuela, and he enjoys telling the story about swimming across the Orinoco River while pushing a makeshift

log raft. On the raft were tents, hammocks, food supplies, cases of soft drinks, hunting and fishing gear, three hunting dogs, and my camera equipment. Since there was no room left for us, we had to hold on and kick with our feet to propel this overloaded *Kon Tiki* to the other side of the river.

When God made the Amazon and Orinoco rivers He placed all of the meanest animals, reptiles, and fish, who couldn't get along with other living creatures, on the banks and in the waters of these majestic waterways.

When we were about halfway across, Jack asked if the crocodiles sunning themselves on the bank or the piranhas lurking in the water would attempt to bite a marine major with a valid U.S. passport. I didn't answer. He then asked, "Do you now how much it cost to put me through astronaut training? If NASA headquarters knew what I was doing today, I would be shining the shoes of all the project managers until my retirement!" I think we were both relieved to reach the other side of the river.

Whenever I'm in Florida, I make it a point to spend a day or two around Cocoa Beach and Cape Canaveral. New housing complexes and shopping malls have sprung up in the area. The guards at the South Gate have shifted from being part-time fishermen and orange pickers to part-time day traders on the stock market. Gone is Blackie Blackburn's Bar where fresh oysters were shucked by Blackie himself. No longer is the Mouse Trap known on both coasts as the ultimate body exchange.

The space pioneers of the past, who have long since retired, never miss the opportunity to witness a launch, no matter what time of day or night it occurs. Ask any of them what his or her most memorable moment in our short space history was and most will answer: when Neil Armstrong announced "Tranquillity Base here. The Eagle has landed." The voice then goes up an octave and the person says with pride: I helped put men on the moon.

Chapter Eight

Napalm, Elephants, and Grey Flannel Suits

The Marine crew chief tapped my jet helmet, winked, and gave a crooked grin, the kind that says, "You'll be okay." The Phantom canopy came down and locked into position. With an ear-splitting roar, the supersonic jet moved toward runway 25 at the Marine air base at Da Nang, South Vietnam.

I had flown backseat in dozens of jets over the years, but this flight was different. I was pushing 50, and the pilot looked like my son. In addition, the Tet offensive had started two days earlier. My timing stunk. The nose gear came in contact with the white line of the runway. The throttle made contact with the firewall as my back tried to extend the length of the plane.

How did I, a civilian, an executive with a major aerospace manufacturer, a man who could go anywhere in the world and make films that were fun, find himself locked in a pressurized shell with a teenage chauffeur looking for a fight? Aruba to Zanzibar was my beat. The world was my oyster. Holy hell, what was I doing in another war?

A slow dissolve back to the Marine commandant's office in Washington, D.C. The Corps had a problem, he said. "Our hands are tied, and we can't take what I think is appropriate action. That's why I wanted to talk to you, Ben." Ben Marble, my boss at Douglas Aircraft, vice president of advertising, customer relations, publications, and my illustrious leader of the film and television department. Ben was concentrating on the commandant like a bird dog jumping out of a pickup

toward the scent of a pheasant. "There is serious talk in Congress that they want to take our aviation branch from us. This would be disastrous in future amphibious landings, not to mention the fact that no one is better with air support to the troops on the ground than the Marine Corps. We need someone to take our position and capabilities to the appropriate committees in Congress. Ben, I'd like you to make a film showing what we are doing in 'Nam. It needs to be made by someone with no axe to grind."

I looked into the steel-gray eyes of the Marine commandant, the leader of the most egotistical warriors on the planet. The kind of guys who raised their hands to volunteer instead of waiting intelligently to see which way the wind was blowing. This green-suited pit bull was asking Ben (which also meant me) to go to the battlefield and make a film. It wasn't kosher. The Marine Corps had some of the best combat cameramen in the profession, and the entire business sounded illegal, especially when he said, "We'll bring you and your equipment by DC3 from Bangkok. No one will know. We expect you to furnish your own airfare to Thailand. You must use all of your own equipment. You will be issued press credentials. We'll support you in every way possible but, from this day on, we know nothing about your activities. Oh, yes, I'd like to see the film before it's shown to Congress." Ben's hand shot forward and gripped the hand of the grim reaper with campaign bars from his shoulder to his belly button.

The phone rang in the living room of our hotel suite at the Intercontinental Hotel in Bangkok. Ben listened, then shoved his fist into the air. "They'll pick us up in 30 minutes." He looked up at me, smiled, and said, "They're furnishing a truck for the equipment. Cheer up, Bill, you'll love it and you know it." Dewey Smith and Dick Schwartz, cameramen from our Santa Monica, California, film group solemnly started moving equipment onto the baggage clothes racks. Both of these men were not only good movie cameramen, but also were not afraid to put themselves in harm's way to get the shot. I finished my vodka martini on the rocks and looked Ben straight in the eye:

"There had better be good-looking females there or your ass is in deep doo doo."

The airport at Da Nang looked like any other military field in the world, but I was surprised to see buildings lit up like Christmas trees. As we taxied down the taxiway, we saw fighter plane after fighter plane—many being worked on with portable lights, making the area look like a movie set. "What the hell kind of war is this? Here we are on the front lines with an enemy within earshot and painting a bull's-eye on our facilities," I muttered to myself. I thought back to World War II and Korea, when light at night signaled a death wish. What kind of war did the four of us volunteer for? Perhaps we were Marines at heart. It took only two hours to find out.

As soon as the door opened, we saw a public affairs officer and four enlisted men who, like true Marines, immediately unloaded our gear into a 6 × 6 and were off into the night. We jammed ourselves into a staff car, and the colonel took off like Andretti at Indy. "Welcome to Da Nang, gentlemen. Only the C.O. and myself know your mission. You name it, you have it. We have a Quonset hut just for you to rattle around in. Your equipment is there already, and your beds will be made."

Dick Schwartz checked the camera equipment, and it was all accounted for. I had lived in one of these armadillo-shaped houses for nine months on Guadalcanal, yet I didn't feel at home in it. Ben and I took lower bunks—rank has its privileges. Right after we fell asleep, this political war changed into a holy war, and our side had a shortage of chaplains. Machine gun fire shook the hut. A voice blasted through a speaker on the wall: "Stand by to repel attack! Stand by to repel attack!" Larger-caliber guns joined in the medley. Dick and Dewey sat up in bed. "What should we do Bill?" they asked. Ben was snoring.

"Wake up the boss, boys, he's got the war he wanted. Then get under one of the tables!" I shouted.

The firing stopped after a few minutes. Ben was still asleep. "We don't have guns to protect ourselves," I said, "and we would be idiots to go out and look for shelter. If a Marine doesn't know you, he shoots you, so I suggest we stay put."

The hands on our watches went into slow motion mode. An eternity later, the sun cast its rays through the small screened windows. All of us uttered a sigh of relief except Ben, who jumped out of bed and bellowed with a grin: "Come on guys, we have a war to shoot!" We didn't tell him until after breakfast about the attack. We really got pissed when he asked if we'd gotten pictures.

The kitchen help and waiters were all Vietnamese. I whispered to the colonel, "Are these pajama commandos on our team?"

He answered rather loudly, "You never know until one of them throws a grenade in your room or poisons you at dinner. We call it pajama roulette. Gentlemen, this is what is called a war of negotiation run by the U.S. State Department. They haven't won a skirmish, less a battle. They call all the shots. We have a hundred five-star generals dressed in grey flannel who are responsible for most of the body bags." His voice went up an octave or two. We were having breakfast with Clarence Darrow dressed in camouflage. No one at the other tables paid any attention. He continued: "Wait till you see and hear the pimps of Washington and the Fourth Estate control this fiasco of black mattress covers with young patriots inside."

"Then what the hell are we doing here?" I asked.

He placed his hand on mine and said gently, "Gibson, it's the only war we have."

The plan was to rendezvous with a Douglas A4 Fighter at 25,000 feet for a live run at some remote Marine squad, under fire, and give them support from the air.

The A4 pulled up on the left side of our plane. I hurriedly taped my black cloth to the canopy on the right side, cutting out most of the reflection. Inside a jet fighter is like the sparkle from one of Liz Taylor's diamonds, creating flares so deadly to film. I peered through the viewfinder of my 16 mm Arriflex. I pushed the start lever. The Arri is a prismatic camera, so you're looking directly through the lens, eliminating guesswork— what you see is what you get.

The A4's wingtip was only a few feet from ours. The sky was

a crisp, dark blue. I zoomed slowly into the nose cone. Early this morning, Dewey Smith and Dick Schwartz replaced the nose cone with the one that we had made at Douglas prior to the trip. Mounted on the bottom of the cone was a bracket holding two high-speed cameras—one looking aft, right down the throat of the missile launcher, the other pointing forward to show the rocket's trip to the target. The scene and the anxiety of the moment supplied me with a latent image adrenaline rush. No longer did I fear getting hurt or ending up in a bag. I was the luckiest person on the planet. "Eat your heart out, you nine to fivers," I whispered to myself. "Tie-wearing sales-people, sell your stock and insurance premiums; get on the phones, you bureaucrats, and tell the caller he has the wrong department. Take that crowded elevator to the tenth floor and spend the day in a box the size of the crates that delivered these jet engines I'm straddling." I was on such a high I didn't hear the pilot give the coordinates to a location where a Marine squad was under heavy mortar fire from the 'Cong. When I finally did become aware, the voices in my earphones were as calm as a voice-over narrator selling a new prescription drug on a 30-second spot. The plan was simple—we would run on the target just off the wing of the A4. I would get a side angle view that could be edited with the onboard cameras.

I pressed my intercom button. "Do I have time to reload?" A short pause was followed with: "Make it quick." Over my head went the black cloth and in 15 seconds I had removed the exposed film, put it in a hundred-foot can, reloaded, made a quick test, and was ready for action. No surgeon had better hands than I did at this moment. When I was chief instructor at the Navy Motion Picture School, I ordered my students to sleep one night with their cameras in bed with them. "Know your camera better than your body and protect her with your life. Treat her gently. Keep her warm when it's 30 below zero, keep her cool when the thermometer hits a hundred. Un-derstand her and how she works and she will take care of you and your film," I intoned.

Through the headphones came a voice—a young voice, the

kind that sounded too young to participate in activities like these. "We have just fired a Willie Pete. It's right over the enemy. It's all yours. Good luck." "Willie Pete" stands for white, phosphorus flare that explodes in the air and hangs there like a white octopus, growing by the second. Hit whatever is under that puss, and you have just silenced the enemy.

I pushed my feet into the floor of the plane, twisted my body to the right, straining every fiber against the harness, and started the camera at the same moment both aircrafts' noses went in search of the target.

There is no way to describe the feeling of being a part of two beautifully man-crafted meteorites hurling themselves at a precise spot on Earth. As you look through a viewfinder, you only see a small part of what's going on, and you're being cheated of a large part of the 360-degree scene. Yet you record it for others to experience. The dive seemed to go on forever.

A tree-covered mountain came into view. One, two, three rockets took off from the belly of the A4 in fractions of a second. Immediately our planes separated, pulling up and heading to the heavens. I knew what I was about to feel for this was not the first time I'd experienced it. Coming in waves, first color turns to black, then white, then gray, then black and white and back to color. In the meantime your innards are being pushed to the nearest exit. I knew the last part of the scene would be shaky. If both cone cameras worked, and Dewey and Dick recorded all of the live sound of the mission along with my coverage, then we could shoot a ground action to match, and that would tell the story of Marine air ground support.

Ben was waiting at the revetment when we taxied in. One Nikon camera hung from his neck, the other was recording the phantom jet parking and being swarmed over by the ground crew. I was inwardly elated over the coverage. My mind, like the film, held only a latent image until a combination of chemicals, baths, drying, and printing completed my work.

I thought about all my friends in the Hollywood motion picture laboratories who would process my film. They were a strange bunch. When the sun peeked over the Sierra Nevada

Mountains they went to work, turned off all the lights, and let their hands and fingertips take over. They could walk through a maze of machinery, reach out, and touch the right button. It's the big frustration of cameramen who wait to view the moving images on a large screen, hoping to enjoy kudos from the engineering team—or dreading the silence when everyone leaves the projection room. Oh, the plight of the moviemaker.

When a surgeon completes an operation, he's pretty sure of the results. The bricklayer finishes a walkway, and it's there for everyone to see. As the baker puts the finishing touches to a wedding cake he experiences instant gratification. The movie cameraman must wait, however, and have the faith of a saffron-robed monk.

After a long shower and testing my singing voice within the acoustical walls of the Quonset hut, we headed to the Press Club for drinks and dinner. The Press Club at Da Nang was located just outside the Marine base. It was formerly a restaurant owned by a Frenchman. A Marine press officer was briefing a group of about 20 members of the press.

He was short for a Marine, but his face was all Corps. He could have won first prize at the Westminster Dog show at Madison Square Garden, placing first in the pit bull category. "We can take four of you by chopper to Chu Lai, leaving at 0700 hours. The enemy has penetrated the perimeter; however, we expect to have them cleared back by daybreak. Raise your hand if you want to go."

Faces tilted upward, not daring to make eye contact with the speaker. Silence. The highest raised hand in the room was a reporter reaching in his shirt pocket for a cigarette.

The colonel took a deep breath. "We lost a C-130 at Hue yesterday by mortar fire. We can furnish transportation for six leaving at 0600. Report in at the terminal no later than 0530." Once again the deafening silence. No hands reached for the ceiling. "Thank you, ladies and gentlemen. Bus transportation leaving on the hour for the base will commence at 0900 hours."

At that moment the scream of a dying animal filled the air. The group moved toward the wall. A rumble was followed by

a sharp crack. It was the start of a 'Nam marathon, Da Nang version, as 20 members of the Fourth Estate headed for the three phones in the open room above. The phones were connected to the press quarters in Saigon, which was where they filed their reports. The scene was right out of *The Front Page* as Pat O'Brien scooped his competitors. "The rocket hit on the air base starting a large fire," a reporter yelled into the phone. The same story was relayed over the other two phones. Overhearing was not a problem, given volume of the voices.

The colonel who had just given the briefing said, "Some Charlie is monitoring those phones, so he'll know what corrections to make."

Why don't you let the American people know what's going on out here?" Ben asked.

"The State Department and the media control this war and there is absolutely nothing we can do about it. How many people read *The Marine Corps Weekly Paper*?"

Ben and I went on a dozen helicopter missions during our three-week tour of duty with the Marines. One of the most interesting, even challenging, was the rescue of an elephant before the 'Cong got its hands on the huge mammal.

During the Tet offensive, the Marine Corps helped evacuate dozens of villages, not only the populace, but the dogs, chickens, goats, pigs, and any household items their inhabitants thought too valuable to leave behind. This was the Marine Corps at its finest. I saw very young men walking with families, helping them move their village to a safer area. One blonde Marine had a baby in one arm and a piglet in the other. If this assignment had been given to the Navy, Army, or Marines of World War II or Korea, their griping would have been heard throughout the halls of Congress. But this group of leathernecks looked like part of the village family as they entered the main gates of the base. Evidently the story wasn't big enough for the world press who were waiting for the briefing that would give them the day's body bag count.

"Gibson, have I got a story for you! We're evacuating an elephant from a village north of here and we're flying her down

by one of our banana boats. We've manufactured a makeshift sling, an Army vet will tranquilize her, and we'll furnish you with a chopper so you can get air-to-air shots. It's a Marine Corps first," stated the colonel.

The Army veterinarian who flew in from Saigon seemed very nervous about this mission. I understood when I found out that his specialty was small animals.

The elephant was standing over the sling with its owner, who was obviously distressed watching the equally uncomfortable veterinarian insert the needle. I moved my camera back quickly so as not to be flattened by the beast when it fell.

I now had a long shot of the elephant swaying like a drunken sailor on his first liberty. It sank slowly to the ground directly onto the sling. So far so good.

In minutes the helicopter hooked on to the ring and hovered over the sleeping passenger. I set up at the open door of the photo chopper and gave the crew chief the "up" sign, which he relayed to the pilot. We were about 50 feet in the air when I gave the signal to start the lift. The scene in my viewfinder was as bizarre as any I've ever photographed. There was the chopper with **U.S. MARINES** painted on its side, a jungle in the background, and a working member of the village, sound asleep, slowly flying to a new home with its owner and friends.

We photographed that 'copter and its passenger from every angle. While changing film with the black cloth over my head, I received a sharp blow to my shoulder. It was the crew chief pointing at the other chopper. It took just one second to note that the elephant had awakened and was flailing its legs. The irregular movements were causing great concern in the cockpit as the pilot tried to control the flight despite the antics of his frightened passenger. I could see the 'copter swaying now in reaction to the weight and motion of its huge cargo.

"I'm going to have to drop her," said a voice in my earphones. The helicopter was clearly out of control and filled my frame. The life umbilical separated and the chopper suddenly lifted as 9,000 pounds dropped, heading for a hillside suicide landing.

Later that afternoon at the public affairs office I was asked
to destroy the film. The office had not had all the necessary
permissions and it would make the Corps look bad if the film
got into the wrong hands. I unwound 200 feet of exposed film
into a bin. It felt like losing a close friend.

The Cold War in the 1950s and '60s created some strange bed-
fellows between the Soviet Union and the Western powers. If
you were an American businessman and traveled to out-of-the-
way locations, such as Indonesia, Africa, Vietnam, Thailand,
and so on, you were prime pickings for recruitment by the CIA.
Both Ben Marble and I were made a part of this gumshoe op-
eration, as were hundreds of other amateur James Bonds with
American passports.

After returning to the states, a CIA debriefing would be
arranged, usually in your office. On one occasion, while I was
in the Soviet Union, I spotted a massive helicopter at a military
base about ten miles out of Moscow. I was in a car furnished
by the Soviet Academy of Science, driven by a man I was sure
was KGB. I was stunned by the size of this huge transport
'copter I saw it for only about a minute in passing, but its size
and shape were etched in my mind. A few weeks later I de-
scribed the configuration of the 'copter to two CIA agents. The
following day another agent quizzed me on this mystery
weapon of the then "evil empire." The all-seeing, all-knowing
agent stated, in no uncertain terms, "You must have imagined
the length, height and double rotor blades."

"Damn it," I retorted, "I've been around planes, airships,
and helicopters most of my life and this one dwarfed anything
we have produced." He gave me that "grin"—the one that a
postal clerk gives you when he or she puts the "Next Window"
sign in your face and closes the window.

A year later, at the Paris Air show, the Soviet Union unveiled
the largest helicopter ever built. After the show was over and I

was back in my office, another agent visited with me. I had to bite my tongue to keep from telling him, "I told you so!"

One of my most peculiar encounters with the CIA was in Chiang Mai, where I was making a film on elephants. The film was titled, appropriately, *The Vanishing Titan* for heavy equipment working the forests was replacing this domesticated giant.

At the airport was a hangar with a sign that read "Air America, Charters and Sightseeing." On the ramp, painted in camouflage green, was a high-wing observation plane perfect for aerial photography.

I entered the door that said "Office." Inside was a dusty room with a desk, a large map on the wall, and a tall, thin man shoving clothing into a World War II B4 bag. "The place is closed," he mumbled, "you'll have to leave now."

"Pardon me," I replied, "I'd like to charter your aircraft for a film we're making for the Thai government."

He looked up from his packing, "We don't charter planes. Get out. This is private property." Now I knew the operation was a CIA front for American operations in the area, but if they were going to tout themselves as an airline, they ought to be discreet and make it look like an airline.

Obviously, this called for action, and if I couldn't get the guy's attention, my trusty camera would. It only took a few minutes to set the camera on a tripod and start taking pictures of the sign. My tall, skinny host walked out the door. "What the hell are you doing?" he yelled. I had no film in my camera, but I took on the appearance of a craftsman plying his trade. I swung the camera around, pointing it straight at my adversary. I looked up from the viewfinder.

"I think I can sell this little story about undercover activities by Americans in a foreign country using our hard-earned tax dollars, don't you think?" I challenged.

"When do you want to fly?" he grumbled.

The next day, after the flight, I asked him how much I owed. "Nothing," he said.

While making this film, we hired a local who was an expert in jungle survival. He was an American who had been brought up in Chiang Mai and whose father owned a private zoo just outside the city. I later found out he was contracting to the CIA for undercover activities in Laos and China. He carried a sawed-off shotgun and, to make us really feel good, said it was mainly to kill any cobras we might encounter.

We had arranged for a herd of working elephants, which included four babies and eight workers. The scene was spectacular as 12 elephants paraded past a waterfall with a rain forest in the background. A "God shot" appeared suddenly in the form of a circular rainbow that appeared magically at the base of the falls. The scene was interrupted by the sound of a large vehicle. "What the hell is that?" I asked our jungle expert.

"It's only the weekly load of shit from Burma to Chiang Mai," he replied.

Sometimes I'm naïve. I asked who would be carrying fertilizer over a jungle road, and what the market was for shit. "It's opium," he said. "It will be distributed to three processing plants from Chaing Mai. I understand 90 percent will end up in the United States."

"You're CIA, why don't you stop them," I said as I pointed to the truck while looking at him in disbelief.

"First of all, I'm not CIA. I get paid for doing various tasks for our government. Everything out here is a deal with big payoffs. We wouldn't be able to operate here without a deal. The Thai general who commands this section of the country lets it happen. We close our eyes to this and many other things. In the Orient it's called back scratching. You scratch mine and I'll scratch yours." You can make your own conclusions. I certainly made mine.

The CIA gets a bum rap from the press and general public. Most of the agents I've met have performed great service for our country and are dedicated Americans. Outside of the

agency's director, who's a political appointee, you'll never see an agent's name on a cross at Arlington Cemetery. More than likely he'll be buried in a shallow hole in Angola or Central America.

With all the trips I've made outside the United States, I've only asked for help from an American Embassy once. The city of Abidjan, on the west coast of equatorial Africa, was the site selected to premiere the film, *The Winds of Change*.

Twelve nations of West Africa formed a consortium to finance their own international airline, Air Afrique. They chose Douglas Aircraft to supply passenger planes and, of course, to make a destination film, as well. The film was to be shown in the ballroom of the Intercontinental Hotel. The invitation list included a who's who of West Africa, including the 12 presidents and their staff. Two days prior to the screening we held a "dress rehearsal," and, lo and behold, the projector shipped from Los Angeles was broken beyond repair. To find a 16 mm projector to be operated in a mammoth ballroom with a large screen in West Africa was like finding a replacement for the mission control room on one of our nuclear subs. The only alternative outside of canceling was to borrow a projector from the USIA (United States Information Agency), found in most U.S. embassies around the world.

The embassy was a short cab ride from the hotel. A small bronze sign on the gate informed me that embassy hours were from 2 P.M. till 6 P.M. I returned to the hotel and reached for the phone book to look up the embassy's number. There was, according to the phone book, no American embassy in Abidjan. The clerk at the front desk gave me the number. He explained that his sister worked there in the kitchen.

I dialed the number. A voice as American as the one that comes out of the clown at Burger King mumbled, "USIA."

I explained my dilemma. "Are you an American?" he asked.

"Of course," I replied.

"Well," he stated, "we don't lend equipment to Americans."

"But, let me explain," I said. I tried my best to use the "you're in deep trouble if you don't help me" routine, which obviously didn't bother him in the least.

"Go find a camera store," he said as he hung up.

That did it! Go to the top was what my military training had taught me. However, there's one thing wrong with this tactic at a U.S. embassy. The top people are rarely in the country or they are visiting another embassy for tea, cocktails, or whatever.

I finally talked to someone so far down on the organizational chart, he didn't deserve a box. "If the USIA says you cannot use their projector, then you cannot use it. We have very strict rules on procedures." I hung up on him while he was still scolding me.

I placed a long distance call to Samuelson's Camera in London. It took less than five minutes to be told that the proper projector would be on the next Air Afrique flight, due to arrive in Abidjan the following afternoon. That business concluded, I then took a cab to the Air Afrique Office in downtown Abidjan, went right to the director's office and asked the secretary for the American embassy's invitations to the premiere. I told her I would deliver them personally.

Back at the hotel I found two American couples and handed them four invitations. Later I came across three Peace Corps members and invited them, as well. I thought the American table in the hotel ballroom would be well represented by this group tomorrow night.

The next morning, the day of the premiere, I began receiving calls from the American embassy. I ignored them. The callers all said the same thing: "Where are our invitations?" I had considered the situation carefully. No projector, no tickey—and finally picked up the phone and told them so. I should say, at this point, that for every government employee who gives nothing but a hard time to the American taxpayer, there are ten who give their all and a little bit more. It's just that you never see them. They're busy working.

"What do you mean I can't go to Siberia?" I asked. My question must have seemed amusing to the State Department employee at the other end of the phone line. For as long as I can remember, the threat of being sent to Siberia was the very worst punishment a person could suffer. But, for me, traveling to Siberia was exciting. I had been invited by the Soviet Academy of Science to film a documentary on a total eclipse of the sun that would take place above the eastern slopes of the Ural Mountains.

The voice was authoritative and Beltway firm. "Soviet troops have invaded Czechoslovakia, and we have halted all American cultural exchanges."

"So, what if I go as a tourist and not a representative of the U.S.?" I inquired.

The voice continued, "We advise against that. We would not be able to protect you if you were on your own."

I didn't mention my feelings about the ability of our State Department to protect or rescue Americans overseas. It hasn't had the greatest success in that sphere of duty since Teddy Roosevelt was president. (Just a year earlier, Ben Marble and I were arrested by Chinese soldiers as we entered Brazzaville, Congo. We were locked in a motel with armed guards at the door for two very long days. An executive with Air Afrique got us out with no assistance from the U.S. State Department.)

Prior to our departure to the "Evil Empire," a common way to refer to the Soviet Union in those days, I had a visit from the CIA. The tone of its representative was determined but friendly as he informed me of the dangers to people like me who possessed sensitive and top secret information on current projects.

"From the moment you apply for your Intourist visa, the KGB will have a make on you. Gibson, you're prime pickings for a room in a gulag. We also think it's rather odd they invited a photographer along with all of his equipment to an area where no American citizen has been before. We need to warn you

what could and probably will be attempted when you get to
Moscow. The first setup will be to sucker you into sell American
dollars on the black market. It will sound very lucrative and is
guaranteed to be a serious offense if you fall for it."

"No problem," I said, "black marketing only hurts the little
people in a country. What's next?"

"Setup number two has proven to be a very successful
scheme for blackmailing American businessmen. An extremely
attractive young woman will meet you at a social function or
at the hotel. A few drinks later you're in her room, which has
been bugged by the KGB. When you return to the states you'll
receive a package of photos and a videotape of yourself in
some very compromising positions."

I interrupted, "Excuse me." I picked up the phone and dialed
my wife. As soon as she answered I said, "This is very im-
portant. If you receive photos of me with a good-looking
female performing unmentionable acts with me order me two
8 × 10 copies of all the stills and another copy of the
videotape." I hung up, looked my visitors straight in the eye,
and stated, "I can't imagine anyone selling his country out for
a piece of tail. Sirs, you don't have to worry about this
filmmaker. I'll contact you upon my return."

After landing, I was whisked through Soviet customs like a
senator's chief of staff. My 25 cases of camera gear were not
opened and, with just a quick glance at my passport, I was
allowed to pass through into the terminal.

She was something out of a James Bond movie; blonde and
blue-eyed with a body that belonged in a sarong on the island
of Bora Bora. "Mr. Gibson, I am Valentina. I will be your guide
while you are in Moscow." We shook hands, and all I could
think of was how efficient Soviet intelligence was. For a week
before my flight to Siberia I was wined and dined in royal style,
attended the Moscow Opera, had a special tour of the uni-
versity, and it seemed as though they couldn't do enough to
make my stay unforgettable.

Breakfast at the Moscow Hotel was always interesting and
had a touch I had not seen in any other country. On all of the

tables a flag had been placed identifying the country of its oc-
cupants. I, of course, had an American flag and it made me feel
good. Perhaps it was to alert the servers and others to my
presence, but for whatever reason, I liked it. The third day
every table had its flag but not mine. I immediately summoned
my regular waiter over and told him I wanted my Stars and
Stripes for I enjoyed being a representative of the greatest
country on Earth. He shook his head and nodded to the table
next to me. I couldn't identify the flag of the country. Again I
asked for my "Old Glory," and once again he shook his head.
Then it dawned on me as I looked carefully at the faces, they
were from North Vietnam. Evidently my hosts wanted no con-
frontation between two enemies. I suppose it was a prudent
move on their part, but it ticked me off. I took the slight for a
few minutes before beginning to hum, "It's a grand old flag, it's
a high-flying flag." It was a patriotic challenge that needed a
reply, although my North Vietnamese neighbors probably
thought the gentleman at the next table was a little weird.

Solar scientists from seven nations took over a Pioneer
Camp just a mile from the location that was the spot on Earth
to observe a longer totality of the eclipse.

The Soviet Pioneers were like our Boy Scouts, and the
biggest problem for all of us was the size of the beds we slept
on—they were for small boys, not men, so we ended up
walking around during the day with slightly hunched backs.

The weather was perfect, and God was accurate to the mil-
lisecond putting on his solar extravaganza. Overlooked in the
planning, however, were, when the sun was halfway blotted
out, the cows that started home on their pathway, right through
the elaborate equipment and a bunch of cursing scientists.

Chapter Nine

No Place to Hide

Newsreel or documentary cameramen get some great assignments and some lousy ones. This one was at the bottom of the honey wagon. (In the Japanese internment camps, a wagon was brought daily to collect the POW's excrement. It was used by the Japanese as fertilizer. The American and British POWs referred to it as "The Honey Wagon.")

World War II was over, finished, buried, kaput, but it had moved us from the age of industrialization to the atomic age. The atom bomb was not just another weapon, it was the most lethal force yet devised by man. Prior to July 1946 three of these explosive devices had been detonated: one in the New Mexico desert and two more above the Japanese cities of Hiroshima and Nagasaki.

The first bomb was exploded under laboratory conditions and hastily assembled instrumentation. It was observed by scientists and military personnel only, and its success reported back to President Truman who then had to make the truly awful decision: end the Pacific theater of war with these horrendous weapons, or continue fighting until the Japanese surrendered. To this day Truman is either vilified or cast as hero.

The bombings of Nagasaki and Hiroshima were under combat conditions, so little data had been gathered. There were many questions left to be answered; one, in particular, was the effect this weapon would have on a fleet of naval vessels.

The Joint Chiefs of Staff, with presidential approval, created Joint Task Force 1.1 on January 10, 1946. It was made up of 200

ships, 150 aircraft, 42,000 men, including a cameraman named Gibson. The operation was called "Crossroads," and the two atomic tests, dubbed "Able" and "Baker."

I thought the designation, Crossroads, was well named; would the world use this energy as a deterrent or as a destructive force?

My tower was built by the Seabees, the Navy's construction battalion, on the tiny island of Enyu a mere 50 yards from Bikini Atoll, to which it was connected by a narrow strip of coral reef that I could walk over only at low tide. The tower rose to 125 feet and housed seven cameras; two 16 mm color cameras, two 35 mm high-speed cameras, one normal-speed 35 mm camera, and two still aerial cameras. There were other camera locations, but they weren't under my control nor were they near mine.

All cameras were to start by radio control a few seconds before the bombs were detonated, then after the film had been exposed, a two-inch lead door would close to protect the film from contamination. Every morning, before the actual tests, a boat picked me up from the aircraft carrier USS *Saidor*, take me to Enyu, drop me off, and retrieve me late in the afternoon.

Each day I took a brown bag lunch that included two sandwiches, a cookie, and an apple or orange, hardly four-star fare. On most days I'd have the island to myself. Twice a day we would make a dry run on the cameras, other times radio checks and other testing procedures. The rest of the day I spent swimming and snorkeling.

Instead of climbing up and down the tower five times a day, I asked the Seabees to install a cable from the top of the tower to a palm tree some 300 feet distant. They furnished a small block and tackle to hook to the cable with a short rope to hold onto and voila! I had a ride that was equivalent to an "E" ticket at Disneyland. Two mattresses were wrapped around the tree trunk to cushion my impact in the event I didn't let go of the rope in time.

To be on an island all by yourself can result in poor housekeeping habits, and my tower house looked like a mini New

York City during a garbage strike. I had just finished snorkeling in the lagoon in my usual attire. After all, I was a Florida boy and skinny-dipping was part of my upbringing. I had returned to my tower for the two o'clock radio check when I noticed a boat pull up to the small pier about a half mile away. I turned one of the cameras in that direction and peered through the telephoto lens only to see something I didn't want so see. My commanding officer, Capt. McElroy, and Adm. Quackenbush, the head of all Navy photography, were climbing in a jeep that was kept at the dock.

Oh no, I thought, what if they want to see the tower? It's a mess and my clothes are on the beach. I swiftly put lens caps and protective covers on the cameras, then shoved waxed papers, a half-eaten sandwich, and two apple cores into a brown bag. I took another look. They were halfway here. I unhooked my block and tackle, grabbed the rope with one hand, garbage with the other, and took off. Their jeep was running parallel to my position so, unfortunately, the captain and the admiral were getting a good view of one naked bronzed body looking like a high-wire artist with Barnum & Bailey's Circus.

"What the hell are you doing, Gibson?" shouted Capt. McElroy, clearly enjoying my extreme discomfort. McElroy was grinning, Adm. Quackenbush was not. In a soft voice, the admiral mentioned something about ". . . disgusting, get some clothes on." Luckily I wasn't put on report.

Thanks to Capt. McElroy, I was assigned to photograph the last ship being towed out of the lagoon after completion of the underwater test.

A boat was lowered from the cruiser USS *Fall River* to take me to the island and drop me off on the beach. I was the last human being on the atoll, when just a few weeks earlier there had been 42,000 men. The ship's communications department had sent a message to Kwajalein Island for a seaplane to pick me up later that morning. The radio directive was confirmed as

having been received. The boat returned to the cruiser, which already had its anchor up and was ready to take off after retrieving its motor whaler.

I could have called the shots in by phone, which is an old saying that the photography was so easy an amateur could have accomplished it. The last target ship being towed out of the lagoon became a flyspeck in my finder. I took a few shots of the empty beach, put my camera and tripod back in their cases, and walked to the water's edge. I looked to the south and waited for the seaplane's arrival.

The sky was bare except for the everyday buildup of cumulus clouds that looked like thousands of down pillows swallowing one another, all the while weaving their towers of deadly thunderheads. I had been dropped off at 0800 hours; it was now after 1100 hours. I was getting a little concerned—no, pissed off fit the situation much better.

I had left Bikini after the tests, only to be sent back from Pearl Harbor to take this one shot. And now the Navy was dragging its feet about picking me up. Since the underwater tests it seemed as if every shark in the Pacific had homed in on this tiny atoll. As I gazed at the lagoon's surface I could see dorsal fins cutting through the water. It was definitely not "everyone in the pool" time. And it was hot, not from the sun but from radiation. I had been told, in no uncertain terms, not to eat any seafood, including shellfish or coconuts, or to drink any water. I didn't even have a K ration, and I was getting hungry.

I looked to my left to the connecting Isle of Enyu. I could see my 125-foot photo tower looking out of place amid the swaying palms.

I remembered vividly the sight of the initial flash. It was indescribable and limited to a millionth of a second. The energy expanded and enshrouded itself in a cloud that emitted all of the colors of the spectrum. Then it died, mushrooming grotesquely to high altitudes as if to have a better look at the havoc it had produced. My post during the "Able" test was on the USS *Saidor*, positioned seven miles from the center of the

blast. On "Baker," the underwater test, I was about four miles from the center.

When the tests were concluded, my job was to photograph the target ships in the surrounding area. I was then stationed aboard the USS *Haven*. Every day a s…all boat ferried two Army radiation monitors and me to our destination ships. We would pull up alongside, one of the monitors would step aboard, check the radiation levels, and tell me how long I could safely remain to get my shots. When I returned to the *Haven* a group of men at the top of the gangway went over my body with a Geiger counter.

The last time I went out, the submarine USS *Skate* was on the schedule that day. I was allowed only 20 seconds to get my job done. Needing to sit to get the shots, I sat down on a coil of line at the bow. When I returned to the *Haven* I was scanned with the Geiger counter, and this time the clicking went wild when it was passed over my butt. I was whisked off to the showers, where I was scrubbed from head to foot with stiff brushes to remove any alpha or beta residue. Not a pleasant experience I can assure you. The doctor specified that I was through—no more exposure, no more photography on or near irradiated ships. But nonetheless I was sent back to Bikini.

Like many others in the operation, I took the radiation business with a grain of salt. We couldn't feel anything (with the exception of a skin-searing scrub down) and were never briefed on any harmful effects of our new technology.

At the moment, due to the length of time I had been on Bikini, I was more ill at ease about the radiation exposure I might be getting. The word was that the target ships would be uninhabitable for the next 99 years. How long, if ever, would it be before Bikini and Enyu could welcome back the bronze bodies and laughter of its natives?

A fly landed on my face. I slapped at it, missed, and wondered if it carried the invisible poison just as mosquitoes carried malaria. In just a few hours I was becoming paranoid. The flies were getting bothersome and once again I blamed the Navy for not providing repellent, food, or water.

It was now three in the afternoon and I felt I had been here a lifetime. Then I had the frightening thought that I had been forgotten, just as the sinking USS *Indianapolis* had in World War II when frantic "May Day" messages brought no response and hundreds of men perished from exposure, shark attacks, and drowning in the deep waters of the Pacific. If the order to pick me up had been misplaced or, God forbid, forgotten, it would be years before anyone came this way again. How to survive was the next question.

A large raindrop landing on my head interrupted my thoughts. I looked for shelter. About 50 yards down the beach was a small, wooden structure that had been built to dispense beer and cold drinks to bathers. I made it there just before the downpour hit. I put my camera case in a dry spot in the corner of the hut. I was taught: Always take care of your camera first, then think about yourself. Well, I was thinking about myself and I had enough raw stock (unexposed film) for a 15-minute unedited film. It would be a classic. A cameraman covering his own lingering death.

A loud clap of thunder shook the shack, and once again I cursed the Navy and Capt. McElroy for sending me back to this truly Godforsaken place. The afternoon rainstorm began to move on to the next atoll. In another hour it would be darker than the darkroom in which infrared film was developed. I've never been a quitter, but this time I really thought I was doomed.

The Navy did give me one thing, however. It was a nametag imprinted with: Gibson, William J 268 87 19. If I was going down, I'd bury the tag. Let the bastards spend a fortune in tax-payers' money trying to determine whose body they had found.

I was sitting with head on my knees, thinking that I couldn't even build a raft because I had no saw or knife, when I heard another rumbling sound that was pure music to my ears. It was the two powerful Wright engines of a PBM (Patrol Bomber Martin seaplane) skimming the treetops. It made a 180-degree turn and landed parallel to the beach.

Camera and gear held high, I waded to the open hatch and

climbed in. The pilot apologized for the delay. The message had been misplaced, he reported, but "we should make it back to Kwajalein in time for you to get a flight back to the states."

I took one last look at Bikini on takeoff. A chill played on my spine. No more nuclear tests for this boy, I promised myself.

When I returned to the Pentagon, I had a difficult time finding out where I was to report. My orders said to report to the office of Task Group 1.1. But there was no longer a 1.1. It had been disbanded, and I was the last person out of 42,000 to take part in "Operation Crossroads."

I finally found the unit I was to report to. The small sign on the door read: "Operation Deep Freeze" and there, at a desk, was my illustrious leader, Capt. McElroy. This was the man who had been my pilot on a Navy liberator bomber in the South Pacific. This was an Annapolis graduate who broke almost every rule in the Navy and got away with it. Here was a cameraman with four gold stripes who was born in Cuba, Alabama, and had an accent so thick you couldn't have cut it with a Marine bayonet.

Our eyes met. McElroy's voice filled the room: "Lt. Shirley, just look who's here. It's our lost boy. Welcome home, son, I'll bet you're pissed off at me. Are you still pissed off at me, son?"

Three years ago we were flying a photo-mapping mission over the Japanese-occupied island of Palau. All hell was breaking loose as puffs of flack filled the sky. Zero and Zeke fighter planes above us were dropping phosphorus canisters that could have turned our plane into an instant fireball. Nine of our ten 50-caliber machine guns were blazing away at fighters who seemed to elude the steel we were aiming at them. A tracer, an armor-piercing, and an incendiary—that was the continuity of shells spitting out of our black, anodized Jap killers. And where are the cameraman and his assistant? They're operating ten aerial-mapping cameras in the open bomb bay while attached to oxygen hoses. They are 20,000 feet up with nothing but open space between them and terra firma below, except for a 20-inch catwalk. Acrophobiacs need not apply.

My job was to tell the pilot when to correct his flight path left or right according to what I saw in my precision viewfinder. When cameramen go to hell, this is their primary billet. Just as soon as water appears in the viewfinder, you're almost home free. You've just passed the island, and the pilot is now free to make evasive maneuvers, hide in a cloud, and haul ass to the nearest American-held base. The cameramen, however, must now leave the bomb bay with their walk-around oxygen bottles, go aft, and man the starboard waist 50-caliber gun.

When only the sound of the Pratt and Whitney engines can be heard, the pilot wants a report on the photographic coverage. Capt. McElroy called over the intercom: "How did we do, Gibson?"

"All cameras worked, sir, we have a map of Palau."

"Good boy," he laughed, "did you get any shrapnel up your ass?"

I knew the other crew members were laughing it up over the captain's reference to my flak suit, which was normally a vest constructed of small pieces of metal sewed in pockets. It was worn to protect airmen from shrapnel to the area around the heart, stomach, and back. I had read in an Air Corps report that 90 percent of all injuries to airmen were to their rumps and private parts. After reading this I asked one of the ordinance men to make me a flak diaper to protect my real vital parts. As a gambler I go with the odds. I guess I did look silly walking around the plane looking like a woman in her ninth month of pregnancy. Excuse the pun, but I took a lot of flak for inventing my gonad protector.

"Gibson, I have someone I want you to meet," McElroy said, as I followed him into another office. "Is the Admiral available?" he asked a 1st class yeoman.

"Yes, sir, go right in," he replied.

"Admiral, I want you to meet the best little cameraman in the Navy. Gibson, this is Admiral Byrd."

"Welcome aboard, Gibson," the admiral said, as he turned his attention to McElroy. I was surprised and elated, for here was one of the people I had daydreamed about back at the

Plaza Theater in St. Petersburg, Florida. Adm. Richard Evelyn Byrd, the man who spent five months alone, close to the South Pole. His book on that experience? You guessed it: *Alone.*

Considering the exceptional luck in meeting Adm. Byrd, even Capt. McElroy became acceptable for the moment. Before leaving his office, the admiral said he'd like me to accompany him on his next expedition.

"Okay, Gibson, where would you like to be stationed?" My nemesis was asking me where I wanted to go? Perhaps he wasn't such a bad guy after all.

"I'd like to go to Pensacola, sir, perhaps to be an instructor at movie school, I replied.

McElroy laughed, "So you want to go south, son? Lt. Shirley, listen to this, Gibson wants to go south. You're going south, son, you're going to the South Pole." He collapsed into hilarious laughter. If I'd had a gun, there would have been a dead four-striper on the Pentagon floor.

Chapter Ten

Making the News

New York City's garment district was closed down for the day. A blue wrecking truck hitched up the last car for its trip to the City of New York's prison for impounded vehicles. Two of the city's finest were watching the scaffolding being erected for the newsreel coverage of the Communist Day Parade on May 1, 1949.

I don't know why I was three hours early with my camera and six rolls of film, but this was my first time covering a New York City parade. It was billed as a "gathering of Commies."

At this time in my career, I was a master sergeant in the U.S. Air Force assigned to World Wide Newsreel, an organization that covered news throughout the world for various government agencies. One week I might be sent to Morocco to cover a State Department event. The next I was on the front lines with an Army company in Korea, showing what the boys were doing at Christmas.

The civilian newsreel companies hated our collective asses, even though we were only six cameramen in total. They, of course, in typical American thinking, thought that we (because we were part of their government) were hiding things, not letting them cover these special events. However, when we were covering the same assignment, they made it very difficult for us by giving us bad information on the time of the event or imparting misleading instructions on how to get to the location.

I personally had little trouble with my civilian counterparts,

for after a few jobs together I learned to play their games. For example, bumping a camera at the critical moment or having a pair of elbows like the wings of a gooney bird. It didn't take long for my colleagues to learn to stay out of my controlled palsy range.

This day I was working with Warner-Pathé Newsreel. My exposed film would be turned over to the company so they would accept me for at least the next few hours. One of the old-timers called me aside and said, "Gibson, would you like some great coverage on this parade?"

"Yes," I replied eagerly, "what do I need to do?"

"See that group of kids over there?" On the other side of the street there were about ten teenage boys who had evidently skipped school and were cruising the street looking for some kind of excitement. I doubt if they knew what a Communist was.

"There's a little Mom and Pop grocery store on the next block," the old-timer said, as he reached into his pocket and took out a $10 bill. "Buy some overripe tomatoes and a couple dozen eggs, give them to the kids, plus the change, and when you see me raise my hand, give the kids a signal to pelt the carriers of the "Free Willie Jones" sign. Don't have them do anything until I raise my hand. This way you'll get close-ups of the kids throwing the eggs and tomatoes from street level. You should get some award-winning shots, and I'll get the long shots of the start of the riot from up on the scaffolding. Our shots will fit one another like two peas in a pod." He grinned at me. His tobacco chewing revealed a mouth that looked like the opening of the Carlsbad Caverns just before the bats made their nightly exit.

I purchased the ammunition and had a "how-to" powwow with the kids, telling them they would be on the big screen all over the world. A Hollywood contract could be in the offing. The parade was just a block away, and the curbside audience bent forward with eyes left to see the Bolsheviks of the Big Apple strut their stuff. It never dawned on me that my newsreel heroes of the past ever altered the news. They would never,

never tamper with an honest scene to make an event more colorful or less honest, or to take a dull news day and trick the viewing public by setting up fake interviews or adding props that were not in the original (read: true) story. I looked up at the cameramen on the scaffolding. They had their heads pushed against their viewfinders, photographing the bands and the mass of marchers behind them.

"Go up on the scaffolding," I thought to myself, "tell that wrinkled old son of a bitch to wash his own dirty skivvies. I won't be a part of setting up a fake scene." But, I didn't have the guts.

Three bamboo poles held up the huge banner. The pole holders were all big men who all looked like stevedores or union bouncers. I got down on my knees on the curb to frame the scene. In my viewfinder, looking at an upward angle, were five grim youths, jaws jutting out and fire in their eyes.

I glanced across the street. My director had his arm raised. "Get ready," I told the kids. Down came his arm and I started my camera. I yelled: "Now!"

On cue, their missiles of tomatoes and eggs flew at the marchers. I made a swishpan to the banner carriers. All three had direct hits. In a split second, they had thrown down the banner and started running straight toward my camera. Quickly, I backed up to get the entire scene at the moment of contact with the kids.

A body from camera right dove into the middle of my throwers, while another large body pushed me toward the sidewalk as if I were a feather. My smell sensors told me my pusher was not human at the same time my viewfinder went black. I was shooting a scene of a place where the sun never shines; the lens was only inches from a horse's rectum.

In the Warner-Pathé projection room two hours later, I was told I had missed the best part of the fight.

During this same period, I was assigned to cover President Harry Truman on various trips from Washington. I had been in Nebraska several days filming the raging Missouri River. The local populace of Omaha and Council Bluffs was filling

sandbags, desperately trying to halt the wet monster from taking their farms and livestock and resettling them in the Gulf of Mexico.

The president arrived at the Omaha Airport to get a firsthand view of the disaster. Strangely enough, I was the only film person there, which meant copies of my film would be pool coverage, and all of the civilian reels would get copies. This surely added another hate mark to my record with my civilian counterparts.

Col. Barney Oldfield, public relations officer of the U.S. Air Force office in the Pentagon, asked if I had any ideas for filming the president. I suggested he take a shovel and fill a couple of sandbags, sort of a symbolic effort to boost the spirits of the area's frantic population. The narrator, I further suggested, might say that the president himself fought the raging river with the people of Nebraska and Iowa. Barney nodded his head and said, "Good idea, Gibson." Well, he thought so, and I thought so, but the president had a quite different reaction.

"Who the hell's idea was this?" he questioned. Barney pointed at me. Truman looked me straight in the eye. "Stupid idea! I'm to fill a sandbag, someone else puts it on the dike, and I go back to Washington while all of these people try to save their homes? Don't ever try and make a phony out of me!"

The president forgave me, but he never let me forget who and what he was.

All of the newsreel cameramen were waiting at National Airport for the arrival of Winston Churchill. I was assigned from Department of Defense to cover the event and, if there was ever a cameraman as nervous as a fox in a forest fire, it was me.

A driver dropped my camera gear and me off at the military terminal at the airport. I walked into the lounge and said "Good morning" to the cameramen, most of whom I knew by now. One, Tommy Craven, greeted me with, "Well, look who's here, it's the blue kid," referring to my Air Force blue uniform, "the Gainsborough Boy."

"Leave him alone," said one of the other cameramen and then to me, "How 'bout a cup of coffee, Gibson?"

I respected these men who had risked their lives to get exclusive shots. A few days later the public might forget what they saw in the newspaper or newsreel but, to the camerapeople, it was their bag and they loved the job. In that room were cameramen who had photographed Hitler at the Olympic Games in Berlin, Italian tanks attacking Ethiopian warriors whose spears were their only offensive weapons, the Hindenberg disaster, the rape of Nanking. They were true historians and I felt honored to have the chance to work alongside them. I asked Sam Greenwald, a legendary cameraman, how to get a shot different from the other cameramen's when we're all right next to one another. Sam leaned forward and whispered in my ear, "Do something that will shock the subject. Have your fly open," he chuckled. I wouldn't unzip my fly and would have to think of something else to do.

"The plane's on final," yelled an Air Force public affairs sergeant. We picked up our camera gear and took our places in a tight semicircle on the ramp. I was careful not to waste any footage on the landing or long taxi; if something unforeseen occurred, I would be in position to shoot it and not be forced to reload and possibly miss the most important shot.

Churchill stopped at the open door of the plane, looked left, then right, saw the cameras, and proceeded down the steps. I was on the far right of the semicircle, so if I was going to do anything it had to be now when he was only a few feet away. He chewed on his cigar and shot a slow sweeping gaze at the faces mostly hidden behind their cameras. When he looked at me, I raised my camera above my head while shooting, looked him straight in the eye, and winked. He froze and glared. I brought the camera back to my eye and had an extreme close up of Winston Churchill in what looked like deep thought. "Thank you, Sam," I said under my breath.

Do the networks and local news stations today orchestrate their coverage to make a story more dramatic and sensational? Many times, yes, if they can. It's manipulation that's as old as the magic lantern Edison invented. News today is a numbers game. Big numbers of viewers bring in advertising dollars, and

viewers are conditioned to expect exciting coverage. The hype preceding "News at 10" is teasing to say the least.

My first exposure (no pun intended) to manufacturing news was back in early World War II. President Roosevelt had written a letter to Admiral King asking him to recreate the attack on Pearl Harbor. He wanted to make every American "Mad as Hell" when they saw it. The film was titled *December 7th* and cost a fortune and took a year to make.

Bombs were dropped, planes were blown up, a ten foot exact duplicate model of the USS *Arizona* on fire was intercut with actors trying to make it topside to man their guns. There was a Sunday morning exterior church scene and another with dozens of wounded on the ground. It was a film worthy of Hollywood, and I cringe when I see those shots on television today.

A cameraman pal of mine worked for one of the TV stations in Los Angeles during August 1965 when the Watts riots began. The station needed an exciting sequence to draw an audience for the evening's news. My friend and the director went to the rear of a Hollywood market and collected old wooden crates and empty cardboard boxes. They filled up a two-gallon plastic container with gasoline and, with camera gear and props in tow, found a suitable alley near the riot area. Camera ready, they hired ten black men to run by the end of the alley where the fuel and boxes now looked like a raging fire in the foreground. That image portrayed a city in turmoil, and when sound effects and music were added, it sent chills down one's spine. The shots were so good they went national so all America could witness the violence.

Most of the time if a story breaks on the weekend, you won't see it until Monday. Just for fun, call your local TV channel on Saturday and ask for the newsroom. Don't hold your breath waiting for someone to answer.

Chapter Eleven

The World Is My Oyster

I love music, all kinds of music. Big band, classical, opera, Gilbert & Sullivan, Elvis (occasionally), country western, and steel drums come to mind. But my favorite of all is played by the buckets in a jet engine as the aircraft lifts off the runway and heads in the direction I've chosen. The sounds signify leaving the gray-scale world where office meetings took on a host of negative subjects, stopping by the store for this or that on the way home from work, not having to hear for the umpteenth time about a colleague's shot he made on the 17th hole at the LA Country Club—in fact, it's the music of freedom from the everyday world. I especially enjoyed getting away from my golf addict friends whose main goal seemed to be where they would play their next round. I would interrupt their conversations with something like a reference to cow pasture polo being a fine way to screw up a good walk. I was branded as a leper. "Gibson, why don't you take your camera and go play with the kids in the sandbox across the street?" one miffed golfer suggested.

Looking out the window of a jet from 35,000 feet I could see the waves of the ocean licking the shores of a continent covered by a brilliant green carpet. A golfer would think it resembled the 14th green at Pebble Beach, but in truth, the carpet is a jungle canopy beneath which men with spears hunt a boar for a tribal dinner while a deadly green mamba snake glides across a branch watching the activity from just above their heads. Within a 50-square-foot area there is a larger pop-

ulation of living creatures than the number of golfers playing at one time on every golf course in the world. The only difference is that golfers dress in brighter patterns than the creatures. I hate a game when I've been beaten by a ten-year-old kid and an 89-year-old elder!

Now, as I near my first destination and the dive flaps raise, a new musical sound is introduced into the composition. It is mixed with a 500-mile-an-hour collision of air and aluminum. I tighten my seatbelt as a melodic voice announces, in French, that we are beginning our descent to the airport in Senegal. How many other planes are also on final approach at this moment filling their passengers with an adrenaline-spurting moment, while listening to such ports of call as St. Petersburg, Timbuktu, Nairobi, Port Louis, Tahiti? I do know that for every runway to a destination of dung, there are a thousand locations with rainbows, shooting stars, giant butterflies, and life-risking adventures. (Mark Twain wrote this—I added "life-risking adventures.") So fly, you armchair travelers.

That's more or less the idea that sold the airline owner on making a film for his upcoming jet charter service. He had seen all of the travel films we had made; he liked them and said they were good, but too much alike. "I want something that will put small, medium, and large asses on every seat of every flight. I want schoolteachers, retired police, firemen, defeated politicians—full-fare adults to leave their television sets and travel to the most romantic and best shopping centers on this planet."

Three days later, Ben and I went to the Beverly Wilshire Hotel to pitch our ideas to this South American copper baron, who by now had become an entrepreneur in our field of expertise. We were early for the meeting.

"This guy is a hard sell, Gibson. What's your idea?" Ben asked.

"I'll have a Bombay martini on the rocks with one olive and one onion," I replied. I was stalling because I had no inspired concept—nothing to make our customer say, "sí, sí."

"You'd better have an inspiration right now," Ben urged. "This is your opportunity to go everywhere we want to go in

the world. It's my ticket to a safari in East Africa. I can shoot
the big five. We can chase bikini-clad broads on the beaches of
the Seychelles. We can charter a junk and sail the China Sea.
Gibson, come on. This may be our last film. Think of some-
thing!"

At that moment Hernando Courtwright, owner of the hotel,
escorted our guest to the table. As we stood, I whispered to
Ben, "Don't shake his hand." There are three kinds of hand-
shakes a customer relations executive must never use. The first
is the "brush touch," where you pull your hand back just
before it can be gripped. Second is the "limp mackerel," the re-
cipient can whatever he wants to do with this moist, dead
hand—stepping back quickly is the most common reaction.
Number three is "the claw," when you see the recipient's
friendly smile turn into a look of pain. Ben had that kind of
handshake. Because he was out to win the pistol champi-
onship, he would hold his arm straight out while holding a
one-pound weight, an exercise he practiced religiously, even
during advertising meetings with executives from J. Walter
Thompson, Douglas Aircraft's ad company. The result was a
powerful, two-by-four arm covered in freckles and a grip to
rival Muhammad Ali's. Arm out, hand wrapped around the
weight, Ben would strut around the room, changing layouts
and looking like a Forest Service gate guard protecting the
wilderness from the taxpayers.

After the handshake and the recipient's grimace, our Latin
customer took a quick look at his watch, said he had another
appointment, would have a sherry, and leave.

We were eyeball to eyeball when I took a deep breath and
said, "Actually the theme of the film was your idea. Remember
when you said the words, armchair traveler? In a nutshell,
here's how it goes. We fade into a middle-class living room.
There are no people in the scene. The camera focuses on a
rocking chair and a large-screen television set. The camera
slowly dollies in and stops alongside the chair. On the tele-
vision is a close up of an oyster. It begins to open, revealing a
large pearl. Narration fills the room: "The world is your oyster,

so armchair traveler fly, fly to romance, adventure. Fulfill your wildest dreams." Now a series of quick cuts of beauty shots from around the world. The armchair begins rocking and music builds as the chair is at the end of a runway. Sound effects of a jet engine join the music as the chair takes off."

He interrupted: "I don't want animation in my film, no animation."

"We'll get shots of the chair actually flying. It can be done without animation. Now we see the chair visiting the wonders of the world. It's part of the changing of the guard at Buckingham Palace; it circles around the Eiffel Tower; visits the Parthenon; is on stage with a sexy belly dancer in Istanbul; witnesses a bullfight with a cape-tossing matador in Spain; next it's migrating with wildlife on the Serengeti Plain."

"That's enough," he said.

I thought I'd blown it. He reached across the table with an outstretched hand to shake mine. "I'll buy it!" he said enthusiastically. Ben pinched me under the table. "But you must start now. I want this show in distribution a month before delivery of the aircraft. That gives you nine months. If you don't complete it by then, I'll withdraw the funds. Now, let's have lunch. The other party can wait."

Our Douglas Aircraft driver was waiting in front of the hotel. A limousine and large Mercedes were also parked in the circular drive that led to the entrance. The doorman strutted to our vehicle with the Douglas Aircraft logo on the side and opened the rear door. "Have a good day, Mr. Marble, Mr. Gibson," he said, then saluted. I saluted back and reminisced for a moment about an apprentice seaman walking up the officers' gangway on the USS *Hornet*'s commissioning day. I had the distinction of being the last man in the pay line. What a difference a few years can make. Now, when I visit a naval ship or an Air Force base, my rank is equivalent to rear admiral or brigadier general, a courtesy given to corporate executives of aerospace companies who worked closely with the military. From bell-bottom trousers to 100 percent wool, custom-made suits.

It wasn't my IQ or Washington political assistance that got me here. It was the cameras I had used over the years. Eighty below zero on the Polar Plateau, tolerating the moisture, fungus, and leaches of an equatorial jungle; accepting a mounted perch for shots I couldn't make from vintage planes to jets, on the helmets of Olympic ski jumpers, in the nose cone of a ground-to-air rocket, encased in a two-inch steel chamber to record the liftoff of a ballistic missile.

Many times I failed my best friend with bad aperture settings, focus problems, tilted horizon levels, running out of film at the worst possible moment, and, once or twice, checking her into baggage when she should have been in first-class luxury with me. And now, the trip of a lifetime, *The Armchair Traveler*, where I could pick my favorite destinations. No question about it. I love the camera!

The model shop at the Long Beach Douglas Aircraft plant housed some of the finest craftsmen in the world. Their woodworking skills, used primarily in building mock-ups for future aircraft, were poetry in shavings.

I tried to explain to the supervisor that I needed two rocking chairs, one full size and the other an exact duplicate, but one-third the size of the first. The small one would have to withstand the rigors of being mounted outside an aircraft. Both had to be constructed so they could be disassembled and re-assembled easily, fit into a flat case that had to be sturdy but lightweight for airline baggage shipping, and also fit into a small European car.

"Do you have a work order?" he mumbled. I was ready for him. I pulled a small piece of paper from my pocket, and reeled off a dozen numbers that he copied down. I had just given him a phony work order; a real one would have taken weeks to process.

"Your chairs and shipping case will be ready in four weeks," he muttered. "Four weeks!" I exclaimed, "We have tickets to London for a week from tomorrow. We need the chairs and case by this weekend." Before he could say no way, I grabbed his arm, "Did I tell you we're filming your department, which

goes into the Douglas monthly film report? That's this month's report." His eyes looked at me over his granny glasses. "Your chairs will be ready late Friday afternoon."

As soon as I got back to my office I asked Hazel, my secretary, to call in Jack Gabrielson, the producer/director of the company film reports.

"Jack, I want you to feature the model shop in Long Beach in this month's report.

"Can't be done, Bill, we're going into a narration session tomorrow. The show is cut. You approved it." After Jack left, I asked Hazel to close my office door. I really hated to hear crying from the editorial room.

The small chair was mounted on the nose of a Curtis Pusher, a plane made in 1910. The camera, mounted on the wing, framed the chair so it looked like it was hanging in space. It's a wonder there weren't more accidents on the Santa Ana as the old biplane flew low over the freeway. His combat scarf, like the Red Baron's of World War I, stood straight up as pilot Frank Tallman manned the controls. His airspeed was less than 50 miles an hour as cars whizzed by below. All systems were go. The mount worked, the chair looked great, our tickets ready, and our itinerary set.

London was our first stop. The purpose? To get a shot of our chair with the changing of the guard at Buckingham Palace. The street next to St. James Park was lined with hundreds of tourists attempting to capture this royal event on instamatic or 8 mm movie cameras. Royal because only when the sovereign is in residence at the Palace does the entire guard and band perform and the royal standard flies.

From a distance the band started playing. It was my cue. "Pardon me, Press. Excuse me, let the press through," I ordered. I was on the street with the tripod over my shoulder, Arriflex mounted to its head, and a battery belt around my waist.

I set the tripod legs down, adjusted one leg for a straight horizon and turned the camera for a test. It told me, as it had thousands of times in the past, "I'm ready, are you?"

The guard was getting closer now. Where were Ben and the chair? The scene was bizarre. Out from the crowd emerged a madman with a rocking chair held over his head, running into the middle of the street and setting down the chair before he ran off. He gave it a little push. The timing was perfect. Now, a close-up of the chair, a slow zoom back to reveal the drum major leading the band, with the guard directly behind, all 80 of them. If you've ever seen this ritual, you know that the guards never smile; in fact, they aren't allowed to smile or answer any questions put to them by the public. But as a marching group they were perfection personified. The drum major made a slight correction to miss the chair. A pathway, like the parting of the Red Sea, opened around the chair and provided me with some wonderful footage.

The next location for our rocking movie star was Paris, the City of Lights, fountains, chestnuts in blossom, the Red Tower, the Louvre, fresh French bread and onion soup at the market place at midnight. The French, we knew, were not as tolerant as the British. Place the chair in the middle of the Champs Élysées with Charles DeGaulle approaching in an open car, and we have just become the leading actors in a sharpshooter's scope. So, our plan in Paris was simple. We'd mount the chair on the top of our little car, and Ben would hold my legs in the backseat while I sat in the window shooting up at the chair with the Arc de Triomphe in the background.

It's difficult to raise eyebrows in a city where they've seen everything before, but our act grabbed their attention. Horns are beeped on a regular basis in Paris. For every Frenchman's hand, I was told, there is a car horn to be pushed, and that morning a siren joined hundreds of horns.

After being pulled over we drew a sizable crowd as the gendarme pointed at the chair while waving his ticket book. Our French driver gave his French salute (a shrug of the shoulders) and joined in conversation with the others surrounding our car. At this moment a well-dressed man walked up to Ben and asked what the problem was while showing the policeman a badge in his open wallet.

"What's the idea of the chair?" he asked, smiling. Ben explained the concept of the film, and his remarks were translated by two or three English-speaking bystanders to the rest of the crowd. "Good idea," he said. He turned to the uniformed officer, rattled off two minutes of instructions, then turned back to Ben. "Claude here will be your escort. Go do your scene and good luck." The sun broke through the low overcast, and we got our shot. Viva la France!

Next we were on to the Plains of Spain, Andalucia, where the finest sherry is made and aptly called "Spanish Sunshine." This is the place where flamenco dancers' feet move so fast they become blurs. Animals with a thousand years of fine breeding guard the fields—these are the fighting bulls of Spain.

When I returned home to St. Petersburg, Florida, after World War II, I don't remember receiving one handshake—American memories are short. But that's not true in this area of Spain, which is located in the heartland of the Iberian Peninsula. These wonderful people appreciate a hero, and Gibson was a local hero. I don't believe even Hemmingway received as much attention in the bars of Seville as I did when I returned to the city of Jerez. Flash back two years when Ben and I were making a film for Iberia Airlines.

Pedro Domecq, the famous sherry, wine, and brandy producer, invited us to film his factory and photograph a "Tienta." This is when the young fighting bulls are tested for heart, athleticism, and the ability to gore a human being.

For the Tienta, we set up on a hill with some 20 workers from the ranch in attendance. On the fields below were grazing bulls, their coats of black shining in the sun of a very hot afternoon.

From over another hill rode five men on horseback with one horse covered with a padded blanket. The riders of the other horses carried 12-foot poles one end of which was padded. They looked like knights of the Crusades on their way to Jerusalem. And from yet another hill, a lone rider on the most beautiful horse I had ever seen (and I have seen many) pranced and moved from side to side in a most graceful manner. The

stallion lifted his legs up and down like the pistons on a ships' engine. The rider was at one with the horse, his back straight as a Marine recruit in boot camp. His name was Fermin Espinoza, internationally known fighter of bulls from horseback, called a "rejoneador."

A massive bull looked up from his grazing to see a charging gray animal rapidly approaching his territory. The huge animal seemed to think for a moment, then turned and headed for the ranch. Fermin's lance was in a vertical position as he advanced toward the rear of the bull. At full speed, he lowered the prod and, with perfect timing, the padded end found its mark. The bull went tumbling head over hooves. He righted himself, shook his body, and pawed the ground with his right hoof. Head down and clearly angry now, he charged the nearest horse with padding on its flanks. Hit after hit, charge after charge, he furiously pummeled his target until the other riders drove him away. The ranch supervisor opened a large ledger and wrote down a score for the bull.

Ben was elated. "This is the greatest thing I've ever seen," he enthused. "We've got to get down there and capture the action," he said to the supervisor and me.

"I wouldn't advise you to do so," the supervisor admonished, "these animals are very dangerous."

"We'll only go a little way off the hill," Ben replied. "Need help with your gear, Bill?" Ben asked.

I knew at that moment it was an asinine idea, but I couldn't back down in front of all these men. The supervisor gave one last word of instruction: "If you are charged, fall down and don't move. He will not step on a foreign object." I wondered if he meant we were foreigners, but the bull couldn't know that.

The bull had the number 20 branded on his side, a number I will never forget. I was set up with the camera and tripod. Once again Fermin set in motion. Down went the bull. He righted himself, pawed the ground furiously, turned his huge head and lethal appendages in my direction, and charged toward me. I don't know how long it took him to reach our un-

protected location; I perceived it in slow motion and it felt like forever. Marble screamed, "Fall down, Bill, fall down!" I wasn't about to throw my body down like a sacrificial lamb in front of this black locomotive bearing down on me. I had a better idea. Step from in back of the camera at the last moment and give up the tripod and camera, not my life. Wrong move. Following instructions, Ben had thrown himself on the ground.

On impact, the camera hit my shoulder like a huge chunk of flak. I felt my body being lifted off my feet and onto the head of the enraged beast. That's all I remembered.

I came to riding in a jeep speeding to the clinic in Jerez. The hole in my abdomen was not that large. After an x-ray and a few stitches, the doctor said I'd be fine. A little sore perhaps, but I would live and, with my luck, enjoy a long life.

Waiting at the entrance of the clinic was a group of locals, smiling and laughing as if they'd won the Spanish lottery. As soon as I came through the door, the laughter stopped. All at once they began clapping their hands slowly, then faster and more loudly. Fermin Espinoza put his arm around me gently and whispered, "The news is out about how brave you are." Good heavens, I thought, these people think I challenged that bull, that I did it on purpose. But, friends, applause has a strange effect when least you expect it. My sore chest expanded and, with a small limp, I gladly shook the hands of my admirers. For a brief, shining moment I mentally added the name "Gibson" to the list of matadors that included the likes of Arruza, Belmonte, and El Cordobés.

My Arriflex needed some repairs, but the exposed film was recovered and processed. All the action had been captured, including a camera "half-gainer" from the bull's collision with the tripod to a shot of the sky.

A few months later we had a premiere screening of the Iberian Airlines film, *To Catch a Dream*, narrated by Ricardo Montalbon, at the Palace Hotel in Madrid. The audience knew about the charging bull, and when the scene came on the entire audience stood up, applauding and shouting "Olé! Olé!" In Spain I was a hero. In the United States I was branded an idiot.

The laboratory chief saw the film and suggested I go play on the Pasadena freeway.

After filming our chair with the bulls on the Plains of Spain, we proceeded to Italy, where our armchair traveler was to visit the Coliseum in Rome and the Blue Grotto on the Isle of Capri. No problems surfaced in Italy. We even took the chair into a restaurant in Naples, set it at the table, and pigged out on a four-course pasta dinner.

Greece was a different story. In Athens we needed a government permit to photograph the Parthenon. Approval would have taken three weeks, and we had only two days. Since neither Ben nor I would take a "can't do" as an answer, we headed up early the next morning to the top of the hill, the highest point in Athens, known as the Acropolis, which means "the defending place."

We knew as we walked to the top with chair and camera gear that we would have to be very clever to be able to smuggle all of our paraphernalia into this ancient structure. I thought about the Trojan horse. Will our chair fool the gatekeepers, or will we have to delete the Parthenon's spectacular columns from the script?

Three uniformed men left their refuge to form a human barrier across the entrance. Ben was carrying the armchair on his head. I was directly behind him with the camera bolted by a ¾-inch bolt to the tripod, a battery belt, and six feet of cable wrapped around my waist.

"No photo permit, no entrance," the middle guard stated in passable English. The other two shook their heads in agreement. Where Ben's inspired story came from I don't know, but I felt hysterical laughter creeping up in my throat. To be a moviemaker, you have to have a vivid, unlimited imagination. And Ben revealed his, brilliantly.

He spoke slowly and precisely. "We are from the Greek community in Tarpon Springs, Florida, USA. My grandmother, who was born in Athens, is on her deathbed." One of the guards interpreted for the others. Ben continued, "Her last request, before she passes away, is to have her rocking chair photo-

graphed under one of the columns of the Parthenon from where she can see her beloved city of Athens spread out below."

The Greeks are emotional people and deeply steeped in their culture. Ben's story touched the soul of the guard and, without clearing it with the others said, "We will clear the other visitors out so you may take your pictures. Do you need help with your chair or equipment?" he asked.

"Thank you, but no, we can handle them," I replied. The ghosts of Plato and Socrates probably turned in their togas and rapidly moved toward higher ground far away from these American con artists.

The chair looked magnificent in its setting; the Parthenon truly is one of the ancient world's most beautiful structures. The scene was everything we could have asked for and more. We thanked the guards when we were through and, as we left, it was a very solemn moment. They watched quietly as Ben took the chair apart and placed it in its traveling case. We both waved at our temporary Greek crew members and drove away. We had gone but a hundred yards when we both dissolved into tear-flowing laughter. As D. W. Griffith said, the film is the most important thing—emotions come second.

Kenya beckoned. Ben was acting like a five-year-old on Christmas Eve. At last, he was going to have his African safari. Representatives from Kerr and Downey, the prime outfitters in East Africa, met us at the airport in Nairobi. They shepherded our camera equipment through customs and drove us to the New Stanley Hotel. I could sense something was wrong with the way they were acting. They broke the news to us over tea in the Stanley Bar.

"We have a small problem with our scheduling," said our oh-so-proper English host. "The party that has your hunting area won't be able to turn it over to you until one of the hunters gets the last of his big five. He needs only a Cape buffalo to fulfill his order. So, with your permission, we'll put you up here in the Stanley, best rooms, of course. It's on us."

Marble stood up. He was red in the face, and his voice got

the attention of all the tea sippers in the room. "We have a contract with you for that hunting area and we expect to be on that property tomorrow morning. I'd advise you to notify your clients that they're evicted!" With perfect English dignity and totally unruffled, our host replied, "Excuse me a moment while I make a radio call to camp."

When he returned he smiled and said, "What if we gave you a couple of extra days in the bush? You can photograph to your heart's content. We'll have proper living conditions set up for you. If this meets with your approval, we'll pick you up here at zero seven hours tomorrow and fly you to the most prolific game location in all of Africa. By the way, your hunter guide is Peter Whitehead, the best in the business, as you undoubtedly already know." We agreed immediately. He didn't mention who the current clients were.

The next morning, we were ready and waiting at 0650 hours, anxious and filled with anticipation. The camp was located in a shaded area on a hill overlooking a grassy plain. We were introduced to Peter Whitehead and two familiar faces: Baron Rothschild and Aristotle Onassis, two of the most powerful men in the world.

Ben and I had separate tents. A Kenyan native named Charles was assigned to be my valet. I now became Bwana Bill. In my spacious tent was a large, canvas bathtub to which Charles carried iron buckets filled with hot water. He was also the soap holder and towel rack. The temperature of the water was just this side of perfect as he added more. I slipped into the tub and luxuriated for a few minutes, then dressed and joined the other guests for cocktails. When I returned to my tent later, folded and pressed laundry was stacked neatly at the foot of the bed. If this was called roughing it, I was ready to put in my order for another dozen years.

The next morning our Land Rover followed the guide and two tycoons to a site on the savanna where a record Boone and Crocket Cape buffalo had been spotted. He was less than 75 yards away, near a dense thicket.

I was not elated about filming a world banker blasting away

at a grazing bovine, but I faked it as I set up just in back of the baron with no film in my camera. I could think of no logical reason to film the event. Peter whispered, "We'll move up a few yards to get a better shot.

The baron's answer stopped Peter in his tracks. "Take the shell out of your gun. I want this kill alone!"

Peter explained, "I will shoot only if you wound the animal. It's part of my job."

"You will not shoot," ordered the tooth-grinding hunter. In record time I had a fresh load of film in the camera. The tension was as thick as a morning fog in London.

Baron Rothschild walked cautiously toward his prey, stopped, brought the Holland & Holland 375 to his shoulder, and fired. Gendarme birds left their nests seeking shelter in an endless sky as the buffalo snapped his head up, looked at his would-be assassin, and stumbled into the thicket.

I heard Peter swear under his breath. He double-timed it to the Rover, took out a 12-gauge shotgun, inserted two, red-belly busters, and started toward the thicket. "Come on, Baron," he said, "we have a job to finish." The baron turned and headed for the safety of the Rover.

I picked up my camera and followed Peter. Ben was right alongside with his two Nikons. "Stay here," Peter commanded, "I've made enough mistakes for this day." When Peter gave an order, one had to obey, especially since he was carrying a double-barreled, sawed-off shotgun. This was *High Noon, Gunfight at the O.K. Corral*.

As Peter entered the thicket, I turned my camera on, waiting for man or animal to come flying out. One shot rang out, then another. I quickly panned to get Peter in the finder as he entered the clearing. His head hung down as he walked back to the Land Rover.

Dinner that evening was a subdued affair. The only thing missing was the music of violins; everything else possible was set before us. White linen tablecloths, matching napkins, sterling silver place settings, crystal stemware, food to delight the palate of an emperor, wine from the baron's own vineyard

(so you knew it was the best in the world)—world-class dining without an American Express card. I was almost sorry he and Onassis were leaving the next morning.

For the next five days Ben had his own safari and realized a lifelong dream. He joined the ranks of Teddy Roosevelt, Carl Akley and "Bring 'em Back Alive" Buck.

Our hunting area was in the middle of the Great Rift Valley, the home of the Masai. Peter sounded the horn on the Land Rover as we approached a kraal, a fenced-in community with goats, donkeys, and cattle that lived in the compound with the tribe members.

An older man came out, followed by women and children. He knew Peter and the four men assistants who were in a truck behind us. It was their duty to clean the killed game for meals and prepare the head for mounting by a taxidermist.

The man offered me a drink from his goatskin canteen. "Bill, take the offer to share in his beverage. He would like that very much." I uncorked the animal container. The smell was new to me and I didn't much like it. Just as I was about to take a swig, Peter told Ben the drink was freshly drawn blood from a cow and the owner's urine. I froze, gagged, and passed the container back to its owner.

The Masai tribe members fascinated me. Theirs was a culture as old and strict as any I had ever studied. Its structure for the males was very simple. You are a boy until the age of 12; at 12 a warrior, until, at the grand old age of 30, you become an elder. A male may not marry until he has served as a warrior and reaches 30. The young warrior must leave the village with only a spear. His job is to kill a lion while face-to-face with it.

Toward the end of our safari, while returning to camp, we passed by a body dressed in a saffron-colored robe sitting in a grass thicket alongside a thorn tree. "Stop the car," I yelled at Peter, as he slammed on the brakes. "There is an old Masai out there. He needs help." Peter turned from the front seat, looked me straight in the eye, and said, "He's here for his death. Leave the cultures of others to themselves and don't interfere."

"Bullshit," I said, "he needs assistance now." I jumped out of the Rover and ran toward the body. He was old and thin and stared into space like my Grandmother Mitchell on her deathbed. I carefully picked him up and carried him to the Rover.

"You're making a big mistake, Bill, and truly, you'll regret your actions." Ben added, "Put him back under the tree." But I was determined to take him back to camp where a large fire would warm his old bones. I moved the rocking chair close to the fire, then carried the old man, barely breathing, and set him upright in our chair. The camp workers moved as far away as they dared. I tried to feed him some soup, but it just dribbled out of his mouth. When the generator went out for the night, I lay in my cot thinking about what I'd done. Perhaps I should take him to Nairobi to an old folks' home or a clinic.

After midnight, I got up to check on my tiny, frail friend. At one time he had been close to six feet tall and a fearless warrior. Peter interrupted my thoughts. "Bill," he said, "that old man wants to go to Masai heaven just like his father and their fathers. You're denying him his rights as a member of an ancient culture. Do you know how long he would live out there?" Peter asked.

"Not long," I replied.

"But he would end up a part of this valley that he loves," said Peter.

Early the next morning we placed him back under the same tree. The sky was a brilliant red/orange that matched the old man's robe. I said a silent prayer: God make the prey be gentle and quick. I left a friend on the grassy-covered plains of East Africa. Peter was so right. To this day I still regret my interference.

No sound effects house in Hollywood could ever duplicate the sounds of the annual migration of the Serengeti Plain. Thousands of zebras and wildebeests, newborn running

alongside their mothers, tongues hanging out the sides of their mouths, galloped along. And, in the wings, the underworld, consisting of lions, leopards, hyenas, and cheetahs, smacked its lips in anticipation of a daily smorgasbord.

A light break in the traffic of the migrating herds meant it was time to get to work. Ben held the chair over his head and ran toward the animals. Then he stopped and looked back at me. I waved at him to go farther. He set the chair down facing the running herds, then ran back to our camera location, which was located on a slight rise of ground. It took two hours and two 400-foot reels to get the right shot, but it was well worth it.

We took an Air India flight to Port Louis on Mauritius, located in the middle of the Indian Ocean. I picked this island because Mark Twain had supposedly said it was one of his favorite places to get away from a mad world.

The locals happily joined in the legend of the chair. As we tied it to a pair of water skis, their laughter and obvious delight carried the day. I focused on a speedboat, then slowly panned back to reveal the chair experience its first water sport.

The local underwater club furnished us with a dive boat so we could get shots of the chair settled on a reef about 60 feet under water. They told me the reef would be alive with creatures and was one of the best diving reefs in the Indian Ocean.

We suited up in scuba gear and put weight belts on the chair so we could get it down to the depth of the reef. Well, it was one of those "you should have been here yesterday" excuses. Visibility was ten feet. "Oh, it will take only a few days and the water will clear up" we were told. We replied that, although we were grateful for all their help, we had to be on our way. We shot no film underwater. To top it all off, we had made a possibly costly mistake when we subjected our chair to the pressures of deep water. When we brought it back to the surface, all of the pegs holding the legs together swelled, making it impossible to dismantle and place it in its shipping case. We hoped the swelling would be down by the next morning, but despite heating pads, it didn't happen.

When we arrived at the airport, air cargo was closed. The ticket agent took one look at our 20 camera cases, two tripods, camera car mounts, extra batteries, charges—you name it, we had it. And sitting on the chair case, was our rocker waiting in line for her flight to Hong Kong.

"You cannot put that chair in the baggage compartment," the ticket agent growled, "It does not meet dimension standards."

We tried every one of our customer relations tricks, but with each suggestion his head swiveled from shoulder to shoulder like a pendulum on a grandfather clock. He was inflexible, adamant, and the word "no" really meant something more to him than to us. "All right," thundered Ben, now at the end of his rope and caring not at all that there were three lines of passengers checking in and witnessing our predicament. "Then, dammit, make out a first class ticket for the chair. She goes where we go!"

Just after takeoff, the flight crew took turns leaving the cockpit and tried to look nonchalant as they passed by our chair, now buckled in the seat next to Ben. We toasted our precious wooden lady with Dom Perignon and once again argued over who got to keep her when we returned home.

Our last port of call was Hong Kong, where we photographed the chair at one of the floating restaurants in Aberdeen Harbor. As soon as we were finished, a junk, under full sail, pulled in close to the restaurant, anchored, and launched a small boat. In it was a supply of fresh fish for the eatery.

I filmed the scene while Ben talked to the restaurant manager and the skipper of the two-masted junk who had come aboard. I knew something was wrong as I watched my over-zealous boss sign several hundred-dollar American Express travelers' checks and hand them to the manager.

"What's up?" I asked Ben.

"Hey, another trip of a lifetime, Bill. We just rented this Chinese junk. For three glorious days, we'll sail the China Seas. The captain will wait here until we check out of the hotel and get more film. Just imagine the shots we'll get!"

"We'll miss our plane back to the States," I cautioned.

"Oh, we'll rebook from the hotel. You were in the Navy—you'll love this." When Ben was excited, it was hard not to be excited along with him. I had to admit that the thought of sailing in a junk a hundred yards from the skyscrapers of Hong Kong was enthralling.

There were six adults and five children aboard, all of them staring at the two white strangers who invaded their floating home.

I asked the older lady how long she had lived on the boat. She giggled and turned her head. I asked the younger man if he spoke English. He answered in a Chinese dialect that featured speed speech. "Marble, does the Captain speak English?" I asked, nervously.

Ben started climbing up the ladder that led up to top of the aft mast. "No, not a word," he yelled, as he busily took still photos of anything within range.

"Ben, we need to talk," I yelled back, but he was on his way to a small lookout platform at the top of the mast. I hurried to the open bridge, where the captain stood by the rudder control. He smiled at me. I said, "We will only stay aboard one night, then we go back to Hong Kong, Okay?" He laughed and nodded okay. Face it, Gibson, I muttered to myself, he didn't understand one frigging word you said. My concern was real. My father, a sea captain with Lykes Steamship Line, sailed these waters twice a year and had told me hair-raising stories of pirates, kidnapping, and murders for a few American dollars by thugs who sailed along the China coast. The mainland Chinese Navy ignored the problem. I put my camera in its case and stood at the bow looking down at the blunt piece of mahogany cutting a path to the unknown.

As I looked aft, Ben was taking Polaroid shots of the entire crew, including a baby being breast-fed. It was getting dark as the mate lit red and green oil lanterns secured to the port and starboard railings. Our quarters were the captain's and were furnished with two straw mats, thin U.S. Army blankets, and a bucket for a toilet.

"Not like the George V in Paris, is it?" Ben laughed. I tried again to convince him of the danger we were putting ourselves into.

"This captain will take his junk along the Chinese commie coast. If we're caught, forget about living. We'll be toast, spies with sophisticated cameras." I was mad and started yelling. "Whether you like it or not, tomorrow morning we're going back to Hong Kong before this bunch turns us in for a reward."

"All right, Bill, point taken. We'll go back in the morning," he answered.

Sometime during the night the captain awakened me. He was in panic mode, gesturing frantically for us to follow him. Fortunately we'd gone to sleep in our clothes, but we were confused as he lifted a plank on the deck and pushed my head down in the direction of the bilge. I jumped down as Ben followed, stepping all over me. Our camera equipment was next. We did the best we could to protect our heads as case after case descended over and onto us.

The silence was broken by the sound of a powerful engine as another ship pulled alongside, gently bumping the junk. A dozen voices joined with the sound of running feet on the planking above. I tried to count the cases quietly by feel and prayed that none of our camera or personal gear remained topside. If so, I knew we were goners. I didn't want to dwell on the outcome.

It was not just a sigh of relief but more like a rebirth as the retreating powerful engines began to whisper. Honestly, I've never been so frightened in my life, and even fearless Ben looked a little pale. So much emotion spent with nary a peek at our foe. It took a frenetic session of pidgin English and sign language and $600 more to convince the captain to take us back to Hong Kong.

The fully loaded Philippine Airlines DC8 used every available foot of Kowloon's runway to take the rover boys (our corporate nickname) to Manila. We were then on our way to San Francisco and Los Angeles. Except for underwater shots, the shooting phase of The Armchair Traveler was over. I

thought about the next film. "Cut!" I said to myself. "Give that camera a well-deserved break."

Once back in the states, I had to complete the unfilmable portion of the underwater scenes. Marineland of the Pacific, in southern California, was a suitable replacement and would serve as a perfect double with a hundred extras swimming around the chair.

Over the last couple of years I had photographed commercials and documentaries in the underwater tanks and knew some of their occupants by name.

I had a favorite bottlenose porpoise named Smiley, who loved to be photographed. As soon as I lifted the underwater housing and pointed it at him, he went into wild gymnastic maneuvers to the delight of viewers watching through viewing ports.

When diving in the tank, you become center stage while a hundred humans who live and work outside the water world press their noses against the glass. They marvel at how nonchalant you are with the sharks, moray eels, and one monster sea bass that could swallow you whole.

Just before we went into the tank, the chief ichthyologist called me aside and said to be careful; some of the cows were in heat, and Smiley was a little tense. "No problem," I replied, "Smiley and I are old buddies, and I'm anxious to see him again." I was about to find out some basic facts of life.

After starting down the ladder into the tank, I was handed my camera, which was mounted in a Samson underwater housing. Out of water it weighed 25 pounds; underwater it could be maneuvered anywhere with one hand. No one was allowed to use self-contained breathers (scuba tanks) because hitting a viewing port could lead to disaster. So I was hooked up by hose to a compressor above. Where I went, so went the hose.

When I descended to the first level I looked up. There, before me, was a scene that would be considered double-X-rated in Denmark. Smiley, my underwater buddy, was servicing the cows, one after the other, only penetrating for a few

seconds each. His penis lowered like the landing gear on a 747, did its quick job, and retracted into a slit in his belly.

I wasn't worried for myself until Smiley spotted a four-foot leopard shark that had been placed in the tank to keep it clean.

Smiley smashed the back of the shark with his erect landing gear. Oh no, I thought. I'm in this tank with a sex maniac and I'm the next victim. We—Smiley and I—made eye contact. He turned in the water like a cutting horse after the last steer, sped to the opposite end of the tank, did a pirouette, and headed straight for me. This blue-grey pervert was out for the coup de grâce.

I let go of the camera and covered my face with my arms. Nothing happened. I peeked out through my arms. Just a foot in front of my mask was a smiling porpoise. I got the feeling of being watched and, as I turned my head toward the viewing ports, they were filled with faces wearing stupid grins. How could I get out of this tank without these people seeing me? Oh yes, I did get the chair shots done, but there are times when camera work becomes a little bit trying.

When Douglas Aircraft sold a fleet of commercial aircraft to a foreign airline, the first plane that rolled off the production line was put through weeks of test flights before it received certification. A VIP Press Delivery Flight from the production facility in Long Beach, California, to the purchasing country was usually scheduled. One such delivery flight was for Spain's Iberia Airlines to the Island of Majorca. We had just completed a destination film for the island, and I was invited on the flight.

A few months earlier I had met with Iberia's director of public affairs. He asked me to come up with an idea that would make this flight one that would be remembered forever. I knew the historic island well by now, after spending four weeks filming everything: Devil Dances, blue grottos, the romantic hideaway Chopin shared with George Sand, and Father Junípero Serra's birthplace. A flashbulb lit up over my head.

What a story! Here we are, delivering a state-of-the-art flying carpet to within a couple of miles of where the man who had founded the missions of California was born and educated.

"Listen to this," I told our Spanish guests, "We're not only bringing internationally known VIPs on this flight, we'll also carry dirt from the nine missions founded by Franciscan priest, Father Junípero Serra. We'll have a ceremony of mixing the mission dirt from California with the soil in the garden of the home where he was born and raised."

I hate being touched by other men just a little less than having someone grab me and plant a kiss on my cheek, but with this job one took the bitter with the sweet.

"We'll do it, he said. "We'll have the blessing of the Vatican itself."

As we say in the industry, a slow dissolve to close-ups of handshakes, hugs, and greetings in half a dozen languages on the ramp at Long Beach. A sparkling, new DC-8 jet liner was the star of the show, as ground crews moved baggage from cars and limousines and stowed it in the belly of the aircraft, which was named *Velázquez* after the renowned fifteenth-century Spanish artist, Diego Velázquez.

That's when I heard the bad news. "Where's the mission soil, Bill?" asked the Spanish public affairs officer who was joining us for the flight. The question reverberated around me. The mission soil . . . the mission soil. His next pronouncement made it even worse. "The ceremony has become a big event, and press from all over Europe will be there, along with the cardinal from Barcelona, who will bless the soil."

I didn't have the guts to look him in the eye and say, "There is no soil because this asshole completely and totally forgot all about it." But no, I smiled and told him it was already aboard. Beam me up, Scotty, someone get me out of this. The plane was due to take off in one hour, and I was in deep shit.

Frank Roe was the Sgt. Bilko of our film group, a doer and miracle worker when the goings were a little bit shady. "Frank, you have 50 minutes to save my butt. Go over to flight operations and get nine jet fuel test tubes. Call my secretary, Hazel,

have her find out the names of the missions Father Serra founded, have her type labels, and attach them to the tubes. Then get some dirt from the field and fill the tubes, carefully put them in a small box and get them here. You now have 45 minutes to keep me from being lynched." Off he went, like a zebra spooked on the Serengeti.

I knew Hazel Fowler would get her part of the job done; she's one of those "can do" people and, in her job, she was my right and left hands. She protected me from the many corporate villains who were trying to get my job when I was on the other side of the world. To me, she was Secretary of the Year every year.

The passengers were all on board by now. I walked around the aircraft with our chief pilot, Ed Heimerdinger. "Why aren't you on board, Bill?" he asked.

"I'm waiting for a very important package. It should be here any minute," I replied in an unconcerned manner.

"Well, we can't wait," Ed said, "We have to leave on time." I followed Ed very slowly up the gangway thinking how I could blame someone, anyone—baggage handlers in Majorca, perhaps? The sound of a horn filled the air. It was Frank driving like a maniac across the tarmac. A checkered flag on the front of his car allowed him to drive anywhere on the ramp.

Frank's smile was purely diabolical as he said, "Boss, you owe me big. I want that film in Tahiti." He held the box tightly and away from me. The pilot was yelling to me from the door of the plane.

"You've got the job in Tahiti," I said reluctantly, as I pulled the box from his grasp.

The island of Majorca is one of my favorite spots on Earth. Its Moorish watchtowers tell of a period of black knights from North Africa who brought a new dimension to the culture of the island. It is the stuff of legends, myth, and harsh realities, with thousands of years of history. Today, tourism is the island's main source of income, with gypsy palm readers to bullfights, beautiful beaches, resorts, and enough antiquity to make even the most jaded historian salivate.

The garden of Father Serra's home was a melting pot of colors the morning of the "ceremony." The one-lane road leading to the house was blocked with dozens of vehicles, along with the locals of Petra, who were out in full force.

My camera was set up in position to get close-ups of the cardinal gently placing the phony dirt atop the soil near the house. Tears of joy rolled down the cheeks of the faithful with this tribute to the beatified Father Serra, upon whom Pope John Paul II had conferred sainthood. Father Serra, who personally baptized more than 6,000 native Americans, walked an estimated 24,000 miles in California (then called Alta California), founding missions from San Diego up to Carmel.

I zoomed in to record this moment of reverence and felt like a miserable turd caught up in a wind devil. The cardinal blessed me in Spanish. If he only knew.

Many times since that day in the garden I've wanted to confess and repent. After this book has been published, I will drive to the nine missions, collect soil from each one, fly to Majorca, and place my offering where it belongs. I'll do it at dusk and ask to be forgiven.

Chapter Twelve

Movers and Shakers

Hollywood is noted for its namedroppers. If you want to make an impression (meaning "get someone's attention"), you drop a name. And if you want people to think you're close to a big name, you use the person's nickname—it will register a 10 on the name-dropping scale.

I can't drop any names because I was never invited to a function where there was a world-class figure reigning over all. My camera was invited, however, so I'd go along as my camera's helper.

Some of the luminaries my motion picture camera recorded with yours truly as the uninvited guest began with Jimmy Doolittle on the USS *Hornet*. The next was in August 1943 just after I had finished motion picture school. It was to photograph President Franklin D. Roosevelt, an assignment I received through a fluke. Chief Art Black, the president's regular cameraman, had to tend to some family matters and, since I was the only cameraman available, I got the job.

I checked the 35 mm Bell and Howell camera over and over again. Was I ready for this task? I didn't think so. I even thought of saying I was sick. I was one frightened sailor. After taking orders from higher-ranking noncoms and officers for two years, I was unprepared to meet our commander-in-chief, who, I had heard, was a formidable person.

The presidential train was ready to transport the president to Quebec, Canada, from Washington's Union Station for a major conference with Winston Churchill. A Navy commander

briefed me on what I was to shoot. "You will board the train at the presidential car. The president will already be on the rear platform, waiting for the working press to be allowed into the area. You will photograph the president talking to the press from inside the car. The train will begin to pull away. You will stop photographing when he turns around and comes into the car. After he sits down, get a few shots with him as the train is moving. After you've completed your job, go to the other end of the car and wait till the train stops, which will be about 30 minutes out of Washington. Get off. A Navy driver will be waiting to take you back to the photo science lab."

The commander then leaned toward me and said, quietly, "The president has a problem, as you will see. He is a cripple, and this is top secret, Gibson. You must tell no one."

"Yes, sir, I replied.

Waiting in the president's car were the men who ran the country. I recognized secretary of state Cordell Hull and my big boss, Adm. King, who glared at me as I passed by.

The shooting went perfectly. As I turned to leave, The president spoke. I froze in my tracks. He was asking me a question. "What ship were you on, son?" The President had noticed my campaign bars.

"The *Hornet*, sir," I replied with a frog in my throat.

"Good job," he stated.

"Thank you, sir," I rasped as I turned and headed for safety. I slept very little that night. I now knew a state secret, and I was very happy with myself.

Some six years later I photographed the other Roosevelt, Eleanor, at the 21 Club in New York City. This time I was an Air Force cameraman assigned to cover a B29 bomber crew who were VIP guests of New York City for a week. They had just returned from the Korean War. Their aircraft was named *The Spirit of Freeport*, after the city on Long Island, and the Big Apple was wining and dining them like visiting royalty.

One of the functions was tea, tiny sandwiches and sweets with Eleanor. She was not one of my favorite people. During World War II, she toured Guadalcanal while I was there in

Photo Squadron One. She chastised the Navy, Marine, and
Army Air Corps for painting half-clad females on their planes
and insisted they be removed. Just a little touch-up on the
ladies' vital parts made the White House occupant happy and
the troops unhappy.

Mrs. Roosevelt looked up at the camera and said, "Won't
you join us for a cup of tea? The sweets are quite tasty." She
nodded for me to sit across from her. I was surprised; she was
as delightful as the sweets being offered. I thought for a
moment that if some of those salty sailors I had been stationed
with were invited to sit at the table with her, they might have
said something like "pass the f------ jelly." The thought made
me shudder involuntarily. I made a promise to myself that I
would never judge a person until after I had met him or her.
And I've only broken that promise a dozen or so times since.

The next mover and shaker was Gen. Douglas MacArthur. I
was assigned by the Department of Defense to cover him and
his family's every move on his return to the United States. Here
was another person I had prejudged. During World War II, the
Navy called him "Dugout Doug," and I repeated that phrase
each time his name was brought up. My camera and I were in-
troduced to the general in his suite at the Waldorf Astoria
Hotel. The first day I photographed his teenage son at a Giants'
baseball game. The next day, I covered his wife, Jean, shopping
on Fifth Avenue. Other than the ticker-tape welcome home
parade in his honor and his serving as grand marshal of the
Memorial Day parade, he never left the hotel.

Each morning, while I waited in the sitting room of his suite,
he would come out and talk to me and offer me coffee and a
doughnut. On one of these, usually brief, occasions, he asked
if I liked poetry. I replied that I was a Poe, Longfellow, and
Kipling man. He said he liked them all, but Rudyard was his fa-
vorite.

I told him I was the cameraman who had been assigned to
cover his landing on Wake Island at the historic confrontation
with President Truman, and how I had not been permitted in
the waiting room where the meeting took place. "Too bad, if I

had known, I would have insisted you and your camera be in there," he said. The general had a charismatic presence. By force of his personality, he made his listeners hang on his every word. At his farewell speech to the joint houses of Congress, some of the toughest, meanest "have done and seen everything" newsreel cameramen were seen wiping tears from their eyes when he said: "Old soldiers never die, they just fade away." He made that spark of patriotism come alive that day that caused you to feel, "Damn, it's great to be an American."

I have photographed two famous artists in my travels. The one and only Salvador Dali and Pablo Casals, the renowned cellist, composer, conductor, pianist, and humanitarian. Two men as different as an armadillo and panda. Señor Dali greeted me at the door of his home, located a short distance from Barcelona. I had seen pictures of him, but here he was, three-dimensional and in living color. His handlebar mustache, an art form all its own, had not a hair out of place. I felt as though I had just fallen into a rabbit hole and met the original Mad Hatter.

His eyes looked as if they were ready to shoot out of his head and hit you in the face. He welcomed me as though I were a long-lost friend. "First," he said, "a glass of fine Spanish wine." A goblet was more like it. It was ten in the morning, but one did not say no to this man. After two of these eye-openers and a brief introduction to his wife, we sat on couches opposite each other. This is when I knew I'd too much to drink.

The mustache unhooked a brilliantly colored, hand-painted pillow from the back of his couch and threw it at me. I started to duck but it simply tumbled a few times and began to rise toward the ceiling. I laughed; realizing Dali had filled all the pillows with helium and had them attached by hooks to the couches. Okay, I thought, let's play. I unhooked one of my pillows, wound up like a Yankee pitcher and let fly directly at him. Soon there were about 20 pillows bumping the ceiling and moving as if alive.

After our play period was over I took a couple of shots of Salvador (after our experience together I thought I had the right

to call him that—one more session and he would become just plain old Sal) actually painting. That afternoon I filmed the famous Spanish artist at work on a very different project. The Spanish Air Force flew a helicopter over his house so he could do an impressionist painting of the hovering bird. His easel was chained to the ground. With cape flying in the wind caused by the rotor blades, he made bold strokes with yellow paint on the canvas. I thought that the painting, which took him just five minutes, was fantastic! I was sorry to leave and said so. He invited me back "anytime."

How I met Pablo Casals was an entirely different story. It was with a blackmailing American admiral in Puerto Rico. I was making a film for the Air Force on massive troop and equipment maneuvers on this Caribbean island codenamed "Operation Big Slam."

Early one morning I was driving by the naval base, which was headquarters for the Caribbean Command in San Juan. I was stunned to see the flag-raising ceremony accompanied by 20 steel drums played by our sailors and conducted by a chief petty officer. When a cameraman sees something so out of place with military tradition, he is obligated to the big cameraman in the sky to record it for posterity. I was shooting in minutes and was just getting a close-up of a cloth-covered mallet striking marked lines (indicating musical flats or sharps) on a drum when a gloved hand covered my lens. It was a guard from the main gate. "You can't photograph here. Follow me. The admiral wants to see you now."

I could understand if I were filming without permission at the naval base in New London, Connecticut, through the open hatch of a nuclear sub—but a steel drum band? Someone had lost his or her mind. And there he was, staring out the window from the second story of the HQ building at the cameraman who had the temerity to photograph his beloved oil can symphony without his permission.

When you sit across from a legend, to forget why that reputation applies is an impossible task. Here, then, was this pirate, commander of an aircraft carrier in World War II, who boarded

and captured a German submarine—the first capture at sea of
an enemy vessel since 1815. His Navy biography read like he
was part Einstein and part Jack Dempsey. My favorite part,
however, was his moxie when he called the secretary of the
Navy's son a draft dodger and punched him out. That's real
guts, considering it could have ruined a lesser Navy man's
career. The band I saw out front played at both the Brussels
and New York world fairs and was called "Admiral Dan's Pan-
demaniacs."

After we made the film, Ben Marble told the admiral that he
and his band would be invited to the premiere in Los Angeles.
Ben should have known better. Two Navy transports flew in from
Puerto Rico to LAX International Airport—one with the steel
drums and the other with the band members. The sounds of
"Yellow Bird" and "Jamaica Farewell" filled the air from Malibu
to the Hollywood Hills, while neighbors danced the limbo.

But here, with Adm. Dan in Puerto Rico, there were other
things to do. He invited me to accompany him to dinner at a
friend's home, leaving out the name of the friend. He just said,
"We'd enjoy ourselves," and left it at that. Of course, the
admiral didn't know I was a cultural imbecile.

The host, who introduced himself to me as Pablo Casals,
met us at the door. The greeting was short and pleasant. At
dinner I asked him what he did for a living. For that I received
a sharp kick in the leg under the table from Adm. Dan. Mr.
Casals was much more genteel than the admiral, who was out
of uniform, wearing pointed cowboy boots. Casals answered
my question with a modest, "I'm a musician of sorts." I
thought I said the right thing when I asked if he would please
play for us. Another sharp kick from Adm. Dan indicated other-
wise. The ever-gracious Casals smiled. "I would love to. No
one has ever asked me to play at home before."

It was an evening I'll never forget; Pablo Casals was the
world's finest cellist and one of the most influential musicians
of the century. Each note he played was rich and perfect in
every way. Sometimes a little stupidity pays off. Later that
evening as we were driving back, I received an unexpected

kudo when Adm. Dan said to me, "I would have liked to have had you as my cameraman on the USS *Guadalcanal* when I captured that sub, Gibson."

The location? Pad 17A, Cape Canaveral, Florida. Waiting on the pad was *Pioneer One*, destined to leave Earth's atmosphere for our first visit into our solar system and, one hoped, beyond. The countdown was going smoothly, and it was approaching the time to clear the area of everyone except blockhouse personnel. In back of the blockhouse was a small building with toilet facilities and washrooms. I was doing my manly thing by focusing my eyes on a small spot on the wall in front of me when someone stepped up to the urinal next to mine and asked if I thought the launch would go off on time. He was quite a bit taller than I was and I had never seen him on the Cape before, but he looked familiar. "You can bet the farm that bird will be launched to the planned second," I said. I answered as if I were the launch director himself.

We both finished our business at the urinals, gingerly grabbing our privates, pushing our rear ends back, then quickly forward as we put our appendages back in the safety and sanctity of our trousers. I've heard that this series of actions when a man relieves himself is the origin of the "Funky Chicken."

"Don't I know you?" I asked, as we washed our hands. He smiled, threw his paper towel into the waste can, put his hand forward for a handshake, and said, "Lindbergh, Charles Lindbergh." I was stunned. Here I was, about to touch the hand of my lifelong hero. The man who knew no fear. This was the bravest, most modest human who ever took to the skies. Then I did my Hollywood thing. I name-dropped. "I'm proud to meet you," I said, "I was just talking to Jimmy Doolittle about you."

"So you know the general?" Lindbergh asked.

"We've been on a few hunting and fishing trips together," I replied, feeling a bit sheepish.

"He's a good man," stated the Lone Eagle. I was smart enough not to mention I had photographed Doolittle and his Raiders taking off from the *Hornet* on their bomb run to Tokyo.

Now, this was a chance I had to jump at. "General, will you let me take a photo of you with the Pioneer missile in the background?"

"You've probably heard I'm not one for publicity," he said. "Outside of a few, close friends, no one knows I am here at the Cape."

"I'll make you a deal, General. I'll make sure no picture or film will be released until after you're no longer with us. I'll classify it as 'Secret' to make sure."

He smiled. "All right," he said, "let's get it over with. We wouldn't care to hold up that launch, would we?"

I felt like a virgin cameraman as I framed this legend in my finder. Millions around the world cheered at his solo, nonstop flight across the Atlantic, but few knew of his exploits after that. His baby was kidnapped and murdered because of his celebrity, and if that made him a recluse, who could fault him. He flew 50 combat missions against the Japanese in World War II. A combat ace who never bragged about his successes. A consultant to the airline and aircraft industry as well as the U.S. space program. And, over his shoulder in my finder, was a wingless aircraft ready to depart for a trip to explore the universe. What a fantastic time to be alive!

Beginning with Franklin D. Roosevelt, I have photographed all our presidents with the exceptions of Carter and Clinton. Each one had his own camera look.

FDR had his own signature look—a cigarette holder with cigarette inserted and steady eyes that were sometimes serious and intense, other times twinkling. Truman would speak to whomever was nearby. You could never fill your finder with a close-up of his face; he made very quick movements, and suddenly you were shooting air. Eisenhower was just the opposite. You could have bolted your camera to its tripod, gone to get a cup of coffee, returned in three minutes, and he'd be in frame, exactly as when you left him. Kennedy was a Holly-

wood matinee idol. His camera presence was awesome, yet varied enough to make him a really interesting subject. Only once did I see him play second fiddle to another leader. It occurred during his state visit to Paris with his wife, Jacqueline.

The Champs Élysées was packed with the French cheering and waving at their leader and the handsome U.S. president as together they rode rapidly in an open car toward the Arc de Triomphe. They were the parade—no floats, no bands, no baton twirlers—just two grand marshals speeding toward the Tomb of the Unknown Soldier.

President de Gaulle, a good foot taller, stared straight ahead. Kennedy looked and smiled at the waving bystanders. If they had been two actors entering stage left, the audience would have known immediately that de Gaulle was the lead actor. As for Kennedy, the ladies only saw one man in the car, and the seat next to him was theirs alone.

My camera position was on a scaffold at the Arc de Triomphe d'Étoile, an architectural masterpiece conceived by Napoleon Bonaparte as a memorial to France's Unknown Soldier. I could easily cover their route from the Place de la Concorde to the Eternal Flame where the wreath would be placed. Looking down on two of the most powerful men in the world, whose heads were now bowed in reverent respect, made a memorable impression. I couldn't help but imagine a leader from the past watching the ceremony. He was short, wearing a gaudy uniform, with his right hand tucked inside his waistcoat.

I also filmed President Kennedy on a tour of Cape Canaveral. Kurt Debus, director of the Cape for NASA, told me later that the president had asked if his visit could be cut short because he had an important engagement in Palm Beach.

Eisenhower and Kennedy were the presidents responsible for our space program. Eisenhower created the astronaut program, and Kennedy, in the spring of 1961, excited the populace by challenging the country to land on the moon and return safely to Earth in this decade. The race for space had begun between the Soviet Union and the United States.

It was an exhilarating time, but was overshadowed, at least for me, by the Cuban Missile Crisis in October 1962. At this period in my career, I was very much involved with the American plan to develop nuclear intermediate-range and intercontinental-range ballistic missiles. For the first time in my life I no longer awakened each morning with a smile or a new pun or a goal in life that had my feet anxious to stand on new territory. I was privileged, if you could call it that, to know how many nuclear warheads and their destinations were attached to Thor and Jupiter missiles on mobile launchers in Italy, Turkey, and the United Kingdom. They were ready to be unleashed, if the situation called for it, to rain destruction on the innocents of the world.

I made a dozen trips to the launch sites in England for the project, which was called Emily. Each site had three missiles prepared to blast off in a 15-minute period to tactical zones throughout the Soviet Empire.

Enter Fidel Castro, who overthrew Cuban dictator Fulgencio Batista and was hailed as the liberator of the Cuban people. Americans, too, cheered Castro's feat until he aligned his island country with the Soviet Union. The United States, fearing a Soviet threat only 70 miles from its southeastern shores, became a focus of the incoming Kennedy administration. CIA-trained Cuban exiles failed in an invasion attempt against the new regime at the Bay of Pigs, an event Havana anticipated and thwarted. The secret arms buildup in Cuba, sponsored by the Soviets, escalated until intelligence information uncovered in 1962 SA-2 surface-to-air missiles construction; in September 1962 they became operational. The inevitable occurred when one of our U-2 spy planes overflying the island was shot down October 25. Other flights had photographed Cuban sites that were being prepared to host intermediate-range ballistic missiles aimed at the United States.

A dire crisis ensued, and the Kennedy administration's response was to have the U.S. Navy quarantine all Cuban ports. U.S. Navy vessels waited for the Soviet cargo ships in the Atlantic, and for the 14 days of the crisis the possibility of conflict

and its escalation into an extended war became a real possibility. The world held its collective breath.

My job in this whole mess was to document, with photography, the dismantling of ballistic missiles in England while other cameramen had the equivalent responsibility in Turkey and Italy. The two leaders of the most powerful nations in the world compromised and averted what could have changed the world for decades to come. The Soviet ships turned around and headed home and the world released its collective breath of relief.

By the time Ronald Reagan came on the national political scene I was up to my eyeballs in video, black and white balances, screwdrivers, cables, and more cables. The Committee to Elect Ronald Reagan contracted my wife, Harriet, and me to produce a live via satellite program titled, "Commitment '80." The program, to be broadcast from WETA, the Public Broadcasting Station in Washington, D.C., was a major push to Republican groups downlinked all around the country to "get out the vote." Instructions were to be given on how to do this. Republican stalwarts were introduced, then Gov. Reagan was to give one of his stellar speeches.

When a director (which I was) is going to direct a show, he or she discusses, with the actor(s), ideas on delivery. But this is not so with politicians, even if they used to be actors. The director is lucky if he gets to shake hands before the last seconds of countdown to airtime.

It was 30 minutes to "fade in" and no Reagan. I paced the sound stage, I walked the hallways, I peeked out the front door to look at an empty driveway. At this point I cursed actors and would have voted for Tiny Tim. Then, to my considerable relief, the limousines arrived. Dogs on leashes and Secret Servicemen exited the vehicles on the double. They were all wearing dark glasses. I had been exposed to their modus operandi several times, and I've often wondered if they were issued the glasses along with their weapons. I've also wondered if they made love with only their shades on.

I told the first agent we didn't have time for the dog-sniffing.

He quickly scanned my body with a metal detector, pushed me aside, and took his dog to the sound stage. So much for respect.

After the Secret Service had finished its rounds, Reagan entered the building, and flashed his disarming, engaging, vote-getting smile. "Governor," I offered my hand for him to shake, "I'm Bill Gibson, your director for this program, and we don't have much time."

"That's the last thing I want to hear," he smiled, "and what are we shooting today?" Always efficient, Harriet appeared and handed him the script.

Reagan's set was on a different side of the stage from the other on-camera participants. When we cut from live to tape, I asked him how it was going. He looked up from the script and said, "This is great. Is my part on the Teleprompter?"

"Yes it is," I replied, "every word. Would you like to go through it, quickly?" I added, "We have a few minutes before we go live back on the bird."

"That won't be necessary," he said.

When we went live, I knew he'd be good, but I didn't realize just how good his delivery would be. It was flawless, and he even adlibbed a few lines about America and how lucky we were to be able to vote. No question in my mind, then, that he would be elected. And, I might add, he was a director's dream.

I prefer to remember him in front of the Brandenberg Gate in Berlin in 1987 as he challenged the secretary-general of the Communist Party, Mikhail Gorbachev, to "open this gate, tear down that wall" in reference to the Berlin wall and the division of East and West Germany. Perhaps those words seemed the ravings of a dreamer, but two years later the Brandenberg Gate was opened and reunification of Germany began.

Nothing encourages a man to aspire to a higher place among his fellow men than the inspiration of another. Every age has had its titans of knowledge and men of action who stimulated those around them. "Reflect for a moment on the gripping influence exerted by men like Ben Franklin, Dr. Albert Schweitzer, Thomas Edison, and Leonardo da Vinci, who could do everything and he did." Well said by Wernher von Braun.

I still find it hard to believe that I directed von Braun in three films: a full-length documentary for 20th Century-Fox and two TV specials for Hughes Television Network. I've never met anyone with more smarts. The stories told about Wernher von Braun by his associates and co-workers could fill volumes. Not only was he a brilliant engineer—some would call him a genius who ranked alongside Kármán, Tsiolkovsky, Ehricke, and Goddard in space exploration—but an accomplished musician, top-notch administrator, and a person who could, against all odds, get things done. His understanding of people, principle, and character may be illustrated best by the following story told to me by Kurt Debus, director of the Kennedy Space Center, about the early days at the Cape.

The United States was attempting to launch a Jupiter ballistic missile, but it exploded in less than a minute on its downrange flight. The telemetry and photographs gave no indication of what had happened. This meant that hundreds of tests had to be repeated, and time was of the essence. The Soviets had a workable missile while we were finding it difficult to get one off the ground without its blowing up.

The day after this explosion, one of the launch crew members asked von Braun's secretary if he could have a moment with Dr. von Braun. In the meeting with von Braun, the crew member, whose name was Wolfgang, told him he had reset a switch on the control system. Von Braun excused the man and instructed him to be in the conference room at 5 P.M.

Assembled in the conference room were the entire Jupiter civilian engineers and Army staff when von Braun entered promptly. What chilling thoughts must have gone through his mind as he reflected back to the days in Peenemünde? For this mistake, a change in the procedure of the checklist, he would have been put before a firing squad. He knew he had just cost his new country millions of dollars and was at a loss to explain himself.

Von Braun spoke to the convened group and told them that Wolfgang accidentally tripped a switch on the guidance system. "Now, if he had kept this to himself, we would be at least

another month before another bird would go on the pad. In my estimation, it takes a real man and loyal worker to come forward as Wolfgang did. He has made it possible to place another Jupiter on the launchpad tomorrow." Von Braun buzzed his secretary who, with two assistants, walked into the room carrying trays filled with full glasses of champagne. "Let's have a toast to the brave man, one who is not afraid to admit his mistake." There was a round of genuine applause followed by toasts.

While photographing the TV special "Space in the Age of Aquarius," I requested cooperation from the Summa Corporation in Las Vegas, Nevada. I needed to film on a mountain located on Howard Hughes's ranch. When I mentioned the name Wernher von Braun, the floodgates opened. "You can stay at the ranch. Do you need a helicopter to shoot from? Is there anything you need, anything?" Von Braun's name was magic. Everyone wanted to meet him and for good reason. He was the man who had guided our space program to unbelievable prominence and would take it even further in the years to come. The scene on Hughes's ranch looked as if Hugh O'Brien, the host of the special, and von Braun were on a moonscape. I couldn't have asked for a more realistic setting.

That evening, we were all to stay at the ranch when strange goings on occurred. All the vehicles and the helicopter traveled back to Las Vegas, leaving us with a cook and a ranchhand. The gates at the ranch had been double-locked, making the trip to Vegas and lighthearted fun a ten-mile walk. Someone, in his infinite wisdom had made us hostages for the night. My imagination soared as it is wont to do in odd circumstances and I was more than a little concerned.

There was a recluse living on the top floor of the Desert Inn whom no one seemed to be in communication with, including Robert Maheu, president of the Hughes Summa Corporation. I wasn't even sure who had made the decisions regarding our accommodations. What an interesting movie plot; a world-famous rocket scientist is kidnapped by a madman and flown to a remote desert location where they will build their own

missiles and rule the world. Von Braun interrupted my thoughts. "Why can't we go to town, Bill? That's one of the main reasons I am here. I've never been to Las Vegas, and everyone told me you would show me a little excitement."

Then it dawned on me. Here was a man whose entire life had been orchestrated for him. He'd never had an opportunity to go "out with the boys" and this was his chance. Now pushing 53, von Braun wanted to sample something of life he felt he'd missed. Beautiful showgirls, gaudy entertainment, and the lights and excitement Las Vegas could offer, and here we were, stuck on a desolate ranch only to find the phone out of order and the portable radio communications we had were missing. I felt like a failure to my hero. The next morning a helicopter picked us up and flew us to the airport. Von Braun shook my hand and said with a smile, "Don't worry about last night, Bill, I enjoyed playing Moses on the mountain."

Several years later I was at NASA headquarters in Washington, D.C., walking by a small office. I glanced in to see von Braun unloading items out of cardboard boxes and placing them in their new surroundings. I knocked; he looked up and said, "Come in, Bill, this is my new office. Have a seat."

I was shocked. You could have put this little office in the bathroom of his former office in Huntsville. Here was the driving force that put a man on the moon and returned him safely to Earth. I asked him why he hadn't left government service for a really lucrative position in the aerospace industry where he could make ten times the money. His reply was indicative of his deep-seated feelings for America. "Bill, my Peenemünde team and I are beholden to the country that gave us the freedom and opportunity to work in the field of space research, which is all I have ever wanted to do." He held out his hands, looked at them, and continued: "I work with my hands and mind. I used to build things, but now I am liaison to Congress, a public relations person." I could sense his sadness.

I knew why he had been put in this "new" position. NASA didn't think it needed him anymore. He was the darling of the

media, and every university wanted his obvious talents. He was stealing the thunder of the civil service brown-nosers so he was pushed out. It made me angry.

Von Braun finally left NASA to work for the Fairchild Corporation. His office held the plaques and awards of an amazing career. In the corner sat a six-foot model of the Apollo. He shook my hand, "Good to see you again, Bill, would you like me to give my sermon on another mountain?"

Two years later, Wernher von Braun died of cancer. I had known a titan of the twentieth century.

We had just returned from marlin fishing at Rodriguez Hotel in Baja, California. Paul Mantz, movie stuntman and pilot who flew in almost every movie from silent days to the present, had flown Gen. Doolittle and me to this Mexican resort to do a little fishing and bird hunting.

Just before dinner I walked down to the dock where two young children were playing on the beach. The boy picked up a rock and threw it at the girl, hitting her on the forehead and knocking her unconscious. I jumped off the dock, picked up the girl, and rushed her to the office where, fortunately, there was a nurse. On my way there I passed a bald-headed man who was evidently her father. "Is she alright?" He yelled in panic.

I shouted back, "I think so; looks like a bad bump on her forehead." He ran to catch up with me and we went into the office together as I handed her to the nurse.

"Thank you," he said, and reached out to shake my hand.

"You look familiar," I replied. "Have we met?"

"Crosby, Bing Crosby," he said.

So, my favorite singer had been wearing a toupee—no wonder I didn't recognize him. "I noticed you're with Paul Mantz and Gen. Doolittle. Would it be too much of an imposition to ask if I could meet the general? You see, he's been a hero of mine for many years."

I smiled, thinking how delighted Doolittle would be to meet

Bing Crosby. "Of course," I replied, "I'll be happy to introduce you."

Doolittle was thrilled to meet Crosby, and they chatted amiably for some time. Later that same evening, while the general stayed at the hotel, Paul and I went bar-hopping in La Paz. On the way back in the cab, Paul and I harmonized on some of Bing's old songs. "Hey Bill," Paul suggested, "when we get back, why don't you serenade Bing and his wife with the song Bing sings at the Del Mar Race Track?"

With a few drinks under my belt, I did just that. When I was through there was nothing but silence until a rich voice from the cabana said, "Gibson, don't give up your day job."

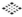

When I started this book, I made a list of camera assignments. Now it's time to mention a few and put some of them on the cutting-room floor.

Out goes the flight in the B-29 with the Air Force Hurricane Hunters; out goes building an igloo on the Arctic ice for a survival film; eliminate the spider monkey, Albert, who gave his life to space research on a V-2 flight; drop the crash of a Navy K ship blimp at Santa Ana; toss the scenes of the Thai International Caravel jet being towed by a bull elephant; leave in the Navy motion picture school at Pensacola. That was my last Navy assignment. It made this illiterate in a white sailor's cap chief instructor at one of the most prestigious film schools in the world.

I was sent to teacher's school at Jacksonville Naval Air Station, where I learned how to follow a lessonplan and motivate the students to excel in their chosen field. The course I taught lasted for four months of six-day-a-week intensive training. Six students per month were admitted, and they would learn everything about chemicals, processing, timing the negative, printing, editing, and, most of all, thorough knowledge about and use of a motion picture camera.

I made up my lessonplans with a few extras I thought would

enhance their enjoyment and understanding of the whole learning process. For example, the first night I made each student sleep with his camera, and I checked several times to make sure the Bell and Howells were snuggled against their bodies. Each morning I began class by yelling: "Do you love the Navy?"

They yelled back: "I love the Navy."

"Do you love your family?" I yelled.

"I love my family," they shouted.

"Do you love your camera?" I screamed.

"I love my camera," they screamed in reply.

"And who do you love more, the Navy, your family or your camera?"

The students would rise from their seats and yell at the top of their lungs: "We love our camera!" I caught some flak about this devotion to the camera over the U.S. Navy from photo officer Dale, but he dropped the matter when I refused to change our daily routine.

Another quirky habit I instituted was the "eye salute" between instructor and student. When we met one another we would close our left eye and keep the right one open. "Here is the reason why we have our own unique salute," I explained. "The left eye is the real world where other humans reside. The right eye is the storyteller's eye, and it makes you different. If you're shooting a spectacular sunset, your right eye can add beauty to the scene by its framing in the viewfinder, whereas if you are shooting combat or a riot, the left eye must remain shut (except if you have to move). Do this, and the big cameraman in the heavens will see you don't get hurt."

I thought I would end this book with a description of my favorite scene, for one stands out from all the rest—at least in my mind's eye. For the third and last time, I returned to Lambaréné, where Albert Schweitzer's hospital compound rested on the banks of the Ogowe River. I saw changes everywhere. The operating room had a new floor and was air conditioned. There was a new nursery where special formulas were being tried out on the babies. With all this newly introduced modern

technology, I noticed something missing: patients. Animals were no longer present, and bickering was constant between staff members.

I looked for the scene I needed to complete my film and found it over by his one-room quarters. It was a simple tombstone, engraved Albert Schweitzer: Born 4/1/1875 Died 4/9/1965." I put my camera in my lap as I sat at the foot of his grave. It had taken me several years to begin to comprehend what the good Doctor had meant by "reverence for life." I was thinking about it when I was interrupted by a slight push on my back. I turned to see a black-as-ink goat, the same one that had followed the doctor on his hospital rounds. He gave a soft bleep and, together, we silently honored this great man. I had no film left in my camera and, for the first time, it really didn't matter.

Index

A

Aberdeen harbor, 148
Abidjan, 109, 110
Acropolis, 141 first satellite in
 orbit, 90, 91,
Adams, Don, 66
Adelie penguins, 36, 37
Admiral Dan's Pandemaniacs,
 162
Aerobee, 79
Air America, 107
Air Afrique, 56, 109, 110, 111
Air group, 8, 23
Air India, 147
Alameda Naval Air Station, 10
Aldrin, Edwin E. Jr., 45
Allen Gordon Enterprises, 84
Amazon river, 95
Amundsen, Roald, 34, 35
Antarctica, 33, 34, 35
Apollo project, 93, 172
Apollo 11, xii, 45, 93
Arc de Triomphe d'Ètoile, 165
Arctic Circle, 45
Arizona, USS, 21, 22, 130;
 Band, 22
Armstong, Neil, A., 45, 95
Arnold, Hap, 15, 18, 75
Arriflex camera, 59, 70, 94,
 100, 136, 140
Atlantic Missile Range, 92
Atom Bomb, 115

Atom Bomb tests, 116;
 "Crossroads," 116, 121;
 "Able," 116, 118; "Baker,"
 116, 119
Automatic tracking system, xii

B

Bailey's beads, 45, 46
Ball, Lucille, 88
Barcelona, 160
Bates, Don, 81
Batista, Fulgencio, 166
Bay of Pigs, 166
Bell and Howell camera, xvi,
 2, 42, 157
Berlin Wall, 168
Bethesda Naval Hospital, 51
Beverly Wilshire Hotel, 132
Bikini Atoll, 116, 118, 119, 121
Black, Art, 157
Blackburn, Blackie, 95
Bluebook, project; "Grudge,"
 42, 46, 48; "Twinkle," 46
Boeing. *See* Douglas Aircraft
Bonaparte, Napoleon, 165
B-1, 41
B-17, 41
B-24, 41
B-25, 4, 8, 9, 11, 15, 16, 18,
 44, 67
B-26, 42, 43
B-29, "Spirit of Freeport," 158

Brazzaville, Congo, 111
Bromberg, Jack, 88
Buckingham Palace, 134, 136,
 137
Byrd, Richard E., xiv, 34, 122,
 123

C
California, USS, 21
Cape Canaveral, 83, 86–92,
 95, 163, 165
Carr, Maj., 41
Casals, Pablo, 160, 161, 162
Cassano, Nick, 3
Castro, Fidel, 166
Catch 22, 44
Cessna, 337; Skyknight, 67
Chaffee, Roger, 91
Champs Élysées, 165
Chiang Mai, 107, 108
China Sea, 133, 148
China Coast, 149, 150
Churchill, Winston, 128, 129,
 157
CIA, 106, 107, 108, 111, 166
C-118, 87
C-130, 33, 34, 35, 103
Cocoa Beach, 92, 93, 95
Cole, Richard, 17
Communist Day Parade, 125,
 126
Courtwright, Hernando, 133
Cousteau, Jacques, 22
Craven, Tommy, 128
Cronkite, Walter, 80
Crosby, Bing, 172, 173
Cuba, 166
Cuban Missile crisis, 166, 167
Curtis dive bomber, 39
Curtis pusher, 136

D
Dali, Salvador, 160, 161
Da Nang, 97, 99; press club,
 103, 104
da Vinci, Leonardo, 168
DC-3, 98
DC-8, 45, 150, 153
Debus, Kurt, 93, 165, 169
DeGaulle, Charles, 137, 165
Director's Guild of America,
 82
Doolittle, James H. "Jimmy,"
 xi, xii, 3, 4, 5, 11, 13, 157,
 163, 164; and Bing Crosby
 172, 173; bombing raid on
 Tokyo, 15–19; character of,
 76; early life, 75; Medal of
 Honor, 18-19; travels in
 Venezuela, 65, 67-73
Doolittle Raiders, xv, 4, 5,
 15–19, 164
Dorsey, Tommy, 22
Douglas A4, 100, 101, 102
Douglas Aircraft Company, 45,
 63–64, 76, 86, 88–89, 97,
 109, 133–136, 152
Douglas, Don Jr., 64
Douglas, Don Sr., 88
Douglas SBD, 39
Duncan, Donald, 8
Duvall, Bill, 88

E
Eclipse, 46, 47
Edison, Thomas, xiii, 129, 168
Eiffel Tower, 134
Eighth Air Force, 41
Eisenhower, Dwight D., 75,
 164, 165
Emily Project, 166

Emperor penguins, 37
England, 167
Enterprise, USS, 12–15, 20, 23, 25
Enyu, 116, 118, 119
Espinoza, Fermin, 139, 140

F
Fairchild Corporation, 172
Fall River, USS, 117, 118
F4F, 23, 24
F-80s, 40
Forster, Bob, 89
Fowler, Hazel, 136, 153, 154
Frankenheimer, John, 88
Franklin, Benjamin, 168
Friedman, Sigmund, 55, 56, 57, 58

G
Gabon, West Africa, 54
Gabrielson, Jack, 136
Gallery, Dan, 161, 162, 163
Gay, George, 25
Gibson, Harriet-Hooper, 167, 168
Gorbachev, Mikhail, 168
Gordon, Ted, 84, 88
Grand Canyon, 44
Great Rift Valley, 145
Greece, 141; Athens, 141, 142
Greenwald, Sam, 129
Grey, Zane, 28, 29
Griffith, D. W., 142
Griffith, Millard "Brandy," 84, 85, 86, 87, 88
Grissom, Gus, 91
Grudge, Project. *See* Bluebook
Guadalcanal, 158
Guadalcanal, USS, 163

Gulfstream II, 44

H
Halsey, Bull, 12, 15
Hansen's disease, 57
Haven, USS, 119
Heimerdinger, Ed, 154
Henderson, George, 29
Hilton, James, 18
Hirohito, Emperor, 18
Hiroshima, 115
Holloman AFB, 42, 47, 48, 79, 80
Hollywood, 16, 102, 147, 157
Honey wagon, 115
Hong Kong, 148, 149, 150
Honolulu, 25; Cottage rooms, 25, 26, 27, 28
Hornet, USS, xv, 1, 3–8, 10–17, 20, 21, 23, 25, 28, 30, 67, 85, 134, 157, 164
Hughes, Howard, 170
Hughes, USS, 5
Hull, Cordell, 158

I
Iberia Airlines, 138, 140, 152
Indianapolis, USS, 120
Italy, 141, 166, 167

J
Jacksonville Naval Air Station, 173
John F. Kennedy Space Center, 92, 169. *See also* Cape Canaveral
Johnson, Lyndon, 92
Johnson Space Center, 91, 94
Joint Chiefs of Staff, 115

Jupiter missile, 89, 91, 166, 169, 170
J. Walter Thompson, 133

K

Kaye, Sammy, 22
Kempe, Hal, 5, 10
Kennedy, Jacqueline, 165
Kennedy, John F., 92, 164, 165; Cuban missile crisis, 166-67
Kenya, 142
Kerr and Downey, 142
King, Ernest, 7, 130, 158
Knox, Frank, 7, 13
Korean War, xi, 125
Kraal, 145
Kwajalein Island, 117

L

Lander, Enrique, 67-70
Las Vegas, 170
Lean, David, 17
Leprosy. *See* Hansen's disease
Liberace, Lee, 88
Lindbergh, Charles, 18, 36, 163, 164
Loftus, Leo, 35, 36, 37
London, 136
Loucks, Grant, 84
Lousma, Gracia, 94
Lousma, Jack, xi, xii, 94, 95
Lunar Excursion Module, 94
Lykes Steamship Line, 149

M

MacArthur, Douglas, 159, 160
MacArthur, Jean, 159
Maheu, Robert, 170
Majorca, 152, 154, 155
Mantz, Paul, 65, 66, 172, 173

Marble, Bea, 63
Marble, Ben, 55, 56, 59-66, 97-100, 102, 104, 106, 111, 132, 134, 137-150, 162
Marineland of the Pacific, 151
Marshall, George C., 18
Marshall Space Flight Center, 92
Masai, 145, 146
Mauritius, 147
McElroy, John H., 117, 120, 121, 122, 123
McGovern, Dan, 41, 42, 47, 79, 80
McMurdo Sound Station, 33, 36, 37
Medal of Honor, 18, 19
Midway, Battle of, 3, 4, 25
Miller, Glenn, 22
Mitchell camera, 23
Mitscher, Mark, 8, 11, 13, 16, 22
Montalbon, Ricardo, 140
Montana, University of, xii
Morris, USS, 4
Moscow Hotel, 112
Mousetrap Bar, 95
Mt. Bolivar, 73

N

Nagasaki, 115
Nairobi, 142
NASA, xii, 45, 91, 94, 95, 164, 171, 172
Nashville, USS, 14
National Geographic, 45
National Science Foundation, 33
Navy Motion Picture School, 101, 173, 174
New Stanley Hotel, 142

New York City, 125, 158
Nimitz, Chester, 24
Norfolk Naval Base, 6
Northampton, USS, 3
North Island Naval Air
 Station, 39
Norton, Kay, 3, 4
North Vietnam, 113

O

O'Brien, Hugh, 170
Ogowe River, 54, 55, 58, 174
Oklahoma, USS, 21
Oldfield, Barney, 128
Onassis, Aristotle, 143, 145
Orinoco River, xi, 68, 94, 95
Osborne, Edgar "Ozzie," 16,
 17, 23, 24

P

Palau, 121, 122
Pan American Airlines, 37
Pan American Support
 Services, 83, 84
Panama Canal, 4
Paris, 137, 165
Paris Air Show, 106
Parthenon, 134, 141, 142
Patrick AFB, 86
PBM (Patrol Bomber Martin),
 120
Peace Corps, 57, 110
Pearl Harbor, 8, 13, 22, 23,
 130
Pedro Domecq, 138
Peenemunde, 169, 171
Petra, 155
Phantom, 97
Philippine Airlines, 150
Photo Squadron One, 159
Pigna, Jose, 73, 74

Pine, Frank, 44
Pioneer One, 163, 164
Plaza Theater, xiii, 11, 123
Poe, Edgar Allan, 46
Pope John Paul II, 155
Puerto Rico, 161, 162

Q

Quackenbush, Robert S. Jr.,
 117

R

Radiation, 119
Rancheros, the, 64, 65, 66
RCA, 83, 86
Reagan, Ronald, 167, 168
Rejoneador, 139
Ride, Sally, 94
Rivatuso, Sam, 5
Rockadyne Corporation, 88
Roe, Frank, 153, 154
Roemer, Kiki, 68–72
Roosevelt, Eleanor, 158, 159
Roosevelt, Franklin D., 8, 18,
 130, 157, 158, 164
Ross Ice Shelf, 36
Ross, Miles "Mike," 91–93
Ross, Pat, 91
Roswell, New Mexico, 47, 48
Rothschild, Baron, 143, 144,
 145

S

Saidor, USS, 116, 118
Sampson Underwater
 Housing, 151
Samuelson's Camerea, 110
Santa Monica Convention
 Center, 48
Santilli video, 48
Schriever, Bernard, 87, 88

Schwartz, Dick, 98, 99, 101, 102
Schweitzer, Albert, 51, 54–58, 168, 174, 175
Scott, Robert Falcon, 34, 36
Seabees, 116
Serengeti Plain, 134, 146
Serra, Father Junipero, 152, 153, 154, 155
Shackleton, Ernest H., 34
Shore, Dinah, 26
Siberia, 111, 112
Skate, USS, 119
Smith, Dewey, 98, 99, 101, 102
South Pole, 34, 35, 123
South Vietnam, 97, 98
Soviet Academy of Science, 47, 106, 111
Soviet Pioneers, 113
Soviet Union, 84, 89, 90, 106, 111, 165, 166, 169
Spain, 134, 138, 140, 141
Spanish Air Force, 161
Sputnik, 90
Starlite Hotel, 92
Summa Corporation, 170
Surf Restaurant, 93

T

Tallman, Frank, 65, 136
Task Force 1.1, 115, 121
Task Force 16, 24
Task Force 17, 25
Tet Offensive, 52, 97, 104
Thomas, Lowell, 77
Thor missile, 83, 84, 85, 86, 89, 166
Thunderbirds, USAF, 40
Tienta, 138
Tokyo Broadcasting Company, 94

Tokyo Raiders. See Doolittle Raiders
Truman, Harry S., 115, 127, 128, 159
TRW, 91
T-33, 40
Turkey, 166, 167
Twain, Mark, 132, 147
Twentieth-Century Fox, 82
"21" Club, 158

U

UFOs, 48
United Kingdom, 166
USAF Ballistic Missile Division, 76, 87
USIA, 109, 110
U.S. State Department, 111
U.S. South Pole Station, 35

V

Vanguard, 89, 90
VD-1, 54
Velazquez, Diego, 153
Venezuela, xii, 67, 72, 73, 94
VIASA Airlines, 72
Vietnam, xi, 52, 98, 99
Von Braun, Wernher, 46; character of, 168–172; first satellite in orbit, 90, 91; White Sands, 81–82
V-2, 80, 81, 82, 89

W

Wake Island, 159
Waldorf Astoria Hotel, 159
Warner-Pathé, xiii, 126, 127
Wasp, USS, 4
Watson, Harold F., 18
Watts Riots, 130
Webb, Jack, 88